pastel
painting
ATELIER

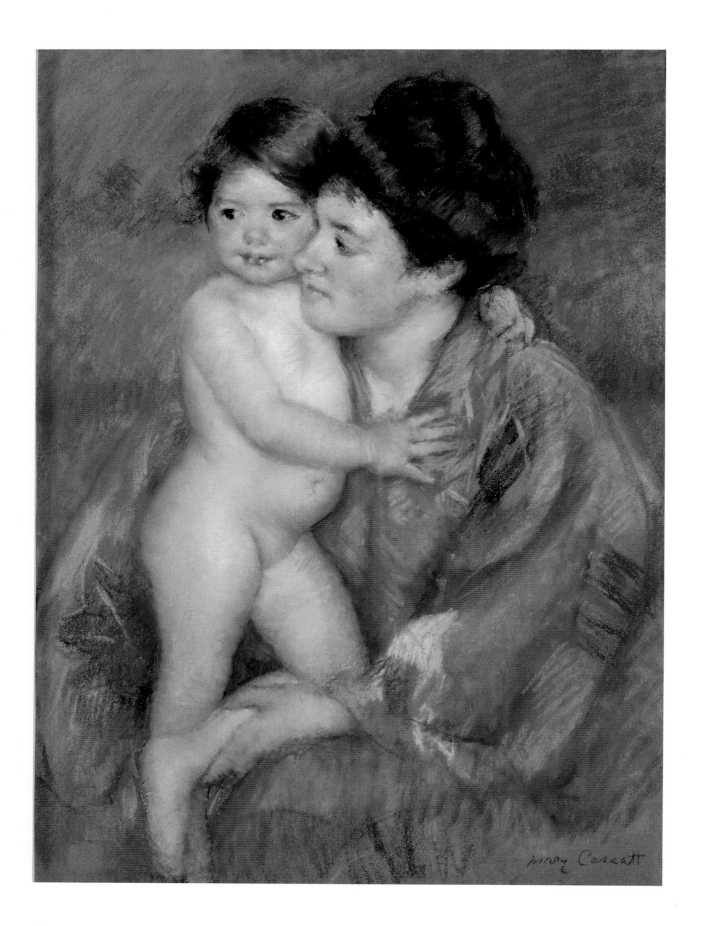

pastel
painting
ATELIER

ESSENTIAL LESSONS IN
TECHNIQUES, PRACTICES,
AND MATERIALS

ellen eagle

Foreword by MAXINE HONG KINGSTON

Watson-Guptill Publications
New York

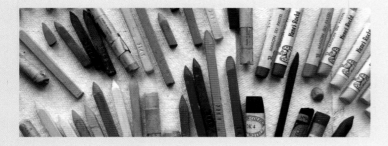

Published in the United States by Watson-Guptill Publications, an imprint of the Crown Publishing Group, a division of Random House, Inc., New York.
www.crownpublishing.com
www.watsonguptill.com

WATSON-GUPTILL and the WG and Horse designs are registered trademarks of Random House, Inc.

Library of Congress Cataloging-in-Publication Data
Eagle, Ellen.
 Pastel painting atelier : essential lessons in techniques, practices, and materials / Ellen Eagle. — First Edition.
1. Pastel painting—Technique. I. Title.
 NC880.E23 2013
 741.2'35—dc23
 2012018761

Printed in China

Book design by Karla Baker

Jacket design by Karla Baker

Jacket art: Ellen Eagle

10 9 8 7 6 5 4 3 2 1

First Edition

HALF-TITLE PAGE IMAGE:

Ellen Eagle, *Anastasio*, 2010, pastel on pumice board, 8⅜ x 6¾ inches (21.3 x 17.1 cm)

This is the first portrait I did of Anastasio. I selected the very close, frontal gaze because of his sharply intelligent observations.

TITLE PAGE IMAGE:

Mary Cassatt (American [active in France], 1844–1926), *Woman with Baby*, c. 1902, pastel on gray paper, 28⅜ x 20⅞ inches (72.1 x 53 cm), collection of The Sterling and Francine Clark Art Institute, Williamstown, Massachusetts. Gift of the Executors of Governor Lehman's Estate and the Edith and Herbert Lehman Foundation, 1968.301
PHOTO CREDIT: MICHAEL AGEE

Cassatt was a superb draftswoman, yet she did not hesitate to break through her fine drawing lines with vigorous strokes of pastel, and often left some areas of her paintings less finished than others.

IMAGE FACING CONTENTS PAGE:

John Appleton Brown, *Old Fashioned Garden*, circa 1889, pastel on paperboard, 21¹⁵⁄₁₆ x 18 inches (55.7 cm x 43.7 cm), collection of Bowdoin College Museum of Art. Bequest of Miss Mary Sophia Walker, Ac.1904.24

Notice the variety of strokes within this painting. They create a multitude of textures, and a depth of space. As do many of Brown's pastels, this image features a buoyant, dance-like composition created by the play of light on distinct forms.

TO MY PARENTS, ROSLYN AND ARTURO T., MY BROTHER,
DAVID, AND MY HUSBAND, GORDON

I would like to thank the following people and institutions for their generous contributions:

My brilliant editor, Alison Hagge, for her expansive vision and sensitivity. Senior editor Leila Porteous and editorial assistant Lisa Buch for their exceptional insights, attention, and support. Executive Editor Candace Raney, for inviting me to write this book. Maxine Hong Kingston for her genuine and sensitive foreword. Marjorie Shelley, Sherman Fairchild conservator in charge, Paper Conservation, and Katherine Baetjer, curator, European Paintings, both at the Metropolitan Museum of Art, New York, for the multiple conversations they granted me about the history and conservation of the medium. Katie Steiner, assistant curator, the Frick Collection, New York, for the private viewing of Whistler's The Cemetery: Venice. Neil Jeffares, author of Dictionary of Pastellists before 1800, for his encyclopedic book, and his help in seeking permissions for reproductions. I extend my gratitude to Jacklyn Burns, registrar, J. Paul Getty Museum, Los Angeles; Michelle Henning, Bowdoin College Museum of Art; Mila Waldman and Stephen Fisher, the Mead Art Museum at Amherst College; Susan Grinois, Fine Arts Museums of San Francisco; Kathryn Kearns, Smith College Museum of Art; Rachel Beaupré, Mount Holyoke College Art Museum; Teresa O'Toole, Sterling and Francine Clark Art Institute, for granting me reproduction permissions. Assistant director and reference librarian Helen Beckert, the Glen Ridge Public Library, for helping me to access JStor for writings about Chardin. Dominique Sennelier and Pierre Guidetti of Savoire-Faire, Bernadette Ward of PanPastel, and Isabelle Roché and Margaret Zayer of La Maison du Pastel Henri Roché for samples to familiarize myself with their beautiful products. Eve and Jeff Friedlander of MTS Frames, New Jersey, for clarifying framing considerations. I want to thank my friend and gifted pastel maker Susan McMurray, Santa Fe, New Mexico, for her fossilized pine cone of blue pigment and her hand-made pastels. Barbara Holton, Joan Heckerling, Nora Cohen, and Lisa DeStilo for their support and so much more. My photographer Peter Jacobs, for his top-quality images of my work over the years, and his exhaustive help in formatting and organizing my images for this book. Teachers Daniel Greene, Dan Gheno, Mary Beth McKenzie, and Michael Burban for their inspiring classes. I want to thank my magnificent friends and professional models who have allowed me to look at them for hours and paint my impressions. I thank my greatest teacher, Harvey Dinnerstein, and my wonderful students. I learn your lessons every day.

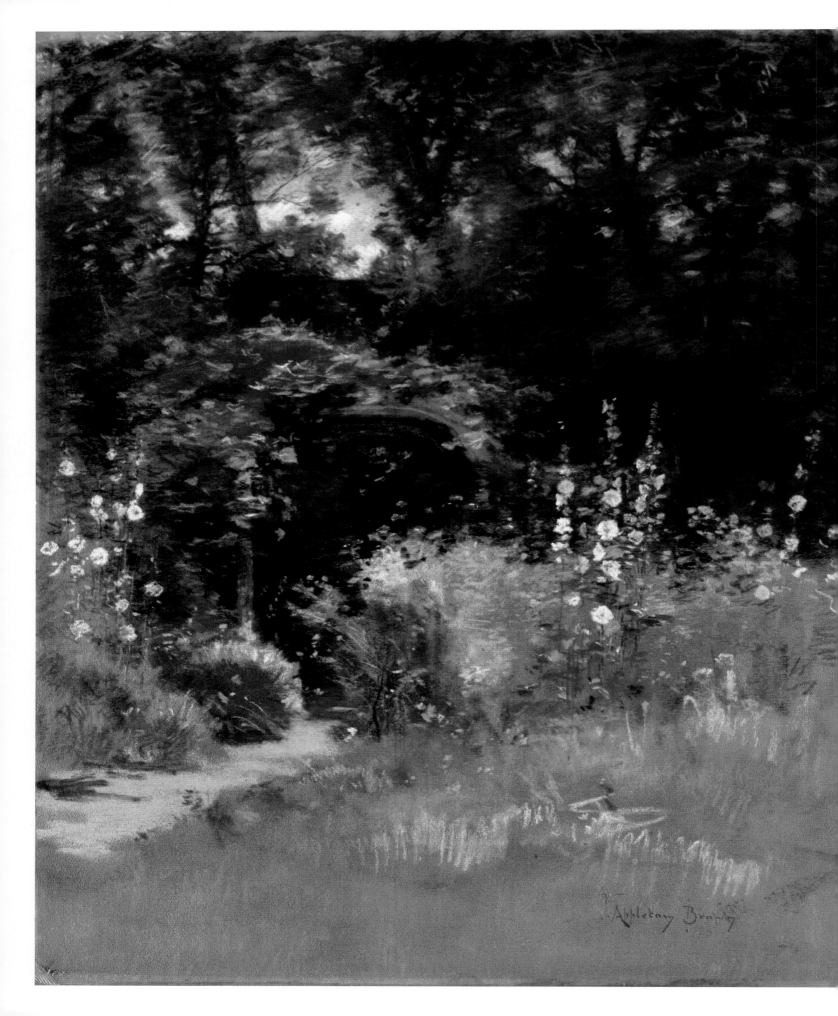

CONTENTS

foreword

by MAXINE HONG KINGSTON

I met Ellen Eagle the summer we taught at Art Workshop International in Assisi, Italy, she a course in drawing with pastels, and I a course in writing the novel. Beauty surrounded us, held us. From our rooms and studios, from the terrace where we ate our meals, we looked down upon the Umbrian plain and the city of Saint Francis. Day and night, bells rang the time.

Ellen gave a slide show of her portraits. One by one, people filled the screen: Mei-Chiao. April. Asha. Phyllis. Lee. Alfredo. Edwin. Mike. Ellen herself. Her mother and her father. I could feel each person's weight, his or her individual energy and beauty. A pull of affection rushed from my heart toward each one of them; it must have been the affection the artist felt when she painted them. I wanted to be beheld the way Ellen beheld these lucky people. Amid the crowd thanking her for the show, I blurted out, "I want you to paint me." At the same moment, she was saying, "I want to paint you."

And so, I sat for Ellen Eagle. The painting took two years. She flew to California three times, and I flew to New Jersey once. But she did not paint me in her studio; we did not work on the portrait on the East Coast. The light had to be the light coming into my dining room, which is like a sunporch, with a bank of windows facing south. Ellen had found just the right light for me, my medium, the light that has shone on me for most of my life.

Ellen wants to paint in silence; I'll need to sit silently. I never

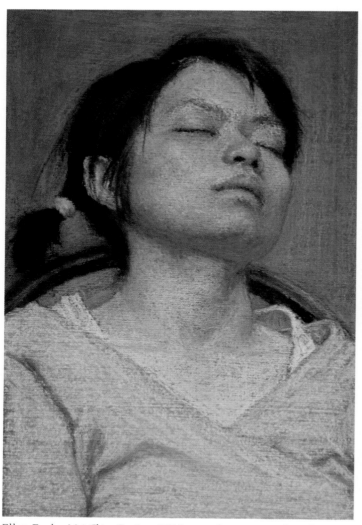

Ellen Eagle, *Mei-Chiao Resting*, 2010, pastel on pumice board, 5¾ x 3⅞ inches (14.5 x 9.8 cm)

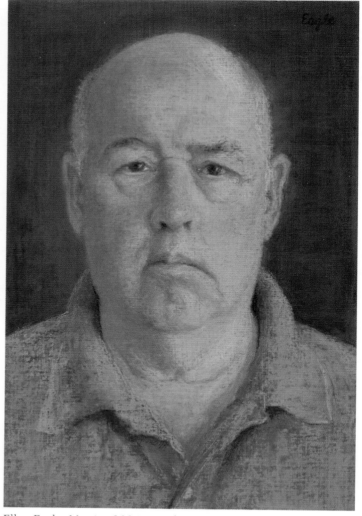

Ellen Eagle, *Maurice*, 2005, pastel on pumice board, 8½ x 5⅜ inches (21.6 x 13.7 cm)

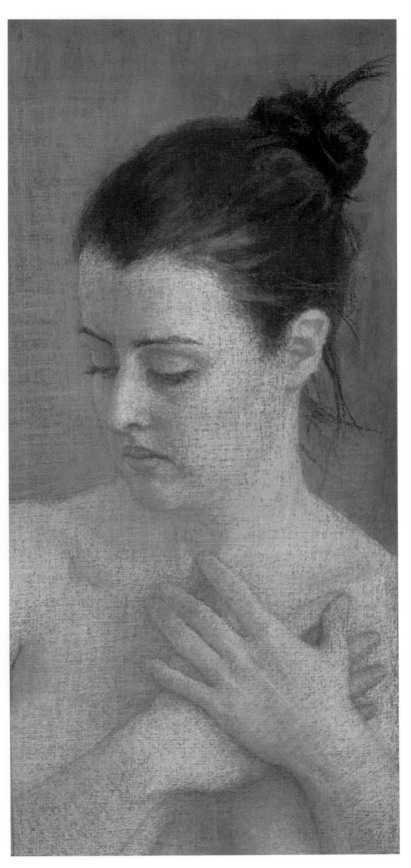

Ellen Eagle, *Nude with Hands Touching*, 2009,
pastel on pumice board, 15 x 6½ inches
(38.1 x 16.5 cm)

sit without doing something. But I am not to speak, or write, or knit, or read, or watch TV. I am to be still.

Ellen gave me a rare gift—rest. I rested, looking out at my garden, letting its beauty enter my awareness, and my being. I hardly ever stop working in it to simply love the garden. Modeling for Ellen, I observed the light, and the way the atmosphere changes according to time, long moments and short moments, and to the weather, clouds, fog. In the very late afternoon, we would end painting for the day. Ellen tells me that she has sat all day in front of a wall, and watched the move and play of light.

I did not get to watch my portrait form. Maybe Ellen does not want me to see the false starts and the experimental tries.

One day, she turned the picture toward me. (The final image appears on page 131.) Voilà. Finis. That's me—I am full of feelings and thoughts. But I'm blonde. I blurt out, "But I don't have yellow hair." Ellen said, "Yes you do. I see many gold hairs." "Please take them out, whiten them." Squinting, Ellen scrutinized my hairs, each hair. She has to see a hair before she paints it, one hair at a time. Strands of yellow hair remain; it must be the light.

She pointed out to me the beauty that she'd discovered: the range of mountains that is my cheekbone. Yes, I see the magnificence, my cheekbone the Sierras.

As I write this, Ellen is touring China with an array of portraits. She and they are being feted all over the land. She is a star artist. Spangly motley confetti rain upon her. Happy New Year of the Black Water Dragon! She sends me a picture of herself among a panel of artists; behind them is a big screen with the portrait of me. Ellen has brought me to China, land of my ancestors. My face is full of feeling and thoughts. I am beholding China and the Chinese people, and saying to them: I hold you in my full heart.

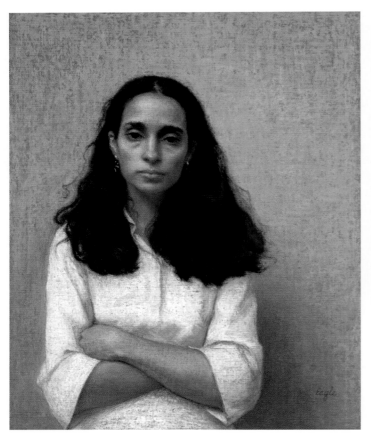

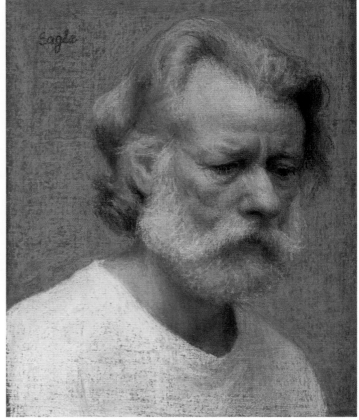

CLARIFYING THE TERM *PASTEL PAINTING*

Pastel can be used as a drawing medium and as a painting medium. When the artist uses pastel to highlight a drawing, or uses it in a sketchy, loose, linear manner in which much of the paper is left untouched and remains as a component of the finished work, the work is considered a pastel drawing. When the forms of the subject are fully rendered via shifts of color, and pastel covers the canvas corner to corner, the work is a pastel painting.

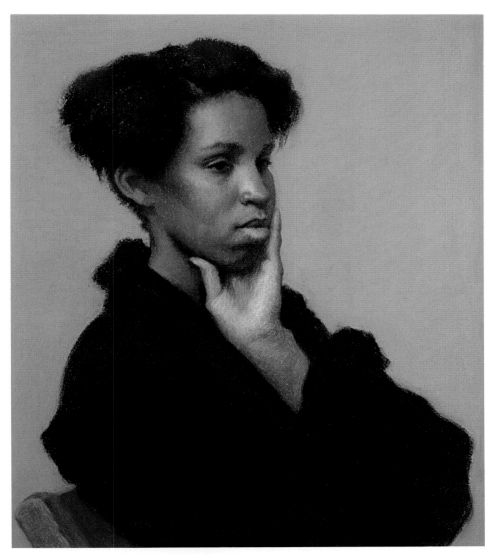

OPPOSITE LEFT:

Ellen Eagle, *Evelyn with Arms Crossed*, 2003, pastel on pumice board, 11 x 9 inches (27.9 x 22.9 cm)

OPPOSITE RIGHT:

Ellen Eagle, *Edwin*, 2003, pastel on pumice board, 5½ x 4⅜ inches (14 x 11 cm)

LEFT:

Ellen Eagle, *Andrea*, 2001, pastel on pumice board, 14 x 12¼ inches (35.6 x 31.1 cm)

preface

I am writing this book in my pastel painting studio. I look at my easel, yellowed pieces of paper taped to its wooden beams like little flags fluttering from a ship's mast. The papers contain notes to myself written in the act of painting; statements by Hopper, Thoreau, Tolstoy; reproductions of paintings by Degas, Eakins, Vermeer. Joyful reminders of my painting encounters, they bid my return to the easel.

I look around my studio and see trays of color, boxes and boxes of pastels everywhere. Pastel sticks, pastel shavings. Pastel fingerprints here on my keyboard. Stacks of pumice boards ready for pastel. Boards in the making taped to the floor. I am always ready to work.

I completely embraced pastel the first moment I touched it, years ago. I loved the crumbly, powdery texture of the stick itself. Then I drew my stick, my baton of color, across my board. Tiny granules of pigment dislodged and mingled with other granules on my surface, transforming powder into image. I was hooked.

My love for pastel has only deepened through the years. I take the material very seriously. I use it to build form much like a carpenter builds a house, each stroke providing a foundation, a support, a jumping-off point, for the next stroke, each shape essential to my image structure. I have also delighted in the playful aspect of pastel, which I discovered in the course of my research for this book. Mixing it with water, for example, and applying it with a brush, achieves an entirely different outcome than applying it dry. Pastel invites experimentation. It is like having a close friendship that exists within a particular context, and then being invited into another, very different, corner of the friend's life. The subsequent discoveries provide a whole new, and richer, appreciation for that person.

When working, I aim to record the feelings stimulated by my subject as I look, carefully, into her forms in space, in light, in the moment. I reach for the color I need the instant I see it in my subject. I place it directly into the painting. I move quickly, trying to keep up with the constellation of shapes and colors I see. My bliss animates my strokes.

At the same time, I love to build my paintings slowly, over a period of weeks, and often, months. It is important to me to be faithful to my subject's qualities, and I have to find a way to coalesce all the moments of looking, all my revelations, into a single point of view. Pastel, dry pigment whose color and texture do not change once on the surface, permits my perception to evolve at its own pace. Working with a light touch, on a surface that can take layer upon layer of pastel, I seek the emergence and full crystallization of harmony. Pastel is perfectly suited to my temperament.

All artists share an ever-deepening fascination with the questions we are driven to explore, and the revelations that replace them and lead to new questions. It is my deepest joy to participate in that tradition. My goals in creating this book are twofold: first, to provide some history of approaches to pastel; and second, to share with you my experiences of working with this brilliant medium. I hope that you will find notes that ring true for you and that our differences will help you clarify your own priorities.

Ellen Eagle, *Winter 2006–2007*, pastel on pumice board, 17¼ x 16⅝ inches (43.8 x 42.2 cm)

The dress I wear represents my respect for classical traditions, and the bandage (with pastel smudges) on my hand acknowledges my love for observing everyday reality. I worked through several seasons on this painting. The light changed drastically as the leaves fell from the trees, snow drifted onto the windows, and the leaves returned. My neck was stiff for months from being turned, and my working arm ached from being suspended for so long. But I really wanted to paint this gesture.

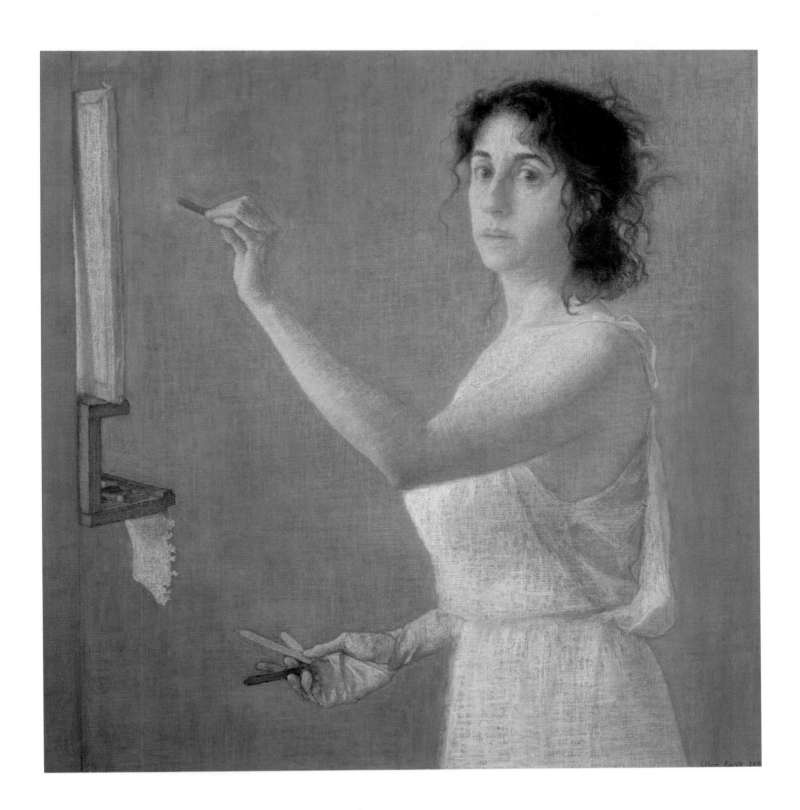

introduction
a luminous history, A LUMINOUS FUTURE

In the year 1495, in Milan, an artist wrote in his notebooks of his desire to "make points for coloring dry." He described his recipe, which included pigment, wax, and water. He was to be one of very few artists to document a recipe for pastel sticks—or anything else about pastel—in the first three hundred or so recorded years of the medium's use. But this artist is known for his brilliant investigations and writings. He was Leonardo da Vinci.

Leonardo (1452–1519) was curious about pastel largely due to a visit to the Milanese court by French pastelist Jean Perréal (1455–1530). The fruits of Leonardo's inspiration are to be seen in his exquisite, mostly chalk, portrait drawing *Isabelle d'Este*, completed in 1499, in which he touched the collar of the sitter's dress with golden yellow pastel.

The earliest drawings in which pastel appeared were similarly constituted—mostly of chalk, but heightened with delicate, linear strokes of pastel. These drawings were made by artists who used their homemade hard pastels as they might use a pencil. But a gradual evolution in application methods ensued, as artists created soft pastels, which in turn enabled them to mass in broad, painterly passages of pigment with both delicacy and vigor.

In the five hundred or so years that have passed since Leonardo documented his recipe for pastel sticks, multitudes of artists have discovered the sensuality of the powdery medium and created stunning works in pastel. The artists mentioned below are but a handful of those who bequeathed significant innovations.

In sixteenth-century Venice, the religious painter Federico Barocci (circa 1535–1612) and the extraordinary draftsman Jacopo Bassano (circa 1510–1592) discovered the rewards of manipulating soft pastel in painterly ways, using *torchillons,* or paper stumps, in studies for their oil paintings. In his lifetime, Bassano was recognized as the Italian master of pastel. Seventeenth-century France's Robert Nanteuil (1623–1678),

using subtle colorations, brought pastel into the realm of finished portraits. Initially creating full pastel paintings in preparation for his commissioned engravings of royalty and the aristocracy, he ultimately created pastel portraits for their own sake. His pastels are animated with the same elegance and precise detail that characterize his engravings.

A document dated 1663 confirms the dawn of the commercial manufacture and distribution of pastel sticks. In the coming decades, merchants expanded their range of colors, tints, and shades to fulfill the needs of the portrait painter's highly modulated flesh tone palette. The most dominant French pastelist of his time, Joseph Vivien (1657–1734) was the first to develop pastel paintings into virtuoso, monumental compositions meant to stand on their own as complete paintings. His industriousness was aided by the development, in 1691, of large sheets of plate glass. This allowed for the conservation and exhibition of pastel painting on a scale that had heretofore been impossible, when only smaller sheets were available. In 1678, Vivien became the second recipient of the Prix de Rome and, in 1701, he was the first to be accepted into the French Royal Academy of Painting and Sculpture as a "painter in pastel." These artists helped to form the foundation of pastel's imminent emergence as a major artistic discipline.

Rosalba Carriera (1675–1757) was perhaps the most important woman artist of her time. Her portraits are known for their lush, dense buildup of color, and the incorporation of mythological imagery. Prior to Carriera, pastel had been employed mostly for formal portraiture of royalty and the aristocracy. Carriera's intimate, airy, casual approach was a crucial precedent.

In 1720, Carriera journeyed with her pastel paintings from her native Venice to Paris. Her visit coincided with an explosion of education, research, manufacturing, and marketing throughout

Robert Nanteuil, *Portrait of Monseigneur Louis Doni d'Attichy, Bishop of Riez and Later of Autun,* 1663, pastel on paper, 13½ x 11 inches (34.3 x 27.9 cm), collection of The J. Paul Getty Museum, Los Angeles, California, 98.GG.13

This elegant 1663 pastel painting is a study for the artist's engraving. The strokes of pastel and color selection are exceptionally delicate.

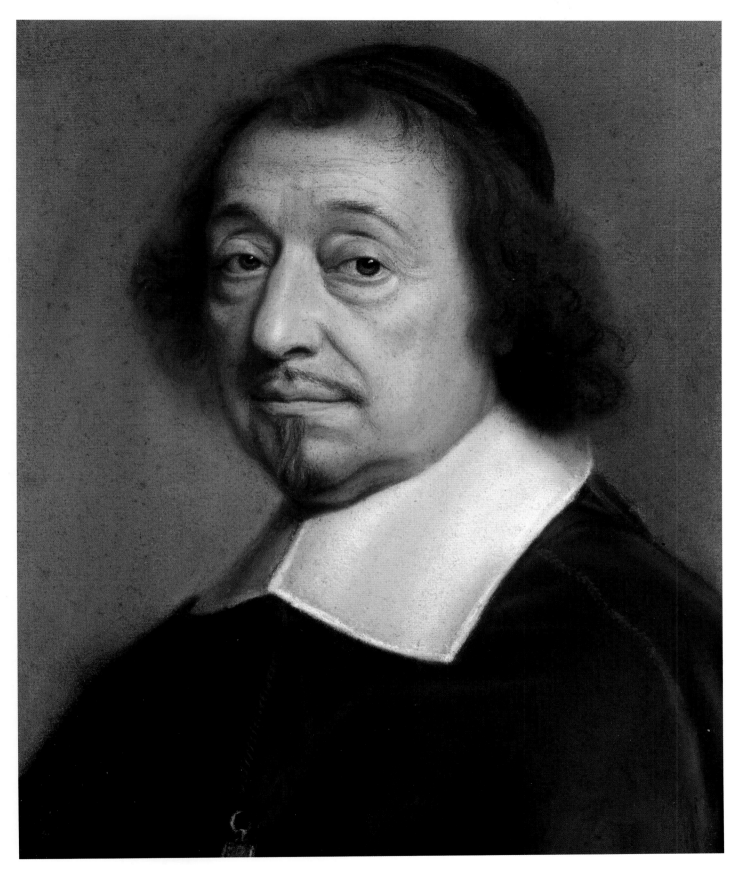

Europe and the United States. It was the Age of Enlightenment. The imperatives of the era had a greater impact on the sciences than on the arts, but pastel was positioned at the convergence of the two disciplines. Sets of pastels, which featured an ever-increasing range of colors, tints, and shades were now widely manufactured. This freed professional artists, who had been devoting a great deal of time to the enigmatic fabrication of their own pastels, to spend more time at their easels. An increased range of tones enabled portraitists to create the incremental color and value shifts that they saw in their subject's flesh.

For much of the eighteenth century, the Parisian aristocracy, having fallen in love with Carriera's work, clamored to have their portraits painted in pastel. The demand further fueled the manufacturing industry. New binders were sought, fixative ingredients were explored, and paper with a fine tooth was introduced. Some artists, including Jean-Étienne Liotard (1702–1789) and Maurice-Quentin de La Tour (1704–1788), experimented by altering their supports—for example by smoothing the texture or tinting the surface—to suit their personal styles of pastel application.

The appeal of pastel to professional artists, their patrons, and amateur artists was deeply layered. Due to the light-reflecting properties of the granular pigments, pastel offered a brilliance of color not to be found in oil paint. Its dry body enchanted Paris in numerous ways. Artists and patrons saw the color the moment it was applied as it would appear forever. Artists were able to rapidly apply the medium, which allowed them to convey an intimate spontaneity. They also found pastel relatively easy to travel with, so their portrait patrons could sit in the comfort of their own homes, without the fumes and mess of oil paint to disrupt the well-appointed order of their domesticity. And the rapid resolution of the portrait meant that busy aristocratic patrons had only to sit briefly before dashing to their other pleasurable exploits. Pastel painting became all the rage in eighteenth-century Paris, and its impact was felt particularly in England, Ireland, and Germany.

Amateur artists, who were attracted to the odorless, relatively clean, and portable pastel sets, adopted the medium as a hobby. In 1772, the English pastelist John Russell (1745–1806) published an instructional booklet entitled *Elements of Painting with Crayons,* which became an important guide to materials and techniques, but, because so little had been written about pastel, amateurs had no long-standing authorized coda to intimidate them. They were free to experiment, and some became quite proficient, as I observed at the Metropolitan Museum of Art.

I had the joy of visiting the Met's exhibit *Pastel Portraits: Images of 18th-Century Europe* in May 2011. Displayed were some

Rosalba Carriera, *A Muse,* circa 1725, pastel on laid blue paper, 12³⁄₁₆ x 10¼ inches (31 x 26 cm), collection of The J. Paul Getty Museum, Los Angeles, California, 2003.17
Intimate compositions, exquisite blending of pastel, and the incorporation of mythological symbols characterize the portraiture of Rosalba Carriera.

forty-four portraits approached in every style imaginable, testaments to the complete adaptability of our medium to the spirit and intent of the artist. I saw works by Rosalba Carriera. In her *Young Woman with Pearl Earrings,* Carriera mixed her pastel with water and blended it on the surface with her finger, creating, in essence, a thick gouache. In *Pleasure,* Anton Raphael Mengs (1728–1779) created color and value shifts of such subtlety that the pastel powder appears to have been breathed onto the paper. In contrast, Jean-Baptiste-Siméon Chardin (1699–1779) used energetic, broad strokes of muted colors in his *Head of an Old Man.* Also, using a variety of thin lines, he made clear distinctions between the texture and growth patterns of beard and hair on the head. In *Madame Joseph Nicolas Pancrace Royer,* Jean-Marc Nattier (1685–1766) paid exquisite painterly attention to the textures of the intensely blue, satin-like dress. Ireland's Hugh Douglas Hamilton (circa 1739–1808) employed a looser application of pastel, and combined it with graphite in his portrayal of his friend, sculptor Antonio Canova.

Unlike many of his contemporaries—including those feted in the exhibition at the Metropolitan Museum of Art, most of whom worked primarily in other mediums, particularly oil paint—Maurice-Quentin de La Tour stands apart in the history of pastel painting. Upon seeing Carriera's work during her stay in Paris, La Tour devoted himself exclusively to pastel. Most of his paintings are portraits. His subjects ranged from friends to royalty. He left a cache of preparatory pastel studies, in which he considered various aspects of his sitters. La Tour was a dramatic person. In obsessive pursuit of perfection, he worked his paintings over and over, cutting down and expanding his compositions, and even cutting out central sections and fastening replacement parts in their stead. He hatched, scratched, and smoothed, disclosing a full engagement with his subjects and a search for verisimilitude and character.

When one reads of the volatile La Tour, one is frequently led to the story of the sensitive colorist Jean-Baptiste Perronneau (1715–1783). The two were considered rivals for the position of central figure in eighteenth-century French pastel painting. Because La Tour, ten years Perronneau's senior, achieved "painter of aristocratic and royal portraits" status, Perronneau, who many considered to be the more gifted of the two artists, was forced to

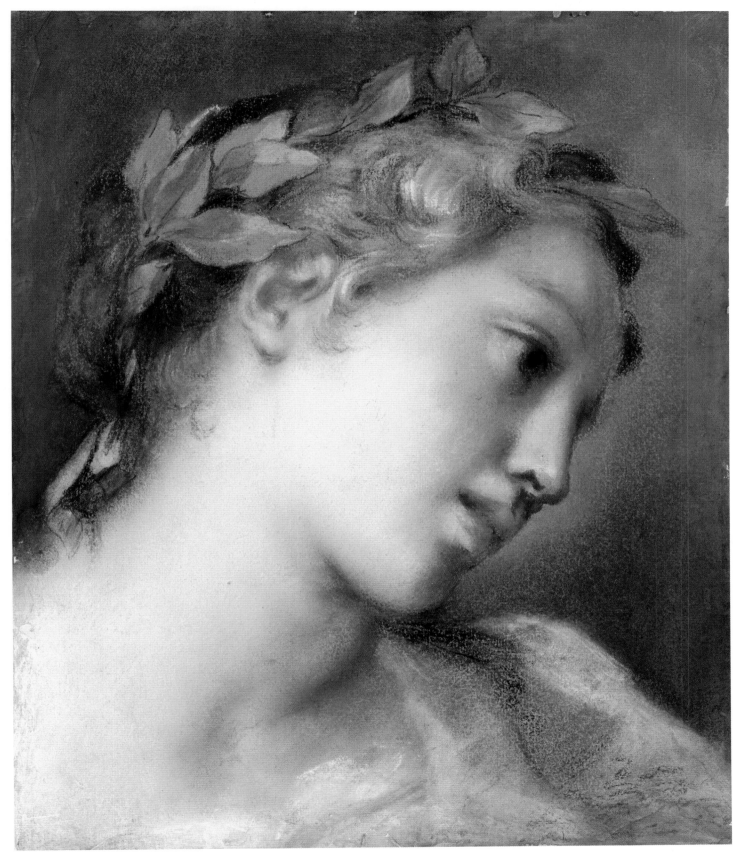

seek commissions outside Paris, and even outside France. His use of color was expressive, and foreshadowed that of the Impressionists. Fidelity to his sitters' likenesses was very important to him, as was capturing the textures of their clothing. His portraits are deeply affecting in their delicacy of color and facial expression.

As illustrated in Neil Jeffares's definitive *Dictionary of Pastellists before 1800*, pastel was employed mostly for portraiture; however, many artists used pastel for nonfigurative compositions. France's Jean-Baptiste Nicolas Pillement (1728–1808) was considered the eighteenth century's greatest landscape pastelist. He developed a particular interest in seascape painting, and often explored the dimensions of nature's powers in series of two: one, a painting of a peaceful harbor; the other, an ocean whipped by darkened, stormy skies. A series of landscapes in which mythological themes are pictured is attributed to the portrait painter Louis Vigée (1715–1757), father of oil painter and pastelist Élisabeth Vigée-Lebrun (1755–1842).

In the United States, John Singleton Copley's (1738–1815) mastery of pastel is of mysterious origin. He is believed to have been self-taught despite having had limited-to-no exposure to actual pastel paintings. It is possible that he saw a pastel portrait by England's Francis Cotes (1726–1770) of Boston resident James Rivington Sr. It was the only known pastel painting to have been in the United States in the late 1750s. He may have gleaned some information in the mezzotint manuals he studied or seen prints of pastel paintings by Jean-Étienne Liotard (1702–1789). In 1762, Copley wrote a letter to Liotard, asking him to please help him procure "Swiss crayons for drawing of Portraits."

While the eighteenth century drew to a close in Europe, the taste for a spare and stable classicism prevailed. The Rococo sensibility was now deemed shallow and excessive. Despite the restraint so many artists had displayed in their color work, pastel, having first gained prominence during the affectations of the period, became a casualty of the indictment.

During the early years of the nineteenth century, when pastel was not particularly in favor, especially in Europe, many important artists nonetheless employed the medium, making valuable contributions. In France, the Romantic movement's Eugène Delacroix (1798–1863) was a deeply emotional artist. In his turbulent images and riveting writings, one can feel his passionate, and sometimes tortured, convictions and struggles. Highly educated in the classics, Delacroix drew his subjects from historical, mythological, and literary sources. He was also a muralist and portraitist. His pulsating images were made in oil, watercolor, etchings, and pastel. He created both pastel studies for oil paintings and fully fleshed out pastel works. His vivid use of color was a major influence on the Impressionist movement. His student, the refined Pierre-Cécile Puvis de Chavannes (1824–1898), created pastel paintings with an ethereal feel, which he achieved through his mysterious light and muted color.

Later, Jean-François Millet (1814–1875), a member of the Barbizon school, which asserted that depictions of the countryside should be derived from direct observation, created landscapes and figures in pastel. Millet's portrayals of workers in the fields are magnificent evocations of the miracles of nature, and the toil and prayer of those who tend to it.

The second half of the nineteenth century brought about a tremendous revival of interest in pastels, with many of the Impressionists—including Camille Pissarro (1830–1903), Alfred Sisley (1839–1899), Claude Monet (1840–1926), Édouard Manet (1832–1883), and Berthe Morisot (1841–1895)—translating it according to their own aesthetics. Among the Impressionists, Edgar Degas (1834–1917) was the greatest innovator. Degas cofounded the Pastel Society of France, the first organization of its kind. He combined pastel with water, steam, gouache, and fixative, which he laid on top of his monoprints, lithographs, aquatints, and drypoints. His unflinching eye and voracious investigation into the ordinary injected his pastel paintings with a grit that should have extinguished pastel's reputation for frivolity.

Degas and Mary Cassatt (1845–1926) met in Paris, and in 1879 he invited her to exhibit with the Impressionists. The two artists shared an interest in Japanese compositional techniques, which can be seen in many of Cassatt's intimate mother-and-child scenes. Her pastel paintings were often high key, with all the

Maurice-Quentin de La Tour, *Portrait of Gabriel Bernard de Rieux*, circa 1739–1741, pastel and gouache on paper mounted on canvas, 79 x 59 inches (2 x 1.5 m), collection of The J. Paul Getty Museum, Los Angeles, California, 94.PC.39

Maurice-Quentin de La Tour's obsessive mastery of pastel and insight into character are evident in this portrait. Almost seven feet (two meters) in height, it was constructed from several sheets of paper, as were many artists' works at the time.

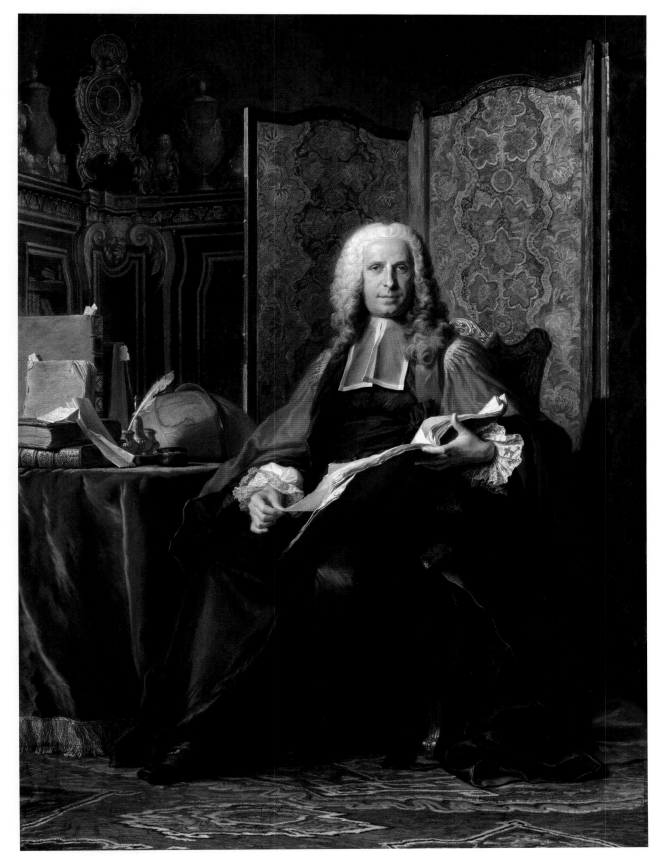

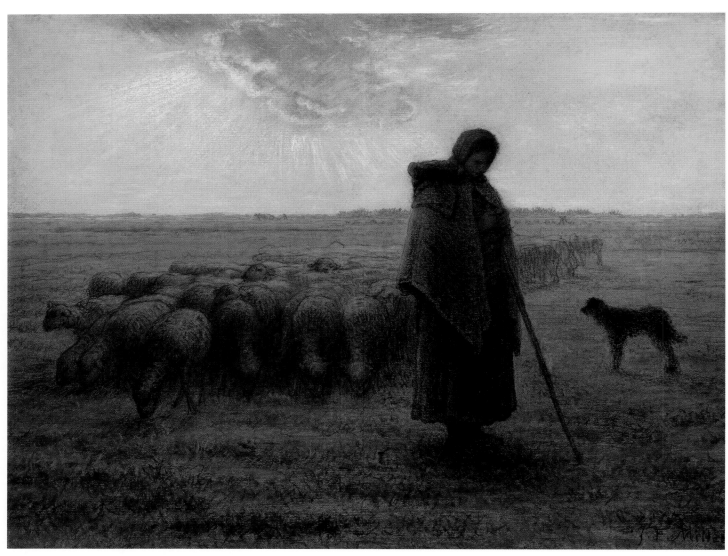

Jean-François Millet, *Shepherdess and Flock,* 1862–1863, black chalk and pastel, 14⁵/₁₆ x 18¹¹/₁₆ inches (36.4 x 47.5 cm), collection of The J. Paul Getty Museum, Los Angeles, California, 83.GF.220

This pastel suggests religious content. The light in the sky deifies the shepherdess. She has gathered her congregation, who take nourishment from the earth. The shepherdess is the link between heaven and earth.

colors falling within a range of light values, or tints. Her use of line syncopates with expanses of simplified planes, anchoring and reinforcing the weight in her forms. In some of her oil paintings, I see a brushstroke quality that may have been influenced by her pastel strokes.

In the same year that Cassatt exhibited with the Impressionists, America's James McNeill Whistler (1834–1903) took an important trip to Venice for the purpose of creating a series of etchings. There he also created a body of work in pastel. His use of pastel suggests a visual dance of Morse code. Maintaining expanses of the brown paper throughout his images, he applied pastel in a variety of densities, spots of color swiped here and there in energetic open patterns. His Venetian pastels influenced a generation of artists, among them Julian Alden Weir (1852–1919), John Henry Twachtman (1853–1902), John Marin (1870–1953), and William Penhallow Henderson (1877–1943).

Once the Impressionists succeeded in recontextualizing pastels, it was warmly welcomed by many artists throughout Europe and the United States. French Symbolist Odilon Redon (1840–1916) exploited the intense color of pastel. Édouard Vuillard (1868–1940) and Maurice Denis (1870–1943) of the Nabi movement, which sought to depict universal, rather than specific, qualities in their subjects, created complexly patterned canvases with pastel.

I was astonished to discover, during the course of my research, the exquisite pastel portrait of Mrs. Edward Clark Potter (née Mary Dumont), 1894, by American sculptor Daniel Chester French (1850–1931). French is the designer of the Lincoln Memorial, which, though a monument to one of the seminal figures in American history, is resonant with interiority. *Mrs. Edward Clark Potter* is equally breathtaking in its expressive insight and delicacy.

Philadelphian Cecilia Beaux (1855–1942), who became the first full-time female faculty member of the Pennsylvania Academy of Fine Arts, turned to pastel to strengthen her understanding of color. Pastel's color range and direct application are perfect for experimental study.

William Merritt Chase (1849–1916), who was born in Indiana, was one of the most sought-after teachers of his time. He founded his own school and taught at the Art Students League of New York. (It is said that he taught in Studio Eight, in which I studied, and in which I now teach. I find this possibility enchanting to ponder.) Chase, as a founding member of the Society of American Painters in Pastel, was also a compelling figure in the revival of interest in pastel. He prolifically created vigorous pastel landscapes, still lifes, portraits, figures, and interiors in styles ranging from loosely suggestive to highly rendered.

The first president of the Society of American Painters in Pastel, Robert Frederick Blum (1857–1903) created solid and sumptuous interiors and figures. His works range from airy landscapes in the tradition of Whistler to single figures in barely defined spaces to multiple figures in fully realized interiors. In his *Venetian Lace Makers*, 1887, Blum animated his figures and furniture in such a way as to create a sense of dancelike movement from foreground to background, despite the fact that all but one of the figures are seated.

As the twentieth century approached, Boston's Thomas Wilmer Dewing (1851–1938) first used pastel in 1892, and he utilized it almost exclusively beginning around 1919. His subjects were society women. His limited palette and suggestive, yet detailed, closely spaced strokes of pastel imbue his figures with apparition-like qualities, as though they are being conjured from the brown paper that surrounds them. A few decades later, Joseph Stella (1877–1946), who had been a student of William Merritt Chase, created powerfully abstracted stark industrial scenes of New York, New Jersey, and Pennsylvania in pastel, in which immovable structures yield unsettled clouds of smoke into the skies.

In the 1930s the American Ashcan school was founded by, among others, oil painters and pastelists Robert Henri (1865–1929) and William James Glackens (1870–1938). Robert Henri, so beloved by generations of artists for the wisdom he imparts in the book *The Art Spirit,* integrated figures into forests, achieving an overall mosaic-like pattern. William James Glackens combined pastel with watercolor, ink wash, charcoal, and carbon pencil. He painted portraits; urban crowd scenes in which bold rhythmic carbon pencil lines carry the figures across the page; landscapes; beach scenes; and color studies for oil paintings.

Everett Shinn (1876–1953) turned his attention to the energy of New York City. His subjects included street scenes, circus scenes, and scenes of performances in a small theater he constructed in his New York apartment. He often combined pastel with other mediums, including charcoal and gouache, which he laid on top of monoprints. Arthur Bowen Davies (1862–1928) painted all manner of natural formations. One can see the influences of Whistler, Redon, and Puvis de Chavannes in his quiet, dreamlike, intimate landscapes. Works created in the twentieth century reveal the pastel artist's growing infatuation with pastel's ability to interact with other media, increasing interest in informal application and spirited explorations into a limitless range of subject matter.

Unfortunately, many historical pastel works are rarely exhibited because of concerns about the lightfastness of the pigments. This is less of a concern with contemporary works because our materials are more likely to be stable, and because now we have ultraviolet glass. Nonetheless, shipping pastel paintings for exhibit continues to present challenges. Shaking during transit can loosen pastel granules from a painting's surface. And because so many pastel works were portraits executed for commission, many paintings remain in private collections, handed down from ancestor to heir.

With fewer loans, the art-loving public has had limited exposure to the accomplishments of pastel artists. And fewer exhibits, in turn, suppresses the market value of pastel below that of oil paintings. Together, these factors have reinforced a perception that pastel is a lesser medium. This is a tragic loss to our collective scholarship and our spiritual and artistic nourishment. For six centuries, artists have been touching pastel to surface, conjuring personal images of brilliance and sobriety.

Today, the tradition of pastel painting in the United States continues to be enriched by powerful contemporary artists such as Aaron Shikler (born 1922), Daniel Greene (born 1934), and Harvey Dinnerstein (born 1928). Their works speak for themselves and belie the myth.

BRINGING THE TRADITION TO THE EAST

I have just returned from China, where I was invited to exhibit twenty pastel paintings and largely introduce the medium to the Chinese community. The exhibit was curated by Chinese-American artist Kang Chung, who was my co-exhibitor. I had the extraordinarily moving experience of witnessing people looking at pastel paintings for the first time. Many artists in China have worked masterfully in oil, watercolor, and ink for decades, and have never known pastel. I handed sticks and paper to them. They tentatively made light lines, then darker, surer ones. They touched the thick, textured paper and blended powder into it. They felt the powder on their fingers. They dipped sticks into water, and created watercolor-like swirls. During a demonstration, they watched as I layered dry color upon dry color in pursuit of my model's skin tones. As I ponder the very personal works throughout history, works of Leonardo da Vinci, Maurice-Quentin de La Tour, Edgar Degas, James McNeill Whistler, and Harvey Dinnerstein, I am elated to imagine how Chinese artists will paint with their pastels as they contribute their heritage to the luminous continuum of pastel painting.

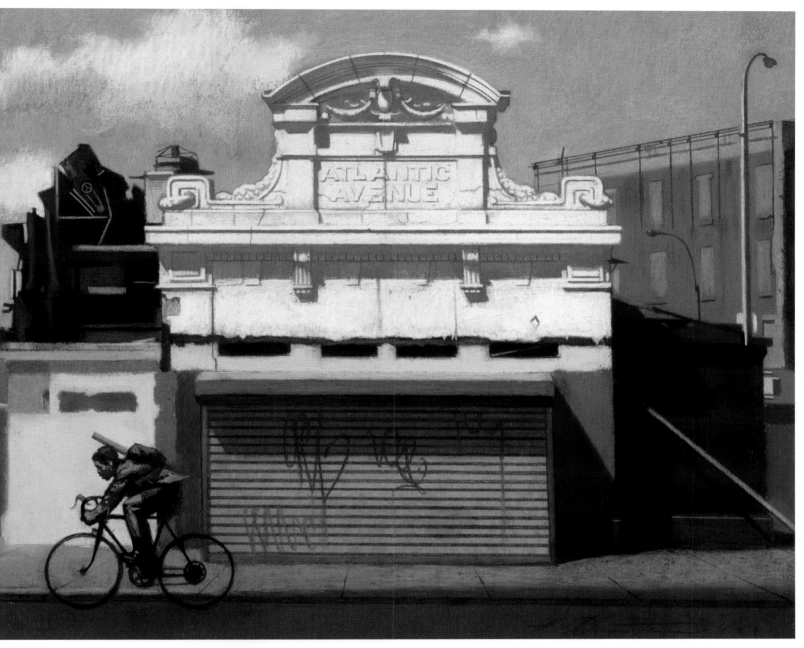

Harvey Dinnerstein, *Morning Light, Brooklyn*, 1991, pastel on pumice board, 17½ x 22⅜ inches (44.5 x 56.8 cm)

The artist gorgeously simplified the forms into powerfully abstract shapes. Small and large forms interplay throughout, all crowned by the elegant arc atop the central building. It is morning, and still quiet on the street. The cyclist is headed out, beyond this moment in time, toward his life story, which will continue in the day ahead.

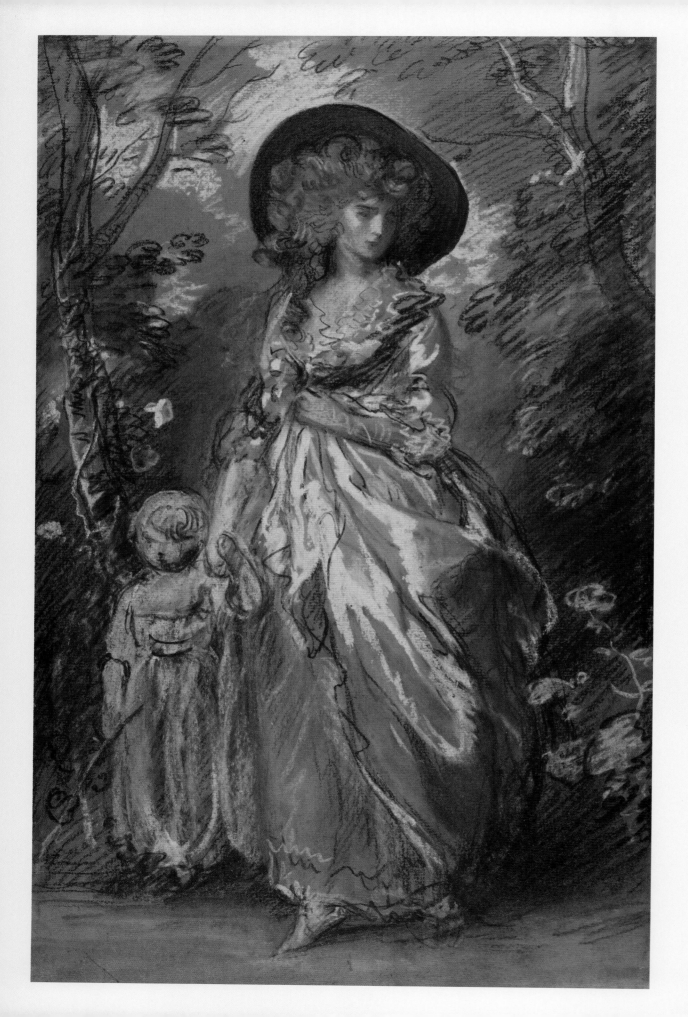

basic materials

Thomas Gainsborough, *A Lady Walking in a Garden with a Child,* circa 1785, black chalk on light brown paper, heightened with white pastel, 20 x 8¹¹/₁₆ inches (50.8 x 22.1 cm), collection of The J. Paul Getty Museum, Los Angeles, California, 96.GB.13

The artist created this work as a study for an oil painting. He did it out-of-doors and probably carried minimal supplies with him. In his portrait of Carolyn, Fourth Duchess of Marlborough, in which she is elegantly seated, his use of color is similarly restrained. Therefore, I suspect he enjoyed the concise approach to the art of quick outdoor pastel studies.

I have never known an artist who does not love the tools of his or her trade. My students are always on the hunt for a new stick of pastel and a new surface. When they bring a find to class, they can't wait to show and tell. Excitement ripples through the studio as the potential eloquence of a new product or an old one newly discovered are envisioned. I suspect that the ebullience of discovery is particularly acute for pastelists because of the relative mystery surrounding the history and manufacture of pastel. We are hunters and gatherers, always searching out information to add to the pot, helping to rescue our beloved pastel from neglect. Uncovering a fact here and there brings us new insights into the accomplishments of our predecessors and into our own promise.

In this chapter, I wish to shed light on some of the mysteries of pastel. I will introduce you to the physical properties of our materials, from the constitution and lightfastness of pastel sticks to textures and tones of papers, and explain not only how to select these materials but how to use them safely. I will also address organization and record keeping, to help you avoid becoming overwhelmed by the sheer numbers of tints and shades that most pastelists find themselves falling in love with and bringing home to the studio.

what is pastel?

Pastel is sometimes confused with chalk. In very early writings about pastel, the words *pastel* and *chalk* were often used interchangeably. This is understandable, since the two mediums are similar in many ways. Chalk is a naturally occurring material. It is solid, so can be used in the form in which it is found, taken directly from the earth, or it can be shaped into uniform sticks. Similarly, pastel sticks are composed primarily of powdered pigments mined from the earth. Sources for pastel pigments include plants, minerals, soils, shells, bones, and fossils. The main distinction between pastel sticks and chalk is that the former requires a binder in order for it to maintain a stick form; if the pastel stick is a tint or shade, it will contain an extender as well.

Naturally occurring pigments typically require some kind of binder in order for them to be used to make art. These binding vehicles—the oil in oil paints and the water-soluble gum arabic or honey in watercolor—suspend the pigments. With pastel sticks, the binder is often a water-based substance such as methyl cellulose. This is what makes it possible for us to hold the stick.

Very soft pastels of the highest quality are almost pure pigment, containing only minute amounts of binder. The proportions of pigment to binder vary not only between soft and hard pastels, but within both categories of stick. This is because the pigments themselves vary in texture, and therefore require different amounts and types of binder. Each stick has to be cohesive enough to be held in the hand, yet crumbly enough to yield its granules when drawn across the support. The development of a single stick of pastel requires a great deal of experimentation to achieve the proper balance of the constituents. Manufacturers pride themselves on the qualities of texture and color unique to their products, and generally do not divulge their recipes.

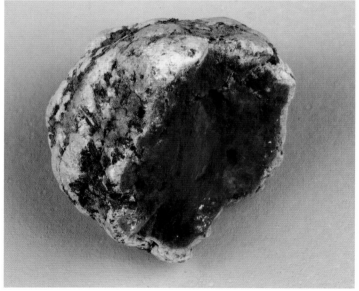

TOP:
These pure pigments were mined in Santa Fe, New Mexico. The pigments that make up pastel sticks also comprise the color in oil paint, watercolor, acrylic, gouache, and tempera.

BOTTOM:
This fossilized pine cone contains pigment. Great care must be taken when removing the pigment from its shell, so as to prevent foreign matter from infiltrating the pastel stick.

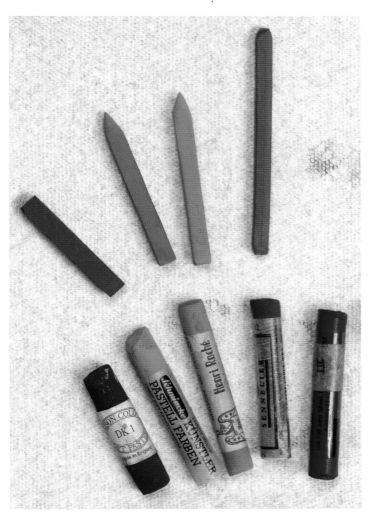

Both hard (top) and soft (bottom) pastel sticks contain minute amounts of binder.

In pastel, white extenders, such as talc or kaolin, are added proportionally to create light gradations of color (tints). Black pigment is added to create a range of dark values (shades). Being almost pure pigment, with no need for varnish, and containing minimal binder, pastel color is highly permanent. Pastel paintings created in the seventeenth century that have been well cared for display their brilliant chroma today. The intensity of pastel's color is due to the interaction of light reflected by the irregular, bumpy surfaces of the stick's granules.

The method of fabricating pastel sticks has remained basically the same since its inception. Pastel makers finely grind the pigments and mix them with the water-based binder and talc to create a paste—hence the word *pastel*. They then press the materials to remove excess water, roll them into sticks, and set them to dry. Cold or damp weather conditions sometimes require the sticks to be placed in a dryer rather than air-dried. Some manufacturers create pastels by machine, some by hand.

Pastel sticks are the most common form of pastel available today. Many of my students also like to use pastel pencils for details, but they tell me they break easily when sharpened. I have never found the need for them. PanPastel is relatively new to the market. It is made of pigment with so little binder that it remains in powder form and is packaged in shallow cups. Because it is not a solid stick, it is swiped and applied with sponges and brushes.

building a collection of pastels

When you go to the pastel department of your art supply store, you will often see pieces of paper lying around, or anchored to a shelf, with pastel scrawls of varying thicknesses and colors. These are the marks of pastelists who have come in to test sticks. It is a smart practice, because colors look different in stick form, in their boxes, than they do deposited on paper, intermingling with other colors. Also, not all sticks feel comfortable in any given hand.

I use pastel only in stick form, and the following suggestions relate to both hard and soft pastel sticks.

full sets and individual sticks

I personally feel that because we never know what colors we will see in our subjects, it is important to have as many colors as possible available for use. Procuring a large prepackaged set of pastels can be financially daunting, but it is a onetime purchase, making the replacement of frequently used sticks necessary only from time to time.

On the other hand, many artists feel that it makes a great deal of sense, especially if you are concentrating on one genre, to build a collection of individually selected sticks. You can buy multiple sticks of the colors you use frequently instead of spending money on a set that may contain colors you will rarely, if ever, touch. For instance, I see a lot of greens, blues, and violets in my sitters' flesh tones, but not as many as landscape artists see in their subjects.

hardness and softness

My basic set of soft pastels is the Rembrandt 225-stick set. Rembrandts fall into the category of a harder soft pastel, so they do not wear down that quickly, and I use them throughout the course of the painting, from beginning to end. I also use Art Spectrums, which are quite soft and whose colors are rich and earthy, and a beautiful, old, no-longer-manufactured, seven-tray Grumbacher set that I acquired from the estate of an artist. I use the Art Spectrums, Grumbachers, and my Unisons more sparingly; because they are so soft, they abrade too quickly for my purposes when used directly on the pumice board. I layer them on top of the Rembrandts.

Also in my collection is the 525-stick set of Sennelier. Senneliers are renowned for their exquisite range of shades and tints.

OXIDE REDS	BURNT SIENNAS	RED VIOLETS
PERMANENT REDS	RAW SIENNAS	BLUE VIOLETS
ORANGES	BURNT UMBERS	GREEN GRAYS
OCHERS	RAW UMBERS	BLUE GRAYS
OLIVE GREENS	PRUSSIAN BLUE	BLACKS
LIGHT BLUE GREENS	COBALT BLUE	

In my sets, the colors above are the ones I reach for most frequently. If you prefer to buy individual sticks, and you work primarily in portraiture, you might begin with a similar selection.

I find I use these colors frequently in portraiture.

The company states that they are almost pure pigment with minute amounts of binder. This accounts for their exceptionally soft, buttery bodies and chromatic brilliance. Because I generally work on a small scale, and with incremental shifts of color and value, I am often unable to use such a soft pastel as Sennelier. However, when I have a large area, even within a small painting, for which I want a steady value, I open my box of Senneliers. I used them liberally in the background and nightgown in *Self-Portrait in Blue,* which appears on page 68. I generally use Senneliers in the final moments of painting, because they are so soft that I cannot layer the pastels of other manufacturers on top of them.

I have recently added a set of Henri Roché La Maison du Pastel to my collection. When I first opened the box, I could hardly bear to close it again—the proportions and colors of the sticks are so beautiful. Even the labels are exquisite. Being handmade, Henri Roché pastels are gorgeously soft, yet the granules tenaciously hold to my board.

In addition to my full sets, I have sets of fairly hard dark Giraults and soft dark Unisons, and individual sticks of soft Schminckes and Rowneys.

All the colors from all the manufacturers can be combined within a single painting, provided that if you are using vastly different degrees of hard and soft, you work with the harder ones early on and the very softest ones toward the end.

I find very little difference in the degree of hardness among the Nupastel, Holbein, Richeson, and Cretacolor hard pastels. It is the quieter sound of the stick on the board that distinguishes Richeson as ever so slightly softer than the others.

colors

Colors vary from manufacturer to manufacturer, and there is, unfortunately, no universal numbering system for pastel sticks. I have never seen exact replicas of color from one brand to the

Colors of the same name vary among manufacturers. Compare the permanent red lights on the left (Rembrandt) with those on the right (Grumbacher). Likewise, compare the green grays on the left (Art Spectrum) with those on the right (Rembrandt).

next. Even when they have the same names there can be substantial differences. For instance, Art Spectrum green grays are worlds apart from those of Rembrandt. It is helpful to build your color library with pastels from various makers, so that you have as full a range as possible.

textures

When trying sticks out, you will be responding not only to color, but to texture. Within the category of soft pastels, there are degrees of softness, from buttery to gritty. One option for testing pastels is to purchase one or two sticks from various manufacturers and experiment with them at home. You will find that each stick interacts differently with each support. If you like the feel of the pastel and the way it glides onto your support, you can expand your collection accordingly. Another possibility is to bring small pieces of your papers to art supply stores and sample the sticks there. Good art supply stores encourage this. They know that pastelists are selective about their colors and textures. You might even make a small sketchbook of various papers, and label each pastel test. You'd have all your samplings in one place, and it would be a great reference for comparisons and identification when you are ready to buy.

gradations

Manufacturers create gradations of all their colors. To identify the gradations, each stick is labeled with a number. Generally, the lowest number is assigned to the darkest shade, the middle number to the pure pigment (with no white or black added), and the highest number to the lightest tint. In Rembrandt pastels, for example, the darkest is labeled three, the pure tone is five, and the lightest is anywhere from seven to twelve. (Rembrandt pastels run on the light side.) To start your collection, I recommend you select the darkest, the purest, and the lightest grade of each color you select, so that you can attain a full range of values in your paintings.

experimenting
with pastels

Pastel invites experimentation. There are no limits to the medium's expressive potential. Some artists stroke it onto the surface with exquisite delicacy and precision. Others mass in with spirited sweeps of soft pastel. Some use it in a sketchy, suggestive manner, maintaining areas of paper untouched by pastel. Others use a full palette of color, fully modeling with incremental tones into highly resolved studies of form and light, covering all or most of the paper. Some artists favor intensely colored statements. Others use color in a quieter manner.

Pastel can be used as the sole medium or, on water-friendly surfaces, it can be combined with gouache, watercolor, or tempera. Pastel itself can be applied wet; you can dip the stick into water and apply the resulting gouache-like consistency onto the surface. Pastel shavings can be mixed with water to create a watercolor-like body and brushed onto the surface. Rubbing or denatured alcohol can be used in place of water when you wish the liquid to evaporate more rapidly. Pastel can be applied dry and then worked into with a wet brush. (If you work in this manner, it is best not to use a delicate watercolor brush if you are working on a rough surface. Also, the water should be distilled, since the distillation process removes mineral impurities, such as calcium and iron, that could otherwise embed in your sticks and scratch your support.) Pastel can be used on top of oil paint if the paint is greatly diluted with turpentine. Pastel can also be placed on top of monoprints, lithographs, and etchings.

New products, such as PanPastel cakes, are widening the definition of the medium and a series of sponges have been introduced for their application. Diane Townsend makes a pastel that includes pumice right in the stick. Many of the new papers make it possible to lift pastel and return to the almost-untouched surface. This is wonderfully liberating, and encourages the pastelist to take risks in color selection and application methods.

I created this nebula-like shape by moving pastel powder around the paper with my fingers.

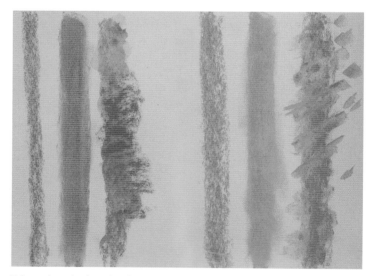

Take a close look at the three manners in which the red pastel was applied on the left side of this image. First, it was applied linearly; next, it was applied linearly and then massed with a finger; and finally, it was applied linearly and then manipulated with a wet brush. The same sequence was utilized for the three columns of orange pastel on the right side. These marks were made on Art Spectrum paper.

SHARPENING PASTELS

I have sets of Nupastels, Cretacolor, and Richeson. These are hard pastels, and I sharpen them to a point. The points allow me to make tiny marks. To sharpen them, I hold the pastel horizontally and at a slight angle, resting the end I wish to sharpen (i.e., the end opposite the number) on a table. Using a single-edge razor blade, I make a downward motion, rotate the stick, and repeat, gently shaving the tip of the pastel stick to a point. I gather the shavings for later use. (See Making Your Own Pastels on page 44.)

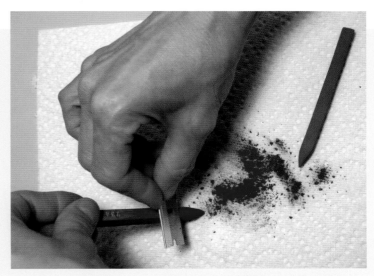

As I sharpen my hard pastel, I rotate it so that I achieve a centered point.

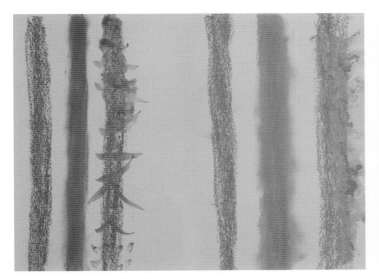

These marks were made on Richeson Unison pastel paper.

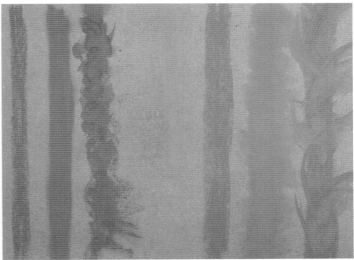

These marks were made on Wallis pastel paper.

storing and organizing pastels

I maintain my sets of pastels as they were boxed by the manufacturer. My storage and working palettes are one and the same. The hard sticks—Nupastels, Cretacolor, and Richeson—are identified by a number that is stamped into the stick. The soft pastels I use are each wrapped in paper that have numbers on them. Before I use a new set, I make a chart of the layout of the boxed sticks, noting the color and number. This list helps me keep track of what I have and what I need to replace as the sticks wear down. Making a list sounds like a lot of work, but I have found that it saves me time and frustration when all I want to do is paint.

As I work, I separate the sticks I am using and set them down on paper towels. When I complete a painting, and frequently during the course of the painting, I replace all the sticks in their original slots, guided by my charts. This allows me to immediately identify which sticks need to be replaced. It also helps me become familiar with where the sticks reside so I can easily reach for them in the course of working, instead of having to hunt. I buy multiple sticks of single colors that I use frequently and keep them in storage so that I am never without a color I need.

Some artists arrange all their pastels by color, mixing together all the manufacturers. This enables them to see all of their stock when searching for a color they need. There are storage boxes made expressly for pastels purchased individually. They come with two or three drawers, each of which has dividers. As your collection grows, flat files also become an option. Really, any shallow drawer in which you can lay out your sticks in a single layer will work.

If you choose to organize your pastels in this manner, I recommend arranging the sticks by color families and labeling the drawers by color names. If, in storage, the sticks touch one another, it is also helpful to coat the tray's compartments with rice. In the course of a pastel stick being worn down, its pigment drifts and settles onto other sticks, obscuring the true colors. The rice absorbs some of the floating pigment, reducing discoloration.

I have plenty of room in my studio to lay out every stick I own, but I would find so many choices at any given moment to be overwhelming. When I don't find the colors I need in my sets from Rembrandt, Nupastel, and Roché, I then bring out my other sets.

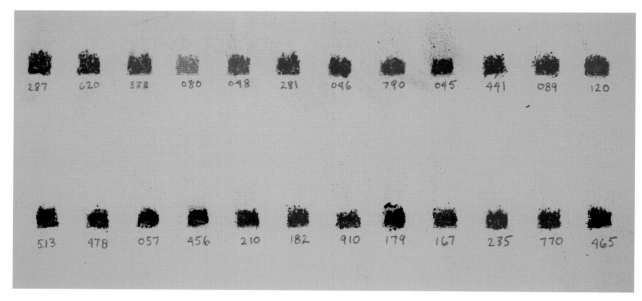

This is my chart of the arrangement of sticks in Sennelier's boxed set of dark colors. I make number/color charts for all of my sets—Henri Roché La Maison du Pastel, Rembrandt, Grumbacher, Nupastel, Richeson, et cetera. Some of my students write the stick number right into the groove in which they are packaged instead of making charts. These very simple steps eliminate almost certain chaos in organizing the pastel collection and knowing which sticks need to be replaced when they wear down.

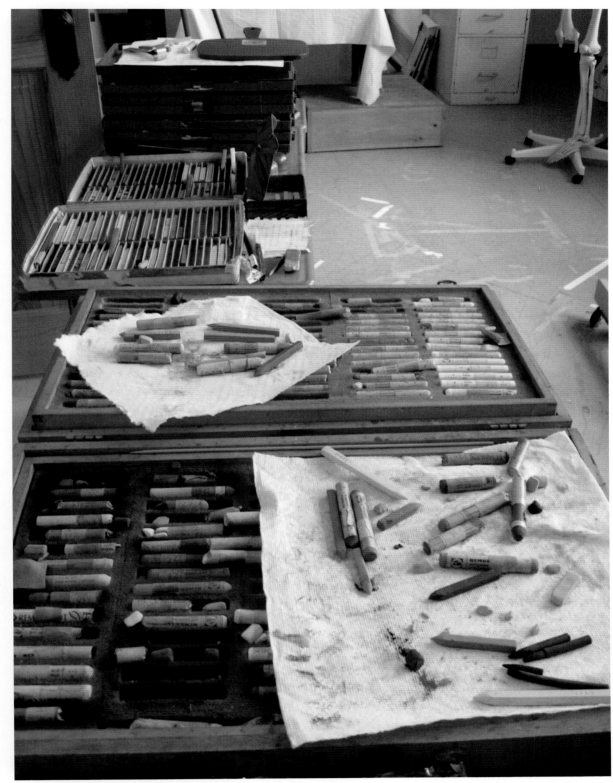

I maintain my sets as they were boxed by the manufacturer. They sit on typewriter tables, which are easy to move around the studio. This allows me to arrange the tables around my easel according to my location in relation to my model stand.

examining the lightfastness of colors

Pastelists face much mystery about the permanence of their colors. Some pigments are prone to fading when exposed to direct light. I have learned that carmine reds are particularly vulnerable, whereas vermilion is stable. Some yellows are stable, and some are not. Earth tones, such as umbers, ochers, siennas, and green earth, are said to do very well. But often, there is more than one pigment in one stick, and one of the more vulnerable pigments may fade, causing another within the stick to become more obvious. I have been told that cadmium colors are sensitive to humidity, causing them to darken.

Some manufacturers give their colors decorative names, so we don't always know what classification their hues fall into. Those are best avoided. I have read that titanium white improves the working properties of some pigments, but I have also been told that it can accelerate the fading of certain other pigments. The ingredients used by some manufacturers are often difficult to come by, but other manufacturers offer color charts that list the constituent pigments of each stick.

I home-tested a selection of reds by making six patches of color, each from a different manufacturer, on a board. I then covered the lower half of the board with another board, and placed the whole package on a south-facing windowsill. A few days later, I compared the protected and exposed areas of color. To my astonishment, the exposed patch of carmine showed significant fading within days. One of the reds did not change, and all the others appeared to have darkened. The darkening could have been caused by fading of the lighter pigments within the stick, or a darkening due to some recent wet weather. In some cases, light can fade paper, especially when dyes have been used to create the paper color, making the pastel appear darker than the artist intended.

Because I was so surprised by the rapid changes in color, I did another test. This time, I made patches of fifteen colors across the spectrum, from seven manufacturers, again covered the bottom halves, and set them in the same south-facing window. When, five months later, I reviewed the results, I detected very slight changes, if any, in some of the pastel pigments. The paper, however, which was not archival, faded significantly. The colors in my first test were clearly impermanent. In the second test, I selected pastels designated by the manufacturers as permanent. To try to clarify if the pastel color had changed, I looked at several without the context of the paper. It was difficult to discern

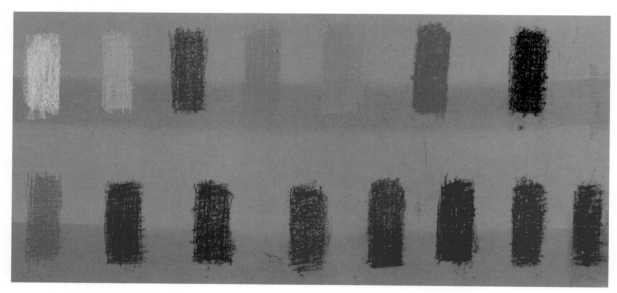

I covered the lower half of each block of color and set it in a south-facing window for five months. It was difficult to detect change in the pastel, but the paper had clearly faded. Faded paper will make the strokes of pastel appear differently than the artist intended.

any change in the pastel colors. But, of course, I would never hang a painting or store my pastels in direct sunlight.

Manufacturers usually print ratings of colorfastness on the labels or in inserts in the set. But there is currently no industry-wide standard for the ratings, so a three-star rating for one brand may be the equivalent of a two-star rating in another. It feels as though the only bit of knowledge about the makeup of pastel that is clear is that very little is clear. And to make matters more complicated, manufacturers sometimes change their formulations.

A committee within ASTM, the American Society for Testing and Materials, has been working for several years to establish industry-wide testing standards by which manufacturers would identify the lightfastness of their products. Such testing standards are in place for oil paints, watercolors, acrylics, and colored pencils, and it is very important that pastel painters be granted the same information so that we can make educated decisions about our materials.

The good news is that with proper care and attention to environmental conditions discussed elsewhere in this book, the integrity of pastel color and its supports are as sustainable as other mediums—or even more so, due to the lack of yellowing varnishes. Clear evidence of this is found in the intensely hued pastel paintings that populate the Musée d'Orsay in Paris, and in those that I return to again and again in the low-lit galleries of the Metropolitan Museum of Art in New York.

The surest route to confidence in the permanence of your color is to make your own pastels, using pigments that are time-tested and proven permanent. (See Making Your Own Pastels on page 44.) Short of that, I recommend making a home test like mine, and comparing your results with the manufacturers' color chart ratings.

When you work in your studio, keep your pastels away from a sunny window. When you complete your painting, frame it securely and install it on an inner wall, away from the temperature and humidity variations of outer walls. (See Framing Pastel Paintings on page 176 for additional information.) Keep it away from direct sun and fluorescent light. If you are going away for a period of time, cover the painting. Note the moisture guidelines in the chapter about framing and exhibition.

addressing questions of toxicity

In the course of my research, I have encountered many opinions about the risks of using pastels. This is what I have gleaned: If handled properly, pastels are perfectly safe. The main issue is the inhalation of pigment dust, which, in vulnerable people, can cause an asthma attack or other respiratory problems. To minimize these risks, and maintain peace of mind, discard your pastel shavings as you create them. If you want to use the shavings, store them in a covered jar. When you want to loosen excess pastel powder from your painting, don't blow on it. Instead, tap the board outside the border of the image or on the back. Don't eat food in the studio. It is best to not drink in the studio, either, but if you must, keep your liquids in a covered cup or glass. Always wash your hands before eating. Remove the pastel dust from the ledge of your easel and the studio floor. I do this with a wet paper towel, so as to not stir the powder up into the air. Put your sticks away when they are not in use or cover them.

Additional precautions are possible: I know several pastelists who wear a particle filter mask when they work. Some artists have skin allergies to their materials and so wear latex gloves while working. If you have a cut on your hand or wrist, be sure to cover it with a bandage. Some artists equip their studios with exhaust systems.

If you make your own pastels and gesso-pumice boards, transfer the pigments and pumice into covered jars when you bring the materials home. They are often sold in plastic bags, which can easily puncture and send particles floating into the air. When you are handling the powdered pigment, definitely wear a particle filter mask.

In terms of each constituent of the pastel stick, there is much concern about certain pigments. Cadmium is known to destroy the liver and kidneys, but only if you ingest it. Pigments containing chromium and cobalt are also of concern. From what I have been told, cadmium pigments (unlike other forms of cadmium, such as that found in batteries) are not absorbed into the skin. Taking precautions mentioned earlier will minimize risk of health problems.

Regarding the other components of pastel, extenders often consist of calcium carbonate, which is nontoxic. Calcium carbonate appears in numerous products that are ingested. I have found nothing to indicate that either methyl cellulose or gum tragacanth, which are binders, is dangerous.

I do want to say that I have been working with pastels almost daily for fifteen years. My physical examinations report clear lungs. In the past, I took few of the above precautions, but my

good lungs may be partially due to the light touch with which I work and the relatively hard pastels that comprise much of my paintings. If you apply your pastels with excessive gusto and work with soft pastels, and even if you work as I do, I suggest you do all you can to minimize the accumulation of pastel powder and maintain a clean studio. In light of conflicting information surrounding the physical properties of pastel, you may want to do your own research in order to adopt safeguards that meet your personal standards.

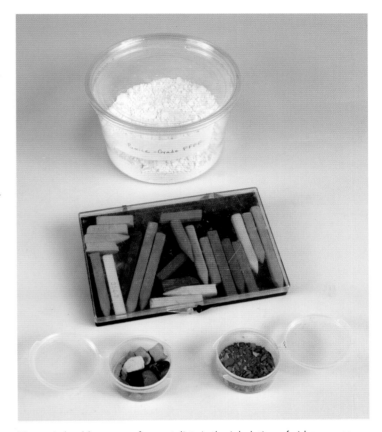

The main health concern for pastelists is the inhalation of airborne particles in the studio. Some very simple steps toward minimizing risk include transferring pumice and pigments, which are sold in plastic bags, to a covered container for storage at home. I also keep small pastel pieces that have broken or been used down, and pastel shavings, in sealed containers. The shavings you see in the lower right will be further ground down before shaping them into new sticks.

257–264	**CERULEAN BLUE** *** : PHTHALO BLUE
265–269	**BROWN LAKE** *** PYRROL RED, AZO CONDENSATION BROWN, IRON OXIDE YELLOW, IVORY AND ANILINE BLACKS
270	**PINK LAKE** ** : ANTHRAQUINONE LAKE
272–274	**PINK LAKE** ** ANTHRAQUINONE LAKE, QUINACRIDONE RED
281–282	**PURPLE BLUE** - 0 : COBALT BLUE, ANTHRAQUINONE AND TRIARYLMETHANE VIOLETS
283–285	**PURPLE BLUE** *** : ULTRAMARINE BLUE, MANGANESE AND COBALT VIOLETS
287–296	**PRUSSIAN BLUE** *** : PRUSSIAN BLUE
297– 301	**CAD YELLOW LIGHT** *** : AZO YELLOWS
303–308	**SCARLET LAKE** ** : AZO RED
309–315	**MADDER VIOLET** - 0 RHODAMINE LAKE
331–336	**BLUE VIOLET** *** : MANGANESE AND DIOXAZINE VIOLETS, ULTRAMARINE BLUE
339–346	**BRIGHT YELLOW** *** DIAZO CONDENSATION RED, AZO YELLOW

Some manufacturers, such as Sennelier, make their pastel stick ingredients available to the consumer. This is the information found on Sennelier's pastel set insert. Such information greatly helps direct the purchase decisions of the pastelist who is concerned about toxicity. The numbers in the left column identify the colors. The stars are lightfastness ratings, three being the most lightfast.

selecting paper with care

My first exposure to the charms of paper was at my mother's clothing pattern making studio—the dining room table. I loved to watch my mother pin warm white cotton muslin to shapes of smooth tracing paper on which she had marked symbols to guide her scissor cuts. Her notebooks were made of slightly yellowy, heavy cotton paper in which the weave was visible. Her notes, her pencil marks, looked different on the notebook paper than on the tissue paper, though they were made with the same pencil. On the tissue paper, the line was slender and light in tone. On the notebook paper, the line was thicker and grainier looking. On the muslin, which is less rigid than paper so had to be held in place while being marked, the marks looked different yet. I was sensitized early on to texture.

A pastel painting's physical well-being and durability begin with the relationship of pastel to surface. The kind and quality of paper we select is of equal importance to that of our pastel sticks. A nonarchival paper that has been toned with impermanent dye will fade if exposed to light. At the Metropolitan Museum, the pastel works of Degas in which much paper is exposed are exhibited in low light.

The character of the paper must be well matched to the artist's subject, pastel sticks, and application methods. As with my mother's papers and pencil, the nature of our marks is determined by this interaction. In this section, I list some of my observations about paper and pastel interactions, but I recommend you go to an art supply store and bring home papers that feel and look good to you, papers you want to commune with. The surface you work on is meant to be loved. When you carry the papers home and store them, be sure not to dent or inadvertently fold the paper. Once dented or folded, the damage cannot be removed. It will always be visible in your painting. When you clip your paper to your backing board to work, be sure the paper is held taut and smooth so it can fully receive your pastel stroke.

I recently perused the paper department at New York Central Art Supply. What a gorgeous selection they have. Pastel can be used on any kind of surface that offers a tooth, including canvas. Many papers manufactured for purposes other than pastel can be used for pastel. Many pastelists work on white watercolor paper and tone the paper with watercolor or pastel powder before beginning the painting. Visiting a fine paper dealer can lead to unexpected paper possibilities, which, in turn, might lead you to discover a new, personal way of applying the medium.

Bringing quality papers home to try out can be costly, and you don't necessarily need a full sheet to determine whether or not you wish to work with it in the future. Some stores offer small samples. Perhaps some friends would like to chip in on a few selections and divide the paper. You can all report your findings, enhancing your trials. In addition, as I describe in Making Your Own Supports, on pages 46–47, you can also create your own surfaces of vastly different textures, even within one "canvas." And you can make the board whatever size and tone you want.

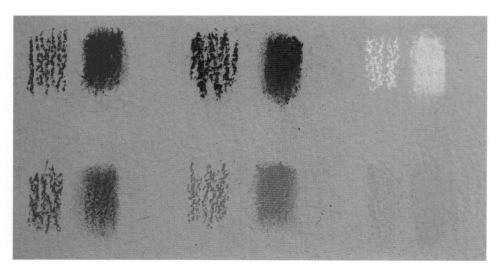

Sabertooth, which is 100 percent cotton, has a texture that remains visible when the pastel is rubbed into the surface with finger or *torchillon*.

textures

The textures of paper are created by their constituent materials and methods of manufacture. Some papers are hand-made, some, machine-made. Different parts of the world produce papers of different natures because the ingredients used to make them are indigenous. Papers may be made from shrubs, bark, inner tree pulp, cotton rag, and more. I delight in the thought that my pastel stick, created from earthen products, returns its particles to surfaces made of wood pulp, hemp, and other of earth's bounties. Dust to dust.

The texture of the paper abrades the granules of pastel from the sticks, and holds them there. The rougher the surface, the faster and greater the abrasion. Both soft and hard pastels will wear down quickly on a rough surface and the deposit of color will be uneven. Hard pastels will have to be sharpened often. Rough surfaces are best suited to broad handling of soft pastel. Smooth surfaces partner with hard and soft pastel for smooth passages of color and incremental changes. The tooth of a smooth paper will fill up more quickly than will a rough one, limiting the number of layers possible, but I find the boards I make can take virtually endless layering.

The selection of papers shown opposite, right, and on page 40 begins with the roughest and ends with the smoothest of those I have tried. They are all beautiful. You can see how soft and hard strokes register on various textures. In the top row of each image (left to right) are the soft Sennelier, Henri Roché, and Rembrandt. In the bottom row of each image (left to right) are hard Holbein, Cretacolor, and Nupastel. The same six pastels were used on each paper. Notice how different a single color looks when stroked on to different color papers.

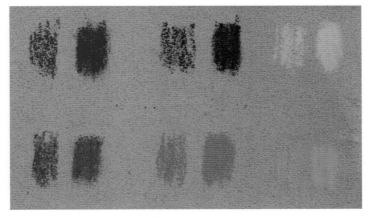

The slight texture of Richeson Unison is apparent in straightforward pastel strokes, but greatly reduced when pastel is rubbed in. It was created particularly to be used with Richeson's Unison soft pastels, but every stick I tried, both soft and hard, registered beautifully.

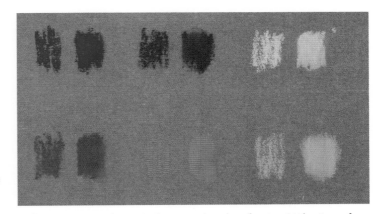

Wallis is a very sturdy paper that can take a lot of water. At the time of this writing, it comes in two colors only, white and what is called Belgian mist, but you can prime it with watercolor or pastel powder to create a base color for your painting.

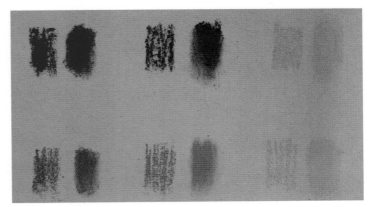

The texture of Art Spectrum disappears when pastel is rubbed on. This quality, all-purpose paper registers lines crisply. It is the paper I recommend to my students who are studying portraiture.

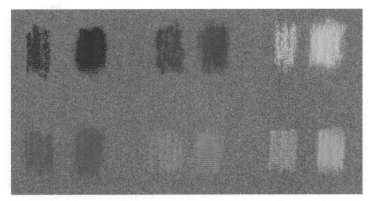

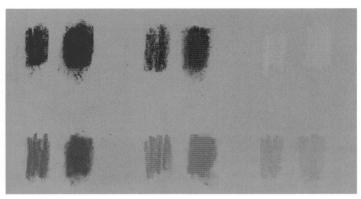

Sennelier La Carte is a strong-bodied paper with a slightly sandy feel due to its cork and vegetable flake coating. It holds dry pastel beautifully, and, according to the company, is lightfast. It is not meant for wet pastel.

Rightly described by the manufacturer as having a velvety surface, Claire-fontaine Pastelmat comes in a variety of tints. It is beautiful for detail work, and for the company's own PanPastel powder.

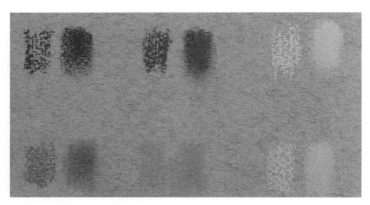

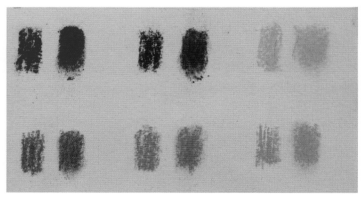

The weave of paper fibers in Fabriano Tiziano is apparent in the pastel strokes and remains when pastel is rubbed. Because of this, it may be better suited for loosely expressive work than work in which the strokes of color have to be seamless.

A printmaking paper made of 100 percent cotton, Rives BFK has more of a blotter feel than the other papers. It takes water very well. I love the touch and extremely light raw umber–like tone of this paper, as well as the deckled edges.

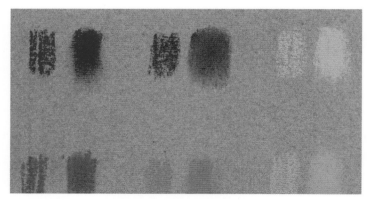

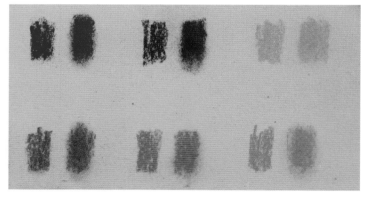

Widely available and inexpensive, Canson comes in a wonderful range of tones. It is most appropriate for relatively brief painting projects, because the tooth fills quickly. It must not be exposed to light for long periods of time.

With an almost perfectly smooth surface, Pastelle Deluxe is made exclusively for New York Central Art Supply and is available through their catalog. It comes in a variety of tints.

tones

Because I am so focused on the subtlety of flesh tones, I generally select a neutral, coolish, middle-tone ground upon which to build my color. But I recommend you try whatever approaches interest you. A warm ground will contrast with, and therefore emphasize, the cool tones in your subject. The converse is, of course, also true. Unless you work with many or very thickly applied, layers, the ground color will maintain its presence in the finished work, imparting a warm or cool glow throughout the image.

Sometimes I want a very warm background in the painting, but I still prefer to work on a cool surface. I create the warms with my pastel application. Regardless of the temperatures, my middle-tone ground also allows me to set up my value range, from dark to light, from the start. If my ground was very dark, I would be forced to make my dark pastel strokes extra dark just to be able to see them. Then when I was ready to add middle tones and lights by calibrating them against the darks, I would be making them too dark as well. I would then have to spend a lot of time making adjustments, just trying to get to step one—setting up the overall value relationships. Therefore, I recommend a middle-tone, neutral ground. For further discussion on this topic, see Making Your Own Supports on pages 46–47.

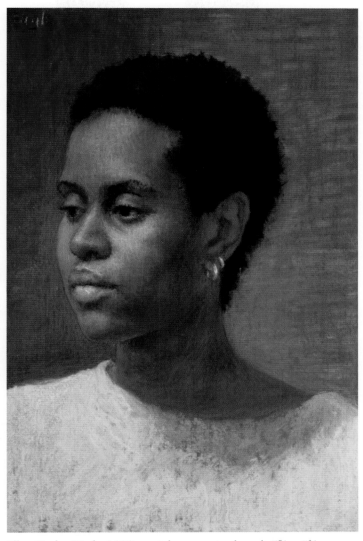

Ellen Eagle, *Nicole*, 1999, pastel on pumice board, 7⅞ x 5³⁄₁₆ inches (20 x 8.1 cm)

I remember making the decision to draw a very distinct edge along the lower cheek and chin. I loved its interplay with the cool light misting across the warm flesh.

advanced studio practices

Don Williams, *Two-Point Perspective,* 2007, pastel on four-ply museum rag board, 32 x 38 inches (81.3 x 96.5 cm)

I love the spare design of this perfectly titled pastel. The artist warms a potentially cold subject by humanizing it: how many people have stayed late into the night here, studying with the help of caffeine, working to wrest clarity from confusion, only to toss failures toward the trash, and missing the mark. The scuffed floor attests to perpetual quest.

When you are on the cusp of being ready to leave your formal classroom training and start working on your own, it is important to set up your own studio where you can develop strong work habits and search into the subjects that arouse your heart. When I was at this point in life I organized my studio quite easily, because I knew what I wanted—a quiet simplicity that would fully support my commitment to study. I wanted my working environment to reflect what is important to me in my paintings. Nothing extraneous.

At that time I could not imagine a drastic change in my aesthetic and emotional priorities. Nonetheless, the direction that my work would take once I was on my own was an open book. I felt it was imperative to be open to change should a new fascination seize my thoughts. Our curiosities create our own syllabus and our inquiries require appropriate practices and tools.

As you work, your questions and vision will develop an increasingly deeper and further reach. Your needs will become more specialized and refined as you familiarize yourself with the characteristics of your materials, as you return to particular themes again and again, and as your own working practices naturally evolve. In this chapter, I offer what I love about working in my own studio, how I tailor the use of the pastel artists' materials to my needs, and the practices that facilitate and enrich my contemplations.

making your own pastels

Occasionally a tiny fragment of hard foreign matter appears in a stick I have bought. Artists who make their own pastels can swear by the quality and purity of their materials. This is a wonderful benefit if one is worried about the permanence and impurities of industrially produced pastels. There are other advantages, too. For instance, if you have not been able to find a color or consistency you need, making your own pastels can fill the voids in your collection. My friend Susan makes pastels in shapes and sizes that fit her hand most comfortably. Of course, if you are going to make your pastels in nonstandard shapes, you will need to store them in boxes other than the type manufactured specifically for pastels.

Making one's own pastels requires patience and experimentation. Because pastel powder and extender can easily become airborne, the process requires that you wear a particle mask. If your skin is sensitive, you might want to wear latex gloves to prevent powder from embedding under your nails. Windows should be open when weather permits. For a more thorough environmental cleansing, an exhaust system should also be considered.

Comprehensive art supply stores and catalogs carry pigments and binders. Once you bring these materials home, transfer them into airtight containers, since plastic bags and cardboard boxes can develop holes, making you susceptible to inhalation. If anyone in your home or studio has asthma, be sure to make pastels in an area to which they are not exposed.

As I noted on page 36, there is some controversy regarding toxicity levels in some pigments, such as cadmiums and cobalts. Some people are sure there is danger, others are sure there is none. If you are interested in making your own pastels, I suggest you read about the chemical makeup of the various pigments.

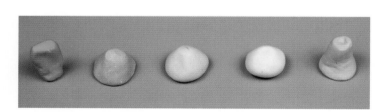

My friend Susan made these pastels to fit her hand. Here again, pastel is responsive to the needs of the artist.

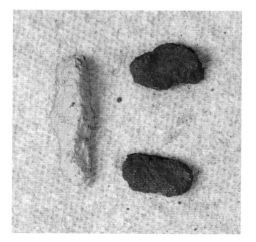

ABOVE:

Shavings from various store-bought hard pastels can be combined to make a new color.

LEFT:

I made these pastels simply by mixing shavings from hard pastels with distilled water.

I have an alternative (and incredibly simple) way of creating pastel sticks. I collect the powder from the hard pastels I have sharpened. I keep the shavings in small covered jars. When I have collected a quantity, I spoon the powder onto a nonporous dish, and, with a beaker, I add a few drops of distilled water to the powder and stir, so that the powder is evenly moistened. I then roll the mixture into a shape sometimes resembling the hard pastels I purchase. If the mixture feels too damp, I add more pastel powder, and roll again. I set the new stick on a clean, nonporous dish and let it sit for a day or two until it is completely dry.

I also make new sticks by grinding small pieces that are too small to comfortably use. The same can be done with soft pastels that have been worn down. Powder from several colors can be mixed to create whole new colors and complementary colors can be mixed to create rich grays.

PASTEL RECIPE

Before embarking on this project, you will want to have the following items on hand: a fruit dehydrator, spoon, bowl or jar, palette knife, measuring cup, palette or piece of glass (about one square foot), and either watercolor paper or mat board. In addition, a particle mask, latex gloves, and exhaust system are highly recommended.

Because of the variety of textures of pigments and binders, I can't give exact measurements for the various ingredients. There are many highly detailed recipes for making one's own pastels, written by people who are more chemistry oriented than I. I offer a basic recipe here:

PIGMENTS*

BINDER (SUCH AS METHYL CELLULOSE)**

EXTENDER (SUCH AS TALC)

DISTILLED WATER

Wearing your particle mask, carefully spoon out a quantity of pigment and place it on the palette or glass. Mix a little binder and water in a bowl or jar. Bit by bit add the wet mixture to the pigment, and thoroughly mix, using the palette knife. Slowly add the talc and mix again until you have a thick paste. Scoop up small quantities of the paste and hand-roll it to the size and shape you want on the mat board or watercolor paper. The board or paper will absorb excess water. Set the pastel sticks on a fruit dehydrator rack to dry. The drying time will vary according to the moisture levels in the air. In general, a few days are needed.

As I mentioned, the pastel-making process takes experimentation. Keep a notebook in which you record your results using various proportions of ingredients.

*Note: Earth color pigments (such as raw umber and raw sienna) contain binding properties of their own, and therefore need no added binder.

**Note: If you use a gum tragacanth binder, it is advisable to use a preservative, such as beta napthol, because tragacanth is susceptible to molds. Some tragacanths are premixed with preservatives, eliminating the problem.

making your
own supports

Today, an expanding number of surfaces are being manufactured for the pastel artist. All have some degree of tooth. A smooth surface is most helpful when you intend to create nuanced shifts of color and value in your painting. Rather than use store-bought supports, I prefer to prepare my own boards because I like having total control over the size, texture, and tone of my surface. I start with acid-free cold-press heavyweight illustration boards, which I then coat with gesso and pumice and tone with acrylic paint. The illustration boards come in various sizes and can easily be

cut down to the size your painting requires, using a mat cutting knife.

Tape your illustration board to a surface, such as a table or floor. Prepare the gesso mixture, as described on the next page. Using a foam brush, apply the mixture to the board as evenly as possible, making all the strokes in one direction. The surface will dry in about 45 minutes, depending upon weather. Working in an air-conditioned room speeds the drying time. Test a tiny, out-of-the-way spot with your finger. When you are certain that the

First, I prime cold-press illustration boards with a pumice-gesso mixture. The firm surface I create ensures a crisp edge to my pastel strokes. If I wish to smudge an area of pastels, my surface accepts that, too.

Next, I tone my boards. This image shows the effect of applying progressive, thin layers of gray acrylic paint to the board—from the first layer (bottom) to the third and final layer (top).

whole board is completely dry, apply another layer, brushing the mixture at a right angle to the direction of the first layer.

When the second gesso layer is totally dry, using a clean foam brush, tint your board either with a medium-value acrylic paint diluted with water or with watercolor paint. I find that about six squeezes of acrylic paint from the tube (as though you were equipping six toothbrushes, each with about an inch of tooth-paste) mixed with about a quarter cup of water provides a smooth application of color. Choose a color that is relevant to your paint-ing. A neutral gray is often very useful. I use Neutral Gray 5 and frequently add just a touch of ocher to warm it up a bit. I find I need several layers of paint to attain an even tone. I apply each subsequent layer at a right angle to the previous layer. Each layer

can take 30 to 60 minutes to dry. Some people mix the paint right into the gesso-pumice mixture and apply it all in one step, apply-ing multiple layers, as necessary.

Untape your dry, tinted illustration board from the table and tape it to a board, such as foam core, to prevent your painting surface from warping. Some artists say they can skip this step, and prevent warping by applying gesso to the back of the illustra-tion board.

Use a fine sandpaper to smooth and even the surface to the texture you want. You can also create a variety of surfaces on different areas on one board, if appropriate for your subject. I prepare several illustration boards at a time, so that I am always ready to work.

GESSO-PUMICE RECIPE

I learned the basic proportions for this gesso-pumice recipe from my teacher, Harvey Dinnerstein. This recipe will yield enough mixture to coat about six 20 x 30–inch (50.8 x 76.2 cm) illustration boards. Before embarking on this project, you will want to have the following items on hand: measuring cups, measuring spoons, plastic container with a screw-top lid, and a spoon.

²⁄₃ CUP ACRYLIC GESSO*

¹⁄₃ CUP DISTILLED WATER

4 TABLESPOONS FINELY GROUND PUMICE**

Using a measuring cup, transfer the acrylic gesso and water to a plastic con-tainer with a screw-top lid. Add the pumice or marble dust or quartz. Mix well to suspend the particles in the liquid.

If covered well, I have found the mixture will keep for up to a year. Stir the mixture prior to each use.

Experiment with adding more pumice to your gesso mixture. A slightly rougher surface may serve your needs for specific paintings.

*Note: I use Liquitex brand.
**Note: I use Rainbow brand, FFFF, which is available at hardware stores. (The F refers to the granular size. FFFF is the smallest I have seen.) Marble dust and quartz are interchangeable with pumice.

organizing your studio

Organizing your studio is a highly personal activity. On the pages that follow I describe my process. Perhaps my practices will help you to articulate what will—and what will not—work for you.

The space that my studio occupies was originally the attic in the one-hundred-and-three-year-old home in which I live. The roofline creates steeply angled walls in the studio, and, at its peak, the walls are twelve feet high. The studio is irregularly shaped. The walls are a soft, warm white, and the angles of the architecture create several shadowed corners. I have screened off one of the intimate corners of the room, using a backdrop board, to arrange a private space for my models' comfort during break times. The view outside the window is of sycamore trees.

I work in natural light only. Natural light is gentle, and it reveals the subtlest and most radiant color and value shifts in flesh. In artificial light, the changes from light to dark are more sharply delineated. My aesthetic is attracted to quiet and gradual, rather than sudden, changes.

When I converted the attic into my studio, I put in a bank of windows that face northeast. North light is the most sought-after light by artists, because it is the most consistent. In the long days of summer, the light permits me to work from about 8:30 a.m. until 8:30 p.m. I also have a skylight that faces the same direction.

Although I love being greeted by my white-walled studio at the top of the attic steps, the studio, because it is so close to the open sky, can be blindingly bright on sunny days, and the colors I am trying to see can wash out in the glare. Therefore, I am considering repainting the studio a light gray. Bearing in mind that the colors and values of the surroundings will be reflected in the flesh tones, white walls can have an unwelcome presence in the shadow areas of our subjects, confusing the sculptural form. Middle-toned or dark backdrop boards positioned around the model remedy the problem. Adhering tissue paper to the windows is also an option, as is a method of permanent glazing. Though I love my uncovered windows, and the views of the tree-tops and open sky, I sometimes want to work with a less diffuse light. A system of up-down shades creates a more concentrated light source for those times.

The combination of the angles of my walls, the windows overlooking the treetops, and the natural light create a feeling of sanctuary. I cherish the quiet. Sometimes I work in silence, at other times I listen to music that relates to the painting with which I am engaged. When I was painting *Roslyn and Arturo*, which is about my parents, I listened to Rosa Ponselle. She was my father's favorite opera singer. We used to listen to her together, and he taught me a lot about her life.

Ellen Eagle, *Roslyn and Arturo*, 2005, pastel on pumice board, 13 x 12 inches (33 x 30.5 cm)

This painting is about my parents, and the only painting in which I have used photographic reference material. I depicted my parents as they were before I was born, and I used images from photographs of them that I grew up with. I painted myself, as always, while looking in a mirror, and for the sake of consistency, I painted the musical notes in reverse. Music was very important in our lives, but the notes also represent the melodies that my parents planted in my heart.

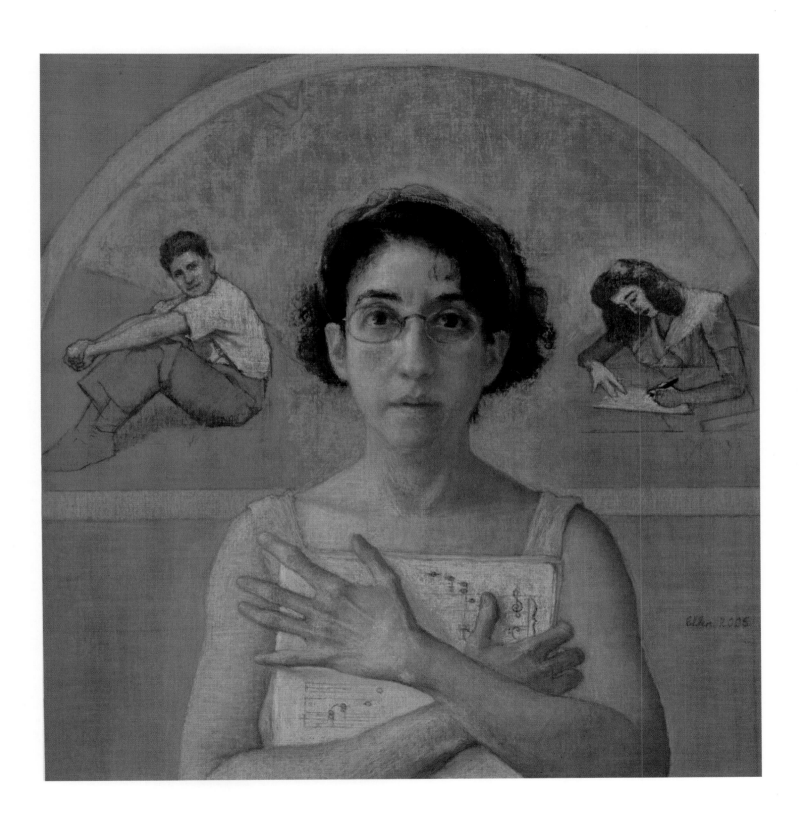

Because I am right-handed, I prefer that the light on my canvas come from behind my left shoulder. This way, my working arm does not cast a shadow onto my painting. Sometimes, however, if I wish to use a certain architectural feature of the studio, or if I want my model to be facing the windows directly, I have to situate my easel with the light coming from behind my right shoulder or completely behind me. I will then regularly take the painting off the easel to check my colors without interference from the shadow cast by my body.

I have backdrop boards that I have painted various shades of gray and a muted grayish pink. They are made of foam core, which is very lightweight. Foam core comes in a variety of thicknesses. I use the ⅜-inch (9.5 mm) thickness. To stand the boards up, I have blocks of wood with notches cut out the width of the boards. I insert the boards into the notches.

Over the years, I have collected quite a few fabrics. I prefer matte rather than shiny surfaces, which reflect too much light for my purposes. In general, I prefer solids rather than patterns.

My bookshelves are in the hallway, to keep the books away from pastel dust. On my shelves are books about, among others, Jan Vermeer, Edgar Degas, Käthe Kollwitz, Mary Cassatt, Thomas Eakins, Harvey Dinnerstein, Hans Holbein, Christen Kobke, Camille Corot, Edward Hopper, Vilhelm Hammershøi, Hans Memling, Jean-Auguste-Dominique Ingres, Cecilia Beaux, Rembrandt, Leonardo da Vinci, Piero della Francesca, Raphael, Titian, Daniel Greene, Burt Silverman; catalogs of Lennart Anderson, Aaron Shikler, David Levine, and many others.

On my studio walls are reproductions of paintings I love: Jan Vermeer's *Woman with a Pearl Necklace, Woman with a Water Pitcher, Portrait of a Young Woman, Woman with a Lute, The Guitar Player,* and *The Little Street;* Thomas Eakins's *Self-Portrait, The Opera Singer,* and *Portrait of the Artist's Wife;* Winslow Homer's *The Sick Chicken* and *Snap the Whip;* Degas's *Self-Portrait;* Ingres's *La Comtesse de Tournon;* and a detail of da Vinci's *The Virgin of the Rocks.* I also have catalogs of Harvey Dinnerstein's work on a table reserved for my most treasured items. News clippings and notes to myself are everywhere. As I work, I often stop to write down a thought, and I have accumulated many notebooks over the years.

I have five model stands. One serves as a table and holds reading material. Two of the stands are about 10 inches (25.4 cm) high, the others are 18 inches (45.7 cm) high. It is very helpful to have different heights available. I am not tall, so I find that I frequently place my model on the lower of the two heights, unless I wish to be looking way upward at my subject. The choice of stand is also determined by the pose, be it standing or seated.

A large mirror on wheels was assembled for me in the studio. I use this mirror primarily for self-portraits. I use the handheld mirror to check my paintings in progress.

It is important for me to maintain a well-organized studio. I find it almost painful to be in the studio when my supplies and reading material are cluttered and disordered. Just as I seek simplicity in form and composition, I like simplicity in my surroundings and supplies.

Ellen Eagle, *Studio Corner,* 2002, pastel on pumice board, 9¾ x 6 inches (24.8 x 15.2 cm)

This is a corner of the Art Students League studio in which I teach. I'm very glad that I painted it when I did, because the studio has been remodeled and the new pipes are nowhere near as interesting as the original. Though there are no people in this interior, the evidence of the corner's long life of service to its inhabitants is visible. I did not include my reflection in the mirror. I wanted the painting to be about the corner, not me painting it.

keeping a notebook

I find it helpful to keep a notebook. At the close of my painting session, I often want to write down how I think the work went today, and what I think I need to address when I come in tomorrow. I may not agree, the next day, with my assessment. I may have a fresher eye the next morning and see something I had not noticed the day before. But reading my notes brings me back to the immediacy of yesterday's experiences. I also find it helpful to make notes at the beginning of the day. Painting is a combination of impulsive response and architectural strategy. Having notes to look at can bring me back to solid ground if a momentary fascination diverts my attention from the singular purpose of the painting.

Going back and reading notes made during the course of a painting completed a while ago is often enlightening, especially if read while simultaneously viewing the painting. I read what considerations were important to me while observing the visual resolution. It can reveal mistakes I am unaware of repeating, remind me of what I have done that is helpful, and provide a record of the chaos and the order that comprise perception and transcription.

I also write notes outside of the studio. There are lessons everywhere: the way something looks; a conversation overheard; a choreographer's transcription of feeling into form. We make connections to our own endeavors, see similarities and differences. Of course, it's impossible to be tuned in to everything, and I am a devotee of reverie. Attentiveness stirs reverie, and reverie enhances our focus. I think it's very important to not separate the awareness you bring into the studio from the awareness you bring to your other activities. Your experiences become a part of you. They shape your perceptions and assimilate into your work.

Ellen Eagle, *With My Drawing Pad*, sketch, 2001, graphite on Strathmore Series 400 Drawing paper, 14 x 10½ inches (35.56 x 26.67 cm)

The composition of this sketch later evolved into a painting. The arm gesture that was a slight inconvenience while drawing portended difficulty during the painting process. I altered the gesture in the painting, but maintained my embrace.

Ellen Eagle, *Paper Towels and Tape*, pastel on pumice board, 2007, 4⅛ x 3¼ inches (10.5 x 8.2 cm)

I was moved by the simplicity of the white column and the graceful arc of the end piece. The warm and cool shadows and the translucency of the paper were beautiful. The tape on the wall works with the diagonal of the end sheet.

Ellen Eagle, *Paper Towel and Tape*, pastel on pumice board, 2007, 7⅞ x 5 inches (20 x 12.7 cm)

I loved the corners of the paper reaching into the light, and the shadows within the paper and on the wall. The overall design evokes a musical note.

Ellen Eagle, *Paper Towels and Hooks*, 2001, pastel on pumice board, 9⅜ x 5⁹⁄₁₆ inches (24.4 x 5.6 cm)

Recently I did a series of paper towels paintings. I love the way the light is revealed through a single paper towel as it separates from the column of the group, and I love the shadow that the sheet throws on the main body. I came upon this painting a few months ago. I had done it years ago, way before my recent series, and had forgotten all about it. Finding it proved to be an affirmation of my love of simplicity and light.

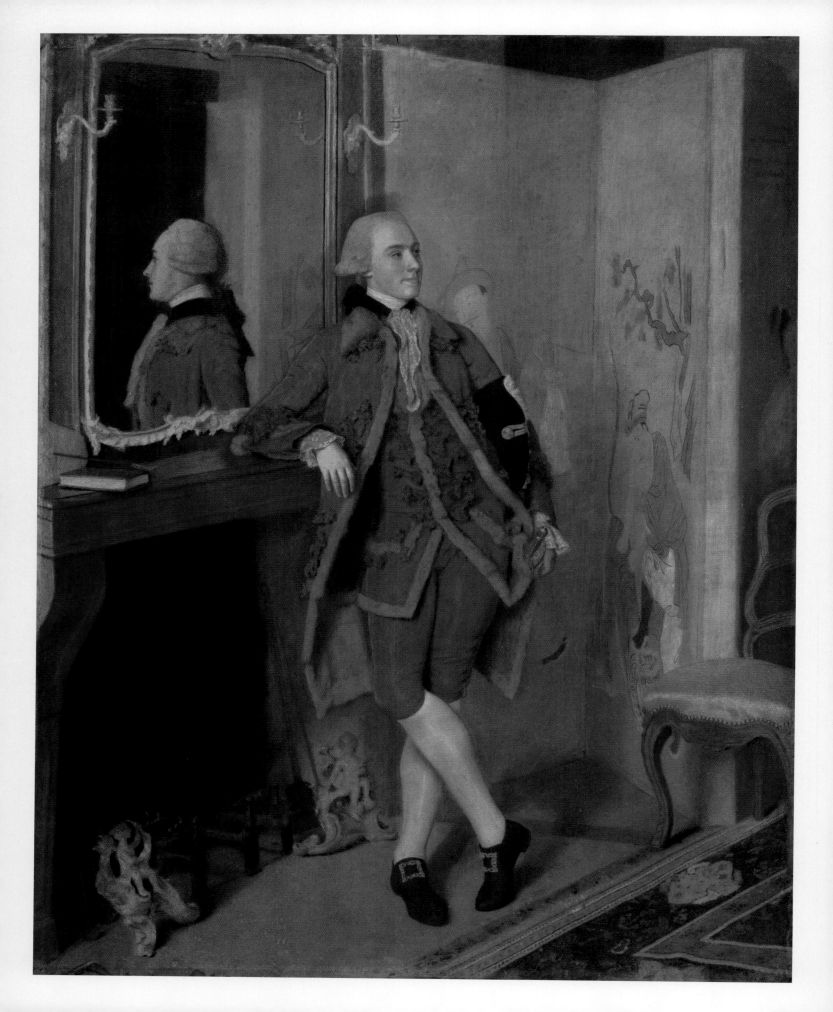

a look at the genres

No matter what genre an artist works in, the task at hand is to weave a seamless fabric of form and content. The content is the feeling that stirs within the artist, inspired by the subject. The form is the shape the artist finds to convey the vibration of feeling. The still life painter looks at the cup and loves it for its curved rim that fits his lips so perfectly and passes tea to his taste buds without spilling it onto his cheeks. The cup's little handle keeps his finger from burning, as he lifts it. The cup fulfills its calling, and the painter paints his affection.

The landscape painter stands in awe of the tree's commanding growth and ability to thrive through vastly changing meteorological cycles. She rejoices when she sees the tree's seeds scattered on the soil below and mourns when it perishes under environmental, or human, assault. To see something so immense come down is a reminder of the inherent fragility of all life.

The portrait and figure painter plumbs the human presence in all its complexity—body, mind, and spirit—the expression of its inherent nature continually shaped and reshaped by environment and experience. In striving to capture life, the portrait and figure painter always carries the awareness of death. Knowing that our bodies are here, and then gone, we are constantly embracing vitality.

Many paintings combine all three genres. A painting of people picnicking in a park requires the figure, the still life, and the landscape. The way the artist orders the shapes and color conveys the spirit of the event and the relationship of the parts to the whole. A great painter of any genre is always painting the spirit.

portraiture

It is a breezy late afternoon in spring and I am in my studio. The light streaming in through my windows is low and long and I am in a contemplative state of mind. My studio always moves me to reflection. Just entering the studio seems to raise the question "What is my premise?"

Today I am looking at small reproductions of portraits I have painted in this room. I see that in all the portraits I have done of my friends, they are looking straight at me. In my paintings of professional models, they look every which way. I had never noticed the pattern before this very moment.

When I first left school and started to paint people close to me, I found the challenges to be very confusing—so much history between friends, so many confidences exchanged over the years, so much awareness of past struggles and joys, so many layers of insights and empathies. How do I extract a singular thread from all that I know, when I love so much about this person? What do I leave out? How can I leave anything out?

I came to realize that my questions were ill conceived. They burdened the freshness of present encounter. My portraits are not about the past. They are about the present, this one precious moment in time that my sitter gives to me. Our histories, and the filter of my nature, will integrate into my painting in the ways they will. In time, I came to discover that, as much as I knew about my friends, here in the studio whole new places within us were being touched. New insights and affections burgeon and reveal themselves in the portrait. I cherish the revelations as silent, epic gifts, and I am reminded, once again, that painting is about discovery.

Ashley was my physical therapist who straightened me out after a fall. I was taken with her cheerful humor, which put her clients of every age, nationality, and shape, immediately at ease. She came to my studio very early before her daily shifts began. As she sat, she told me that she was daydreaming about her boyfriend. I repeatedly waited for her smile to start and grabbed those moments. After observing her warmth and excellence at work, I loved that her private life was happy and full.

Ellen Eagle, *Ashley,* 2005, pastel on pumice board, 6 x 4½ inches (15.2 x 11.4 cm)

I waited for the moments when Ashley's smile would just begin to appear. I knew it would return.

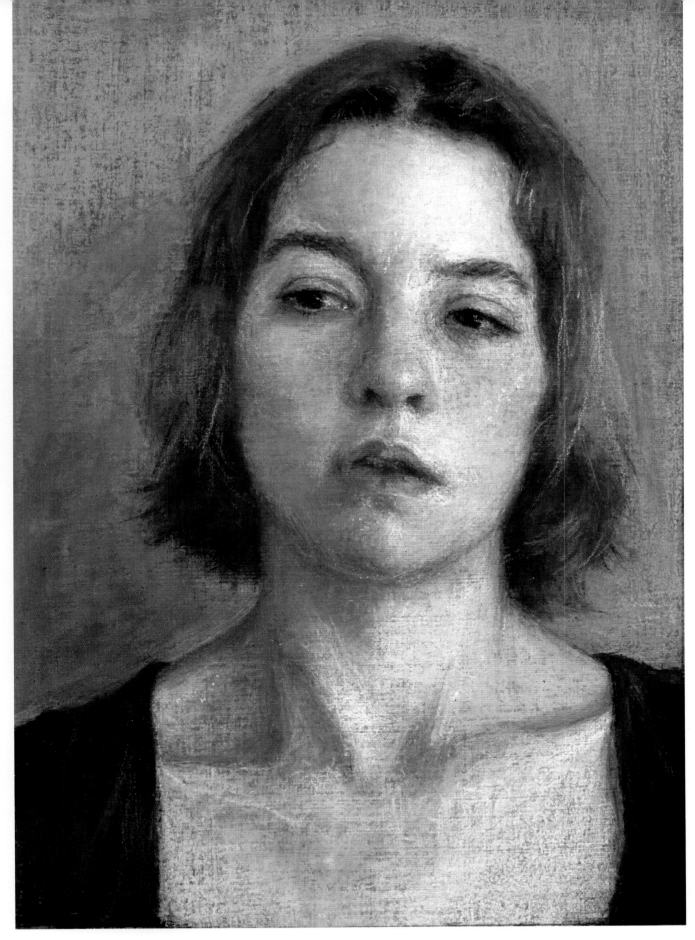

Many of my paintings are of professional models whom I don't know well at the time we begin our work. When I ask a professional model, or anyone I don't know well, to come to my studio and work with me, implicit in my request is that I perceive in the individual an integrity and compassion. Initially, I want to explore that strength. As we work together in the studio, artist and model discover each other. The model is a professional, understands the body's dynamics in space, and the subtlety of remaining still and self-possessed while open to my inquiry. We share an appreciation for study and the pursuit of elegance and order. Trust and respect are cultivated. Sympathy for my subject abounds, as does my gratitude.

I met Pigeon at the Art Students League of New York, where I teach. I was struck by her graceful posture and her wide smile. The shapes in her face and hair—shapes that wing out, fan out, from a central core—suggested an energy that I found exciting. Seeking sequences of perfect fits, I found a pose and clothing for Pigeon that replicated the patterns I saw in her face and hair.

My Portrait of Julie is one of the first portraits I painted of a nearly lifelong friend. Julie saved up her vacation days at work in order to sit for me for ten days. When she arrived for the first session, she brought a huge bag stuffed (neatly) to the brim with pants, blouses, dresses, earrings, and bracelets for my choosing. She had all the clothing and jewelry out of the bag within about three seconds. She was excited and quite nervous. I was, too.

What followed was ten days of fear and paradise. The fear is the fear that always accompanies the desire to do justice. The paradise is letting go and immersing myself in the beauty of the subject before me. The more immersed I become, the greater the communion I feel with my model's qualities.

I found the pose immediately. Julie's life has brought her some very dark times. I didn't want any more darkness for Julie. I wanted only light. For her portrait, I faced her toward the window, so that only minimal shadow would touch her. I brought her very close to the viewer—where some might have withdrawn from exhaustion or pain, Julie remains fully present to the feelings of others. The psychological choreography was intuitive. I was working from feeling. Only in retrospect did I intellectually realize why this light and composition were perfect for Julie. The title of the painting is an expression of my affection for her.

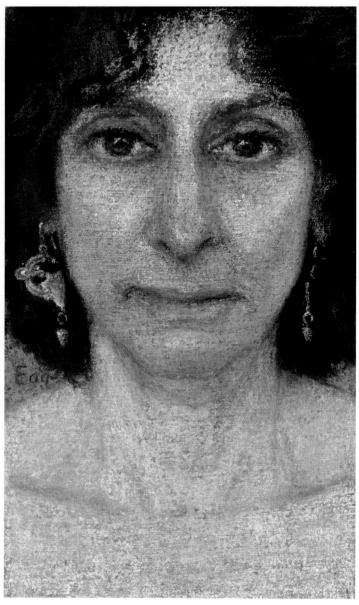

Ellen Eagle, *My Portrait of Julie,* 2005, pastel on pumice board, 4¼ x 2½ inches (10.8 x 6.4 cm)

It was important to my portrayal of Julie that she be very close to the viewer. This painting is tiny because my friend Julie is a gem.

OPPOSITE:

Ellen Eagle, *Pigeon,* 2011, pastel on pumice board, 10⅜ x 5 inches (27.3 x 13 cm)

As Pigeon sat for me, and her mind drifted into private thought, her lips pressed together ever so slightly, each causing the other to almost imperceptibly reshape in response. In this vitality, I found the cause for my painting.

Ellen Eagle, *Lore Koenig,* 2007, graphite on Strathmore 400 Series Drawing paper, 12 x 9 inches (30.5 x 22.9 cm)
She had an equally beautiful profile, but my portrait of Lore Koenig simply had to be face-to-face.

OPPOSITE:

Ellen Eagle, *Asha,* 2005, pastel on pumice board, 6½ x 5⅜ inches (16.5 x 13.7 cm)
In my painting of Asha her head is turned, her sights are set. She is strong and determined.

I enjoyed the playfulness of Asha's ever-changing and multi-toned hair color, and, in contrast, the calm of her facial expression and the nuances of her skin tones. Asha brought several blouses for me to choose from. When I saw the lace strap, so like her eyebrows, and both like and unlike the tattoo, I knew that was the blouse I wanted. The cohesions and contradictions echoed, for me, the circumstances of her life.

Asha, a fine arts graduate student at the time of our portrait, was a professional model. I met her for the first time at my doorstep. In the studio, as we conversed, she displayed a profound

sense of independence and intelligence. She was very well informed and came to every session with a dog-eared newspaper. She had strong, well-thought-out opinions, which she articulated with absolute clarity. I learned that Asha had to become an adult well before her time. It fell to her to raise her much younger brother, to whom she was completely devoted. I respected her enormously. I was charmed by her incongruously whimsical clothing style, which contrasted with her responsibilities, and her automechanical capabilities. More than once, after our sessions, she had to go into her car engine with myriad gigantic tools in order to drive her truck home.

It is natural, when one is moved by someone, to want to give care to that person. I feel that impulse when I paint a portrait. Being attentive to your model while he or she is not on the model stand enhances your insights. Hear her voice. See how he moves. What does he like to wear? What does she say to you? What does he do when he is not with you? Is she a poet? Does he read Agatha Christie? Is she an electrician? Having a feeling for your model is paramount to portrait painting.

Lore Koenig greeted me with one of the sweetest smiles I've known. Within the first minute of knowing her, she proudly told me that she was ninety-five years old, going on ninety-six. I was instantly smitten. To our delight, in that same minute, we discovered that we share a birthday. I drew her at her daughter's kitchen table. She sat beautifully. She told me how honored she felt to be drawn by an artist.

Many decisions about backdrop color and clothing are based upon the model's coloring. When I was doing my second painting of Pigeon (see page 141) there was a long gap between sessions. I mistakenly set up the wrong backdrop board when she arrived. When I saw her against the gray, the warms in her flesh appeared to be much more prominent than I had remembered. When I replaced the correct deep rose color, her cool tones dominated. If you want to emphasize a ruddy coloring, you might select a cool backdrop and cool clothing tones. The direction of light is determined by what you want to emphasize. Light from the front will present symmetry; three-quarter and side light will emphasize plane changes and strong contrasts of value. But the primary strength of your portrait begins with your conviction to the character of your model.

EXAMINING THE WHYS OF A POSE

People paint, write, sculpt, and dance out of all sorts of motivations. I paint from joy and awe. I have always had difficulty painting in a time of grave stress or sadness. One period of my life was an exception, and it bridged the creation of these two portraits.

In the fall of 2007, my beloved friend for more than forty years, Lisa, began to sit for me. My goal in painting her was to show her how beautiful she was and to contemplate her compassionate nature. I knew that I wanted to portray her looking at me as I looked at her, because our friendship was so essential to us. For decades, we had opened ourselves to each other. I also had plans to do a second portrait of Lisa; the long lines of her facial features beckoned a three-quarters-view presentation.

Lisa sat facing the light, her powerful cheekbones thus exalted. She lifted her chin just a bit, and looked directly at me, often breaking into a radiant smile as she watched me reach for pencils, charcoal, and pastels; squint to see the big shapes; and cease all motion save for scrutiny of her presence.

From the start, the painting captured the warm olive and ocher flesh tones of Lisa's Mediterranean roots. Her long, thick, wavy hair, the first physical feature I had noticed about her forty-plus years earlier, spilled over her shoulders. The single pearl that she wore around her neck perfectly accessorized her elegance. She took photos of me painting her. "This is what I see when I sit for you," she said, when she gave me the photos. She asked questions about color, light, perception, and pastel. We were elated to have these precious moments together.

Lisa could come to the studio only every other Friday afternoon, and there were several interruptions to our schedule. Such long stretches in between sessions presented some challenges. I began to feel as though I was spending whole sessions becoming newly acquainted with Lisa's flesh tones, hindering my ability to move past the initial lay-in stage. This deeply concerned me. I worried that by being stalled, some of the joy of our communion would drain away. But something far more terrible was occurring.

Somewhere, sometime, during the course of the portrait's evolution, I noticed that the skin tones that I was struggling with had become cooler. The hair quieted. The chin lowered. The touch of a smile disappeared. And Lisa's gaze, once fully engaged with mine, had turned inward. Lisa appeared to be fading, cloaked inside a haze.

Ellen Eagle, *Lisa*, sketch, 2007, graphite on Strathmore 400 Series Drawing paper, 5⅛ x 4¹/₁₆ inches (13 x 10.3 cm)
Lisa's radiance was compelling and motivated my drawing.

Why, how had I lost her vivacious beauty? Why did something else come to the fore? I felt disoriented and frightened when I looked at the painting. This was not what I wanted to show Lisa. It was not the way I knew her to be. Yet painting is about painting what I see, and sense, and I can't fake it. This was never Lisa, but the portrait was painfully true.

One night, eighteen months into the portrait, Lisa called me. She had been to the doctor. Our only clue had been an occasional delicate cough. But my painting had been fully alert to the subtler clues. Lisa was ill. Our sittings had to stop.

Ellen Eagle, *Lisa*, 2009, pastel on pumice board, 8⅞ x 5¼ inches (22.5 x 13.3 cm)

My portrait recorded subtle changes I was witnessing in my longtime friend. Lisa and I hung it in her bedroom. She wanted it to be the first thing she saw when she woke in the morning, and the last, at night. She told me that in the portrait she saw me looking over her through her own visage. She said it was a great comfort to her.

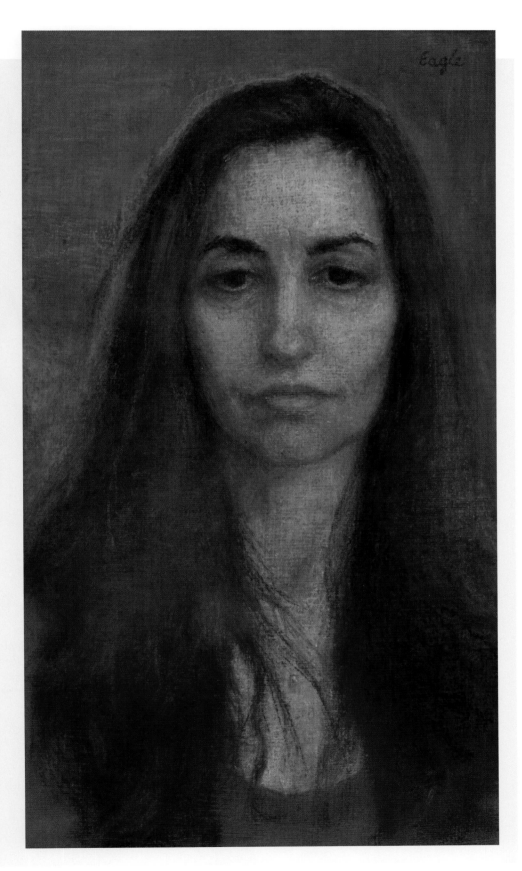

I first met Miss Leonard in the fall of 2009 when she modeled for the class I taught at the National Academy Museum and School. She had arrived before I did, and she sat in the chair on the model stand, her back to the door. Seen from this angle, her posture was my first inkling of her composure. I walked around the model stand. She was tiny. Though seated, her upright composure made her seem weightless. She had, perhaps, the thinnest, while strongest-looking, neck I had ever seen. She held her head high, though without an air of superiority. Her hair was pulled back and up and anchored with invisible pins. Her face was free of cosmetics. Dressed in grays from shoulder to toe, she wore no embellishment. Her simple woolen skirt and sweaters, stockings and boots echoed her refined comportment. In a city populated with dramatically adorned residents and visitors, Miss Leonard had chosen a subtlety that instantly suggested a thoughtful self-possession. I was captivated. As composed as she was on the model stand, when she stepped off and came toward me, her face lit up with a broad smile that said *friend*. Naturally, I wanted to paint her.

Sesame Leonard began to travel a great distance, several days a week, to my studio. Many times she had difficult commutes, but she always arrived at my doorstep, bundled up in warm clothing, smiling broadly beneath her knitted hat. She always took her shoes off just inside the door, though I had never made such a request.

In the studio, we spent several sessions drawing as I sought a gesture to paint. Our working sessions were blissfully quiet. During breaks we spoke of quite personal matters. Miss Leonard knew loss, and triumph, and she, like me, was reeling from current trauma. We spoke of friends, family, color, justice, mangoes, and socks. As we got to know each other, her dignity, warmth, grace, and humor summoned from me a deepening affection and respect.

During these fragile moments in our lives, together we were beginning to create a painting. I heard Miss Leonard breathing. I watched and listened. Our quiet deepened into near silence, save for breath and strokes of pastel abrading onto my canvas. In the final portrait, Miss Leonard stands—an unbroken, uninterrupted vertical. She is touched by the natural light flooding the studio. Eyes closed, she seems at once cloistered in her own thoughts and connected to something beyond.

Ellen Eagle, *Miss Leonard*, 2010, graphite on Strathmore 400 Series Drawing paper, 12 x 9 inches (30.5 x 22.9 cm)

The moment I saw this pose, I knew it was perfection. The simple gesture—standing up, chin lifted—was deeply resonant of Miss Leonard's elegance.

OPPOSITE:

Ellen Eagle, *Miss Leonard*, 2010, pastel on pumice board, 15¼ x 8⅝ inches (38.7 x 21.9 cm)

Sesame's tender beauty and courageous nature were pressing deeply into my heart, and helping to lift me up out of darkness. I didn't want anything to ever harm her. I needed a gesture that would say: Here. Beautiful. Triumphant. Alive.

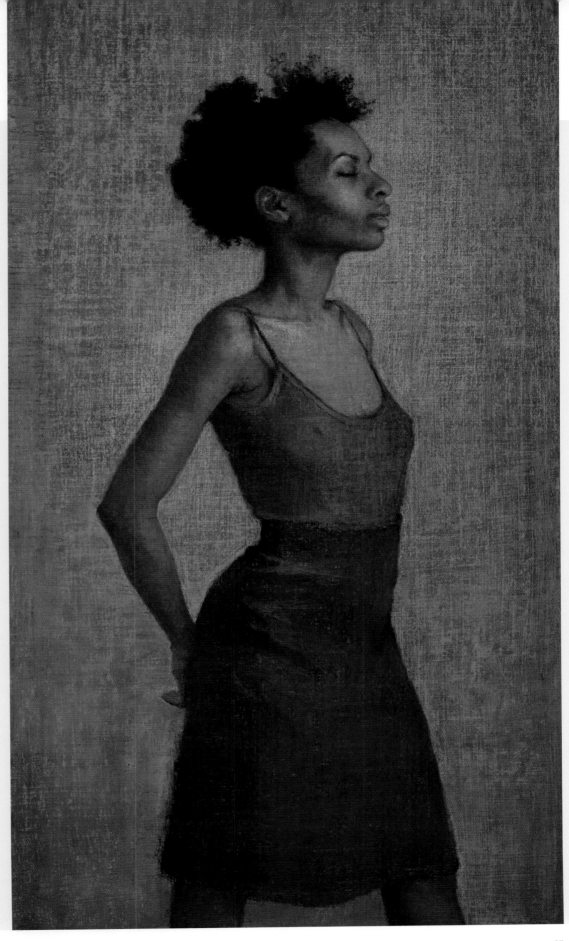

self-portraiture

Some of my favorite paintings are self-portraits—those of Edgar Degas, Thomas Eakins, Harvey Dinnerstein, and Käthe Kollwitz in particular. Artists looking at the artists they are is fascinating to me.

The artist has turned his gaze outward so many times and wielded his pastel or brush in tribute to those people and places he finds essential. His heart and soul exalt in his subjects. Now, he turns his eye to his own presence. How have those he has exalted imprinted themselves on him? Who is this artist when he is alone? Some self-portraits are deeply revealing, painted by artists as best they can see themselves. Others are fictive, painted the way they want others to see them. Perhaps all self-portraits contain a degree of both intentions.

One of the many compelling aspects of self-portraiture is the artist's observation and evocation of his own development—from early career through a fully practiced one. Perhaps in the early years, the self-portrait exposes an insecurity, or an open-eyed eagerness. I am especially riveted by the self-portraits of mature artists whose priorities are clear, and who have been to the easel hundreds or thousands of times. Carrying the legacies of their personal histories in their faces and bodies, they have lived their lives as artists. They continue to show up at work, to get in the ring, and scrutinize, once again, who and where they are today, in solitude. I think, *They know how to do it, but there they are, right there, looking for more.* I look at these incredibly moving self-portraits, and I want to say *thank you.*

The most obvious difficulty in doing a self-portrait is the physical demand of maintaining a pose while working. The artist has to assume the gesture while scrutinizing it in the mirror, break from the gesture, hold the vision in memory, and record what is remembered. The artist then returns to the gesture, looks in the mirror and at the painting and compares the two scenes. Appropriate adjustments are made, and the cycle continues. It is simply exhausting.

Another physical challenge is that we cannot use the mirror to reverse our viewpoint of the model to identify drawing problems. I personally find it difficult to study my own eyes. If I, the model, hold my eyes still, then I, the painter, find it difficult to look. And when I work, though I study slowly, I apply my color rapidly, eager to put in as I see. This causes me to toss pastel sticks from my working hand into my left hand to hold them in waiting as I reach for my next color. I am less able to go through this naturally occurring process when I have to be the model. So I feel somewhat cramped. I also do not give myself breaks, as I do when the model is not me. It's hard to stop painting, but breaks are important. They freshen our eyes.

On the positive side, I am always available to myself, and I am willing to ask myself to take poses that I would never ask of someone else. In *Winter 2006–2007* (on page 13) I suspended my arm in the air for many hours each day for five months while freezing in the dress that was essential to an aspect of my concept. In *Self-Portrait in Blue* (on page 68), I stood barefoot on a hard floor for I don't remember how many sessions over the course of many months until it occurred to me that I could wear socks while not working on the feet.

I never begin a self-portrait out of interest in looking at myself in the mirror. My self-portraits always originate from a situation in my life. For example, in *Self-Portrait in Blue,* I was thinking about my father, who, at the time, was very ill and nearing the end of his life. I was aware that, with imminent loss, my position, my point of view, my perspectives, were about to change. The painting is of me stepping back to look at my painting from a distance. That is how I described my situation of having to see life from a changing viewpoint. One morning, months earlier, I had glimpsed myself in my studio mirror. I was wearing my nightgown. I loved the close value and hue relationships between the nightgown and the studio walls. I loved the pale colors. The open gesture and unclothed shoulders suggested my feelings of vulnerability in the face of my father's illness, and my powerlessness to change the inevitable. The two interests, color and emotion, coalesced and developed into my painting.

Then there is the incessant questioning and self-doubt about premise, which I discuss in relation to *Each Time, And Again* on pages 124–125. Paintings have to feel totally genuine. They are not about a reasoned logic. The conscious mind has to step aside and allow the deepest connections to be truly felt. The solitary practice of self-portraiture mines the artist's connection to his own vision.

Francesco Paolo Michetti, *Self-Portrait,* 1877, pastel and gouache on brown paper, 18 x 11¼ inches (45.7 x 28.6 cm), collection of The J. Paul Getty Museum, Los Angeles, California, 94.GG.48

Pastel's reach in the nineteenth century transcended the well-loved works of the Impressionists. Many artists at this time returned to the graphic approach employed in the sixteenth and seventeenth centuries, in which much paper was left revealed.

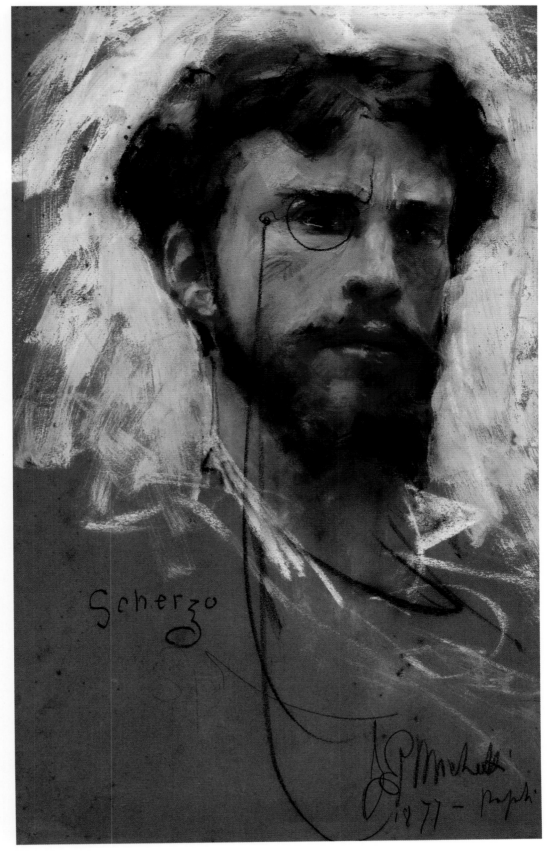

Scherzo

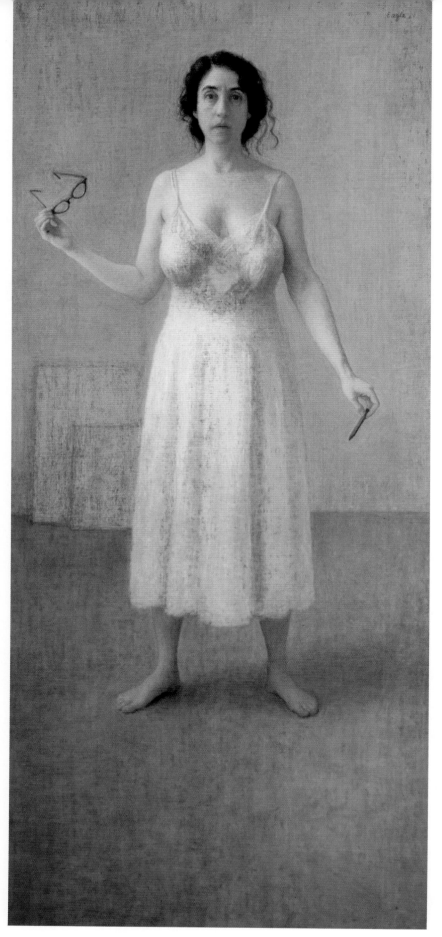

Ellen Eagle, *Self-Portrait in Blue*, 2003, pastel on pumice board, 35¾ x 16⅝ inches (90.8 x 42.2 cm)

The first motivation for this self-portrait was the high-key values and close color relationships between my nightgown and my studio walls. Eventually, a personal situation completed the idea for the final composition.

Harvey Dinnerstein, *Self-Portrait with Plumb Line (Daedalus)*, 1999, pastel on board, 21¼ x 18¼ (54 x 46.4 cm)

Stunningly composed with an economy of form and color, this painting is exquisitely personal. I wonder about the assemblage of images. Whatever its meaning to him, Dinnerstein's image transports our thoughts as he captivates us with his self-reflection and beauty.

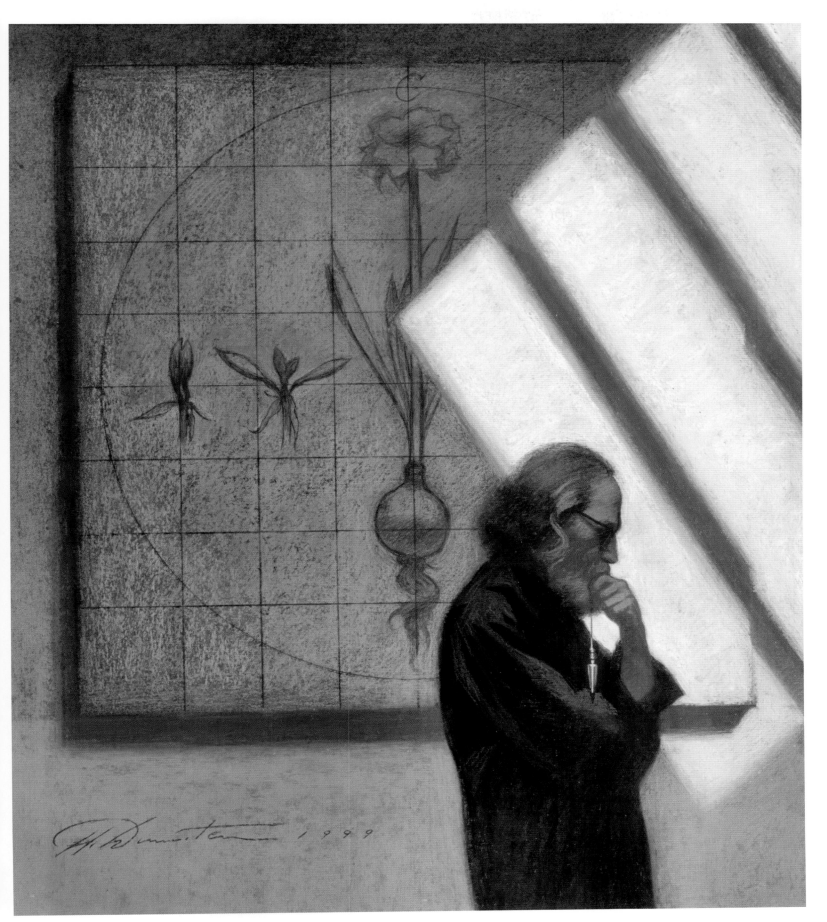

still life

Fish bones and lemon peels. Lace, guitars, skulls, and feathered quill pens. Dish towels, wind-up cars, a painter's brushes. A little wooden figure, a sewing machine. Allegory, religion, morality, beloved objects, forgotten objects, the pleasures and trials of everyday life. All are the subject of still life. I venture to guess that still life is the most congenial genre in art. Whether city or country dweller, we all live with things that mirror our personalities and fashion our daily activities.

The very first drawing that I remember making was a still life. My parents had a small ceramic sculpture of a bird. I remember sitting at the desk on which the bird was perched and doing my best to get the proportions and curves of the head, beak, belly, and wing. I was four years old, I had been looking at that bird all my life, and getting it right was a matter of urgency. I needed that wing to look as though it could lift the bird into the air. My next subject was my old, tiny pair of newborn baby shoes. The bird drawing disappeared but I still have the baby shoe drawing, and I am struck to see in it what was important to me—the shoes look like they are walking. My affection for the subject animated the image, just as, in my pastel paintings, I see the inner chatter of the typewriter, the birds-in-flight garlic skins, and the curtsy of the bee balm. The subject elicits a feeling about being alive.

Whereas I am fascinated by all the questions and principles that arise when staging a still life, I also love the accidental happenstance of encountering an already beautiful arrangement. What could be more inspiring than noticing a design of forms, an order, so naturally harmonious that I stop what I am doing in order to gaze? In my studio I see scatterings of pastel shavings on paper towels; an old, red-handled, double-bladed egg chopper; white rectangular envelopes containing letters to me resting on my windowsill. Beside the window, Jan Vermeer's *Young Woman with a Water Jug* overlooks my old white filing cabinet, its hinge off-center and broken. They are all beautiful. Walk around your home sometime and look at the spaces through a viewfinder. You will see patterns, balance, and order where you may never have noticed them before.

My first still life drawings were of items plopped on a surface, but today my still life paintings are usually of carefully arranged groupings. Still life affords the artist fantastic opportunities to create color, texture, and abstract shapes. Viewpoint and arrangement are entirely at the discretion of the artist, more so than landscape and the figure, unless you are working from imagination.

Many artists refer to nature's absolutely fascinating golden ratio to help them compose their still lifes (and paintings of all genres). The golden ratio refers to the brilliant unifying, harmonious proportion found throughout nature, including in the human figure. Since its discovery in Ancient Greece, the golden ratio has provided the foundation for works by mathematicians, artists, architects, landscape designers, and, I conjecture, those working in many other fields as well.

When I select items to portray based on affection, I am simultaneously considering their compositional potential. Where you place your items in the composition determines how the viewer's eye travels through the painting. Compositional factors to consider are these: If you are placing objects on a surface, where in the composition do you want your surface to be? High, low, or in the middle? You will be working with colors, textures, opacity and transparency, straight edges, curves and angles, and arranging varieties of heights and widths. Where do you want your forms to overlap? Where do you want spaces in between? What will come forward, what will recede? As you place your objects, you will be creating negative shapes in between. As sensitive as you are to the lines and volumes of your objects, you must be equally aware of the negative shapes in between, above, and below the objects.

Look at still life paintings of items on a table. How often does an item cross the edge of the table, in order to break the horizontal and add to the flow of movement? Perhaps a fabric on the tabletop obscures the edge here and there, adding dynamic angles. How do you wish to depict the contact where the bottom of an item meets the surface on which it sits? Remember to squint while creating your painting, and keep your eye moving over the whole setup, so that each edge and detail develops in proper

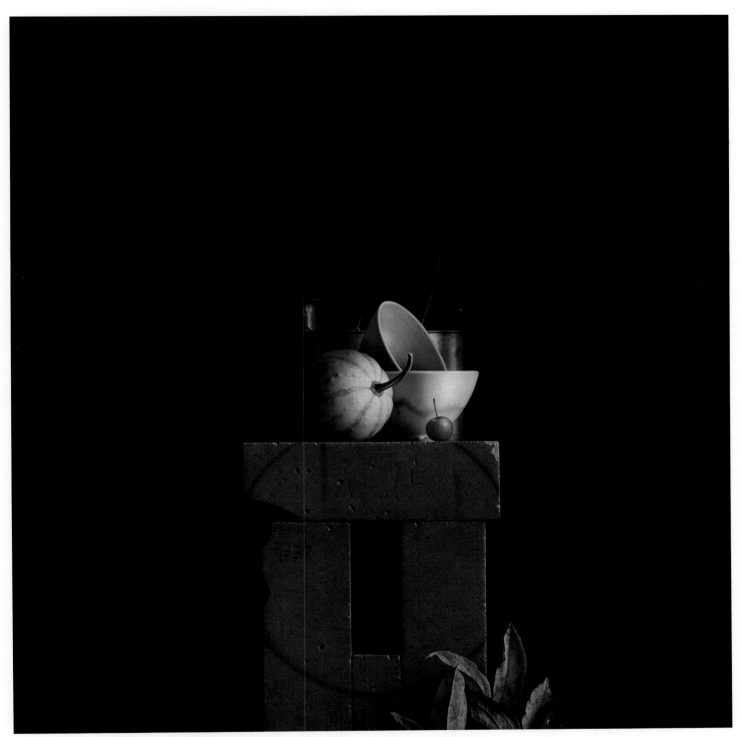

Daniel Massad, *Tau*, 2007, pastel on paper, 24½ x 24 inches (62.2 x 61 cm)

PHOTO CREDIT: SCOT GORDON

The tight arrangement of objects in the low center of the painting produces a feeling of self-containment, much as a figure clutching itself might produce. The circles and arcs move around each other like planets in a galaxy. All the parts require each other to make the whole.

OPPOSITE:

Ellen Eagle, *Peter's Grandfather's Camera,* 2002, pastel on pumice board, 8 x 4¾ inches (20.3 x 12.1 cm)

My friend Peter Jacobs is the photographer of all my artwork. One day at his studio I noticed this beautifully appointed camera sitting amid his collection. Peter told me that it had belonged to his grandfather in Dresden in the 1920s. I loved the evidence of his hands on the strap and the wearing down of the leather casing. The camera recorded not only the scenes the photographer saw, but the touch of the photographer himself.

Laura Coombs Hills (1859–1952), *Yellow Lilies and Gysophilia,* n.d., pastel on paper, 21¼ x 17⅜ inches (54 x 44.1 cm), Smith College Museum of Art, Northampton, Massachusetts. Gift of the estate of Thalma Haven Gordon, class of 1919, SC 1985:15

The artist marries a meticulous rendering of the flowers and vase with a sketchy approach to the table and background. It is unclear whether the ghost-like suggestion of blooms in the lower right are a part of the floral arrangement or are connected to the bouquet-like dabs of color in the upper-right background. This ambiguity lends a sense of mystery to the space and light.

relation to all the others. Do you want the background to be flat, or perhaps you want to set up your arrangement in a corner? A corner will provide a vertical, and a change in value from one wall to the other. Where do you want that vertical to be in relation to the tabletop and shapes of the items? Perhaps you are painting a grouping of objects not on a table, but on a wall, or floor. Or hanging from a string. Or in the bend of a tree limb. One can be highly inventive and playful with still life composition. The entire canvas must be considered in the design. What shape do you want your canvas to be?

Experiment with different locations for the light source: the value, length, and direction of the shadow shapes will yield vastly different abstract shapes across the entire space, depending upon the location of the light. In fact, all the shapes of shadow and light will alter along with the change in lighting. Try a red bulb, or a yellow, or a blue. How does the colored light affect all the colors of the objects and setting? What does it do to the mood of the arrangement?

Materials reflect light in ways specific to their textures. For example, unless made of shiny components, grainy textures are usually more matte in appearance than are smooth textures because each grain will contain some shadow as the form turns. Satiny fabrics reflect light more highly than denim or cardboard. Metallic objects have brighter highlights than wood.

Study still life paintings in museums. Note how the genre has evolved through the ages. Dutch still life painting reached a golden age in the seventeenth century; the paintings are characterized by exceptional elegance, light, and clarity. My own personal favorite still life artist is the French painter Jean-Baptiste-Siméon Chardin. He painted some of the most tender still lifes imaginable. Jan Vermeer's still lifes within his figurative paintings are perfection. Magnificent still life paintings may portray individual items of vastly varying textures, shapes, and sizes, but never break apart compositionally. They are cradled by a unifying design and light.

I recommend that you augment your study of original still life paintings (and, actually, all genres) with the study of very fine quality reproductions. Take a piece of tracing paper and lay it over the reproduction. This will help you to see the main shapes and contrasts of value. These large shapes are the foundation of the painting. Perhaps trace the large shapes—curves, angles, straight edges, and masses—and then look at the tracing to isolate and recognize how the artist choreographed the foundation of the composition.

I love interiors and architectural details. Old buildings often have beautiful and aged plumbing, intricate heating ducts, and features of mysterious origin. Their graceful angles and curves, and their enigmatic forms and functions, intrigue me. I consider them to be material for still life, because they are still, and the life lived in their vicinities is palpable.

Ellen Eagle, *In Case of Fire*, 2012, pastel on paper, 6 x 4⅞ inches (15.2 x 12.4 cm)
The graceful interplay of the abstract shapes of structures and shadows intrigues me, as does the always suggested, never sure, function of the apparatus.

landscape

Contemplations about our relationships to the earth and the universe have been, and will always be, with us. Whether we reflect on the joys and tribulations of life in our neighborhoods, or the earth's relationship to the forces of nature beyond, creating images of our environment reinforces our feelings of awe, humility, and union.

In Western art, the landscape has served as backdrop for mythological narratives, historical and religious scenes, and as a subject in its own right. Eastern artists have always held the genre of landscape painting in the highest esteem. For centuries, their vigorous arrangements of lines, patches, and dabs of ink and watercolor dancing and stabbing across the paper have evoked mountains, rivers, trees, and waterfalls.

During a recent trip to China, I traveled the height of a mountain whose peak rose above the clouds. In the rain, I visited ancient temples of worship. I saw centuries-old trees whose roots had risen from the earth and cemented to nearby boulders. I stood in the shade of banana tree groves and inhaled the scent of lychee flowers.

During my lifetime, I have seen ink and watercolor paintings of such scenes. To my Western eye, the paintings were depictions of an exotic, foreign land, but now, surrounded by the landscape, I recognize in the paintings the intimate, loving eye of an artist for his or her land and culture. I feel a surge of tenderness for the artist's meticulous attention to the shape of a cliff, a shrub, a blossom, a turret, and a deep respect for the traditional Eastern notions of towering vertical perspective. The heights of the landscape have clearly been captured by the artists' eye and brush.

One day, I sat by the Songshan Lake Flower Sea, my pastels in two ArtBin cases at my feet. I was studying a bank of trees whose foliage merged into one big, abstract shape. The trunks twisted and turned, like trees I had seen in Chinese paintings. Beyond the trees, in the far distance, were tall grasses in shades of cool greens and blues.

Kathleen Dunn, *Stacks,* 2006, pastel on sanded paper, 10 x 13 inches (25.4 x 33 cm)

Using a limited palette of Rembrandt and Schmincke soft pastels, the artist created the smokestacks with deep ultramarine and burnt umber. The contrasts of the brilliantly hued smoke and the looming stacks are striking.

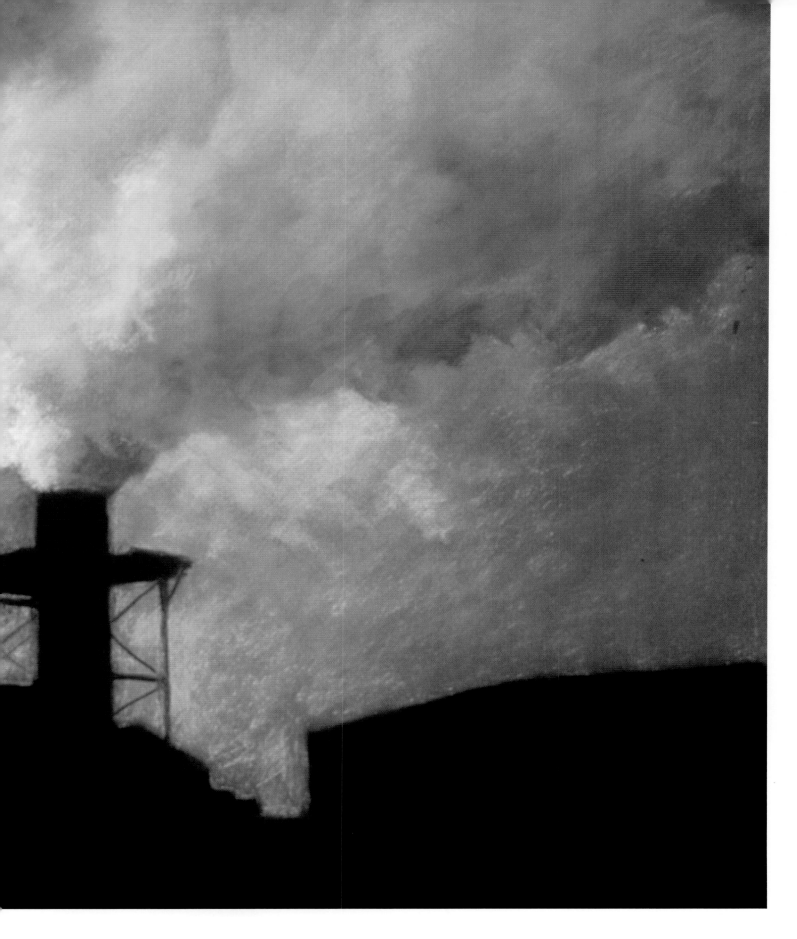

Elizabeth Mowry, *September's Wild Asters*, 2000, pastel on mounted sanded paper, 22 x 28 inches (55.9 x 71.1 cm)

The artist cultivated an ethereal atmosphere that suggests a memory, as much as it does an actual place. The recession of space is beautifully achieved.

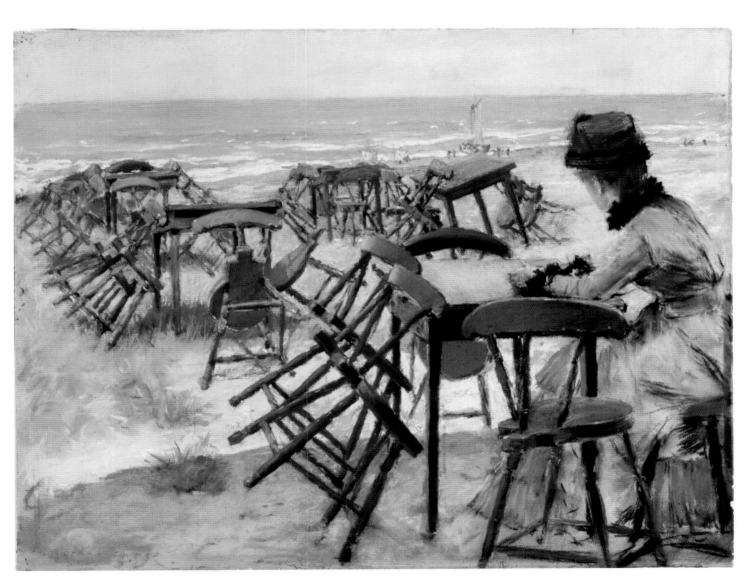

William Merritt Chase (American, 1849–1916), *The End of the Season,* c. 1885, pastel on paper, 14 x 18 inches (35.6 x 45.7 cm), collection of The Mount Holyoke College Art Museum, South Hadley, Massachusetts. Gift of Mrs. Dickie Bogle (Jeanette C. Dickie, Class of 1932), 1976.9

PHOTO CREDIT: LAURA SHEA

I detect a sense of whimsy in this painting. The woman, no longer dressed for the beach, possibly rather for her trip home, sits and glimpses the upending of her summer leisure. She will likely return next summer, as the tide in the distance will continually return. The angles of the furniture and shoreline add to the playfulness of the composition and echo the rhythms of the tide.

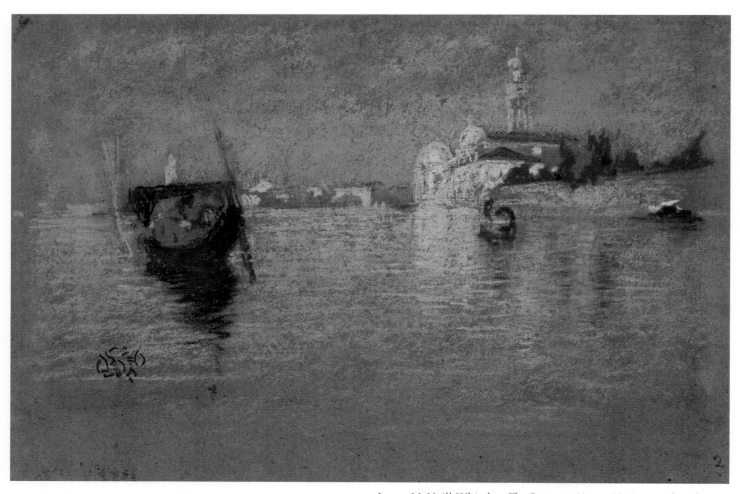

James McNeill Whistler, *The Cemetery: Venice,* 1879, pastel on brown
paper, 8 x 11⅞ inches (20.3 x 30.2 cm)
PHOTO CREDIT: COPYRIGHT © THE FRICK COLLECTION

Whistler maintained the surface of his brown paper throughout the pastel
paintings he created in Venice. This was a major break with the fashion-
able European approach, which favored more formal and heavily applied
pastel compositions.

It was fun to sit so far away from my subject and see masses of textures and patterns on a grand scale. I saw earth, trees, and sky in one glance. Picking up my pastel stick, composition and light were my first considerations. The landscape is without border, so where do I want to frame the scene? How much of the ground in front of the trees do I want? How much sky? This would determine where I place my horizon line. The character of the infinite light touched every element of the landscape, uniting the great variety of colors into tonal harmony. I noted that slender forms appeared lighter and grayer than larger ones, as light from behind wrapped around them, blurred their edges, and muted their color. The large darker forms received light, too, and luminosity was everywhere. Foliage closest to me appeared yellowy, while distant foliage was bluish.

As my Western eye beheld the Chinese landscape, my thoughts turned to the American artist James McNeill Whistler. He and so many artists of his time had been exposed to Japanese art. Whistler resided in Venice for fourteen months from 1879 to 1880. It was there, as he came upon the twisty canals and backstreets, that he began to develop landscapes that reveal the influence of Eastern landscape. Artists' travels have always impacted the direction of their work. This is particularly true in the genre of landscape, as artists are confronted with new land formations, indigenous plant life, qualities of light, and architectural traditions.

With a few brief exceptions, I have always lived in American cities, where land formations are obscured by the verticals and horizontals of architecture. I wondered, *If I stayed longer in China, would I begin to perceive space differently? Would some mountainous angles elbow my love of symmetry off to the side?* And then I wondered, *Are there influences hibernating inside me that would find expression should I venture into new genres?*

I turned my attention back to the vista. Clouds commanded their spaces in the sky, then drifted, transformed, and finally dissolved. The light, the feel of the air, and the sounds of insects and birds were different in the morning than in the afternoon. All of these elements penetrate the artist's sensory experience while painting a place in time. The landscape changes us.

Back home, in my studio, I feel as though I am in a cathedral of sorts—the harmonic current between subject and artist; the vaulted shapes of my walls and roofline; treetops and sky outside my windows; reproductions of paintings I worship dotting the walls. Outside my window is a sycamore tree. The balls that house the leaf seeds hang from zigzagging branches. They look to me like red lanterns suspended from plum blossom trees for the Chinese New Year. The light presents them in brilliant relief. Outside, there are no walls or ceiling at all. Outside, there is no division between heaven and earth.

the figure

When I was a little girl, my father had what was then called a dry goods store. It was located in a busy immigrant neighborhood on Staten Island, whose residents had emigrated from Italy, Ireland, Russia, and Poland. There was also a large African-American population. After school and on Saturdays, I lingered at the store and watched laborers and homemakers examine overalls and undergarments. They inspected the workmanship and checked the fabrics for strength. Many of the residents spoke little English, so I was unable to understand their conversations. I was so curious to know about their lives, but my only clues to their thoughts and feelings were to be found in their postures, gestures, facial expressions, and voices.

I studied their mostly stocky, occasionally thin, builds; their complexions were ruddy, dark, or translucently pale; some hands were rough and scarred and darkened from labor; others, smooth and immaculate. All the fingernails were short. Sometimes, there was a plain gold wedding band. They wore sturdy, unadorned clothing, headscarves, and sensible shoes. At the time I didn't think of it this way, but I was experiencing my introduction to my lifelong study of the human presence.

Sometimes the neighbors sat in chairs meant for measuring shoe size, just to converse with my father as best they could do together. With few words, they offered one another kindness. My father felt genuine affection for his neighbors. I remember him folding tissue paper with precision, to cushion selections of handkerchiefs or tiny blouses and socks for newborns, and curling ribbons around their gifts. I was learning a great deal about character. The neighborhood is long changed, but the memory of the people in the store remains with me still. My memories are of fascinating physiques and ordinary intimacies.

Albert Camus wrote, "A man's work is nothing but a slow trek to rediscover, through the detours of art, those two or three great and simple images in whose presence his heart first opened." I like to paint fascinating physiques, be it purely facial or bodily, too, and ordinary gestures. Fascinating physiques are everywhere, as are ordinary gestures. Perhaps I find the ordinary to be most revealing. I also gravitate to simple gestures because I so love portraiture, the countenance of the mind in thought, the source of all movement.

Harvey Dinnerstein, *Morning Light (Mani and Manisha)*, 1987, pastel on pumice board, 16½ x 27 inches (41.9 x 68.6 cm)

The artist concentrates the power of the forms by keeping them simple, thereby presenting the action with direct clarity. I love that the little foot and diaper are laid in roughly, enhancing the sense of airborne bouncing, while mother steadily holds her baby on her solid legs.

Of all the genres, the figure is the most difficult and potent subject, because of its physical and psychological complexities, and, of course, because it is us. The basic question that all artists, in all media, ask is, Who are we alone and in relation to others? Throughout art history, the nude figure has represented gods, balance, vulnerability, fertility, sensuality, sexuality, innocence, awkwardness, shame, glory, perfection, geometry, religion, war, loneliness, celebration, athleticism, heroicism, individuals, and mortality. The scope of the nude in art is as wide as human experience itself. While the nude often represents universal and time-less principles and characteristics, the clothed figure identifies the individual in a specific time and place. Memories of all our human experiences, and hopes for our potential, are stimulated through the evocation of the human form. A carefully observed and harmoniously simplified figure expresses and arouses the deepest of feeling and thought—the artist, subject, and viewer find communion.

Da Vinci and Degas advised that the body and face must con-tain the same expression. Throughout my attendance at the High School of Music and Art, I traveled to classes via the Staten Island ferry and the New York City subway system. The trip took more than two hours each way, and I had much opportunity to draw commuters as they read their newspapers, drank coffee, talked with friends, and dozed. I was very happy, filling my sketchbooks with studies of gestures and clothing. On the ferry I had thirty minutes, but on the subway I had to work quickly, because I never knew at what station my subject would depart. This kind of drawing forces the artist to take in only the most important masses and angles necessary to express proportion and gesture. It is also a lovely means of connection to the rhythms of one's cultural environment. It is an energizing practice.

Waiting rooms at train stations are great places to draw figures. You see single figures, and groups, of all ages; every build imaginable, their specifics made more remarkable by the con-trasts; you see fatigue, boredom, excitement, trepidation, antici-pation, attention, and reverie; luggage, musical instrument cases, portfolios, working dogs. People stand, sit, eat, read, dig for change, talk on phones. People lean in to push a stroller, lift one shoulder to support the weight of a package they have hoisted on to it, whistle while they saunter but not while they walk briskly, clutch themselves when they are cold, and spread their limbs when they are hot. There is much to learn at the train station about the body's movement, and expression of attitudes.

For a period of time in my teenage years, I drew figures whose heads had no features. If, in our portrayals of others, we reveal ourselves, what, I wonder, did my faceless figures mean? Cave paintings are rife with reductive figures topped with faceless heads, or no head at all, while the forceful animals are rendered with grace and precision. Why? What do these drawings say about the artists' self-perceptions?

A knowledge of anatomy is essential to the creation of a con-vincing figure capable of standing, sitting, walking, or reclining. Anthropologists tell us that the first element we see in a figure is gesture. Gesture runs through our bodies. The motion of one limb causes a succession of motion in other parts of the body. Earlier today I sat in a chair with both feet side by side on the floor. My hands were lightly clasped in my lap. I slid my right foot to the side of the chair, and behind me, on the floor. Only my toes touched the floor now. My right hip lifted, as did my left shoul-der. My hands separated and my right hand fell toward my thigh. My torso turned leftward, and my head slightly tilted to the right, in balance. All I had intended to do was move my foot, but a

Edgar Degas, *Waiting (L'Attente)*, circa 1882, pastel on paper, 19 x 24 inches (48.3 x 61 cm), collection of The J. Paul Getty Museum, Los Angeles, California, owned jointly with the Norton Simon Art Foundation, Pasadena, California, 83.GG.219

Degas loved all manner of movement, particularly the unrehearsed moments that occur between those that are choreographed. The silence between these two figures underlines the content described in the title. The Japanese influence on Degas is evident in the composition.

succession of motions followed in aftereffect. Acupuncturists and reflexologists know well how connected our entire bodily system is, and so must the figure painter. However, a knowledge of anatomy and the ability to create an expressive figure in a meaningful space are not synonymous. The artist must have a personal point of view that inherently guides the selection of subject and the selection of shapes by which we structure our figures.

I am about to embark on a painting of six people. Contextually, my first consideration is each individual personality. The next are the emotional attachments among them. Visually, the first consideration is composition, the interplay of six bodies, color, and light. I will have to choreograph twelve arms. The design of the light flesh of the faces and limbs against the dark clothing will have to be rhythmic and graceful. Forms will overlap, as do categories—there will be six individual portraits, and one group of figures. With such complex content, I have to be sure to maintain an all-embracing unity of design, to attain one rhythmic mass.

Ellen Eagle, *Lor*, 1999, pastel on pumice board, 12¹⁵⁄₁₆ x 9⅞ inches (31.3 x 25.1 cm)

Lor returns the viewer's searching look. While all figure and portrait paintings touch upon death, Lor's weight and facial expression say to me, ever so poignantly, *I'm here, and I'm not leaving.*

OPPOSITE:

Edmond François Aman-Jean (1860–1936), *Les Confidences,* c. 1898, pastel on paper mounted on canvas, 48¹⁄₁₆ x 38 inches (122 x 96.5 cm), collection of the Fine Arts Museums of San Francisco. Museum purchase, Mildred Anna Williams Collection, 1976.7

The daring composition divides the space into two halves of complementary colors. The light shapes of the figure in the upper right connect to the bench, which continues on to wrap around the figure in the lower left. This coupling transforms an otherwise static visual arrangement into a fluid space that is descriptive of the sharing of confidences.

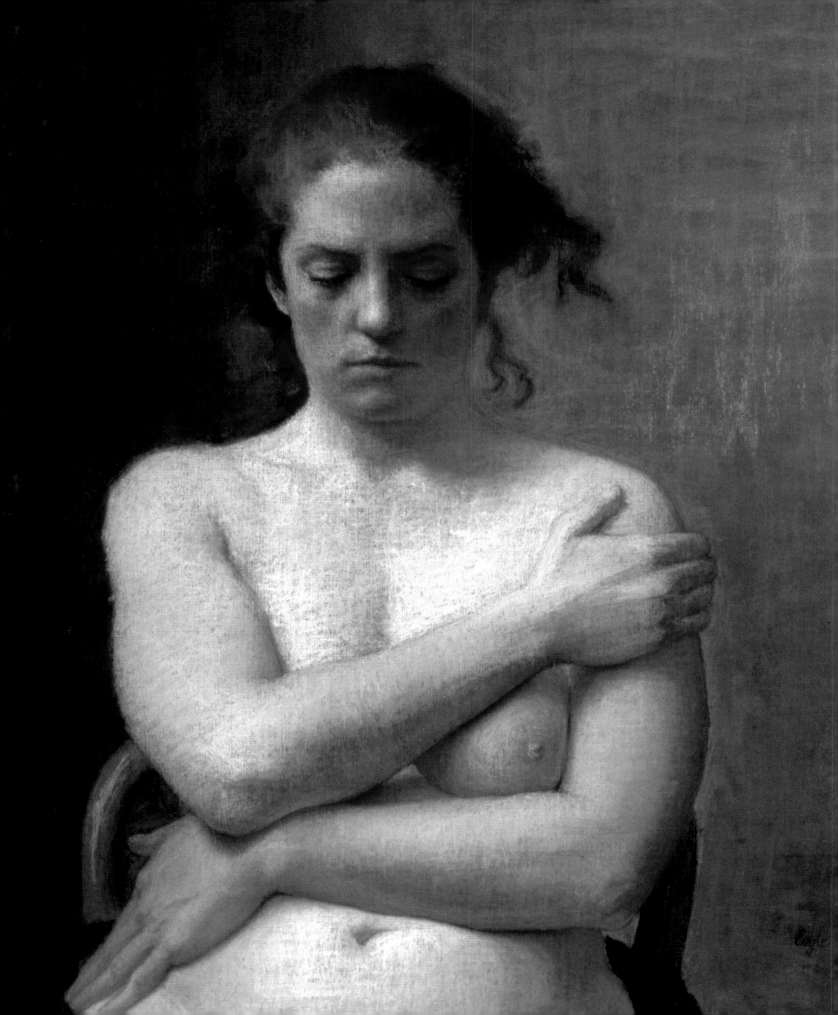

the working process

Ellen Eagle, *Nude with Eyes Lowered*, 2003, pastel on pumice board, 16½ x 15 inches (41.9 x 38.1 cm)

The character of this painting derives from the large pattern of dark and light, the composition. There is a great deal of energy in the gesture, but there is also a sense of stillness, which is due to the statuesque forms. The contrast of light on the torso and clutching arms and the lowered eyes in shadow beneath the turbulent hair are suggestive of concealment.

Throughout this book, I use the words *analyze, contemplate, investigate, explore.* We survey, we canvass the complexities of our subjects. There is so much to see. Where do we begin a painting? I want to help you to observe with a clear eye your subject's unique structure, color, and value relationships. The ultimate goal is to distill these intricacies into a simply expressed, harmonious construction. This goal is a constant. It transcends genre.

Throughout this chapter, I offer a sequence of considerations—from the first moments of careful looking at your subject to recognizing when your painting is complete. I suggest the building blocks of creating the image—ways to establish the vital bond between drawing and painting; to compare proportions in the service of synthesis; to establish gesture; to think about composition; to achieve solidity of form and unity of tone; to truly see, understand, and order shapes and colors; to apply pastel, both in the early stages and the later ones; to identify problems and correct missteps.

The ability to maintain an exploratory attitude is crucial to growing as an artist. Consequently, throughout this chapter I also share with you some of the wonderful questions that some of my students have raised as they search the possibilities of image making.

creating black-and-white tonal studies

I love to draw. The process of drawing is, for me, like waking from sleep. My eyes open, and slowly my surroundings come into focus. As I draw, the clarity with which I see magnifies. Angles, distances, and shapes crystallize. I experience connection and revelation. I become engrossed in looking.

I can't recall the last time I undertook to do a finished drawing, but I always precede my paintings with small black-and-white tonal studies. There are several benefits to doing so. The relatively quick study is where I record my purest, most immediate, and most direct response to the subject. It's a contemplative, joyful part of the painting process. I start by selecting the specific lines, shapes, and tones that strike me as the most structurally fundamental in my subject. Through this process I perceive and select visual harmonies and find my point of view for the painting.

In this initial stage, my goal is to abstract the subject, identifying the largest shapes of darks and lights that comprise the setup. In order to find these large shapes, I squint way down as I look at my subject. All the narrative detail fades away, leaving me with only a generalized arrangement of darks and lights. This pattern forms the structural undergirding of what will become my final painting. Squinting while drawing also helps strengthen my ability to perceive value relationships. The study is also where I become familiar with my subject's proportions, develop an understanding of the gesture, and seek out compositional possibilities for the painting—all of which will be discussed further in the sections that follow.

Ellen Eagle, *Assisi*, sketch, 2012, graphite on Strathmore 400 Series Drawing paper, 8 x 6 inches (20.32 x 15.24 cm)

I did this quick sketch in Assisi, Italy. My approach is precisely the same here, as in *Nude with Eyes Lowered*. No matter the genre, the goal in the sketch is to find the vitality of the most visually dominant construction forms and compositional harmony. Finding the harmony is exhilarating.

Ellen Eagle, *Nude with Eyes Lowered*, 2003, graphite on Strathmore 400 Series Drawing paper, 6 x 5½ inches (15.2 x 14 cm)

In this black-and-white tonal study, I had no need of individual fingers. I was looking purely at shapes of shadow and light. Where the fingers were in shadow, I submerged them into surrounding shadow areas, to create an underlying pattern for the painting, which can be seen on page 88.

SELECTING THE RIGHT **MEDIUM AND PAPER**

The black-and-white tonal study can be done in graphite or charcoal. If you have a tendency to be messy on the paper, I recommend graphite. If you have a tendency to tighten up or get into detail before you establish the relationships of the large forms, I recommend trying hard and medium vine charcoal. I like to do my drawings with graphite on Strathmore 400 Series Drawing paper. The paper has a nice weight, a slight texture, and a soft off-white color. Whichever medium and paper you choose, do not use newsprint. It has a weak character and readily breaks down.

I recommend beginning the drawing with a very light touch. You are exploring the forms and attitude of your subject. A light touch allows the hand to glide across the paper and address the entire form, creating an organic assemblage of lines.

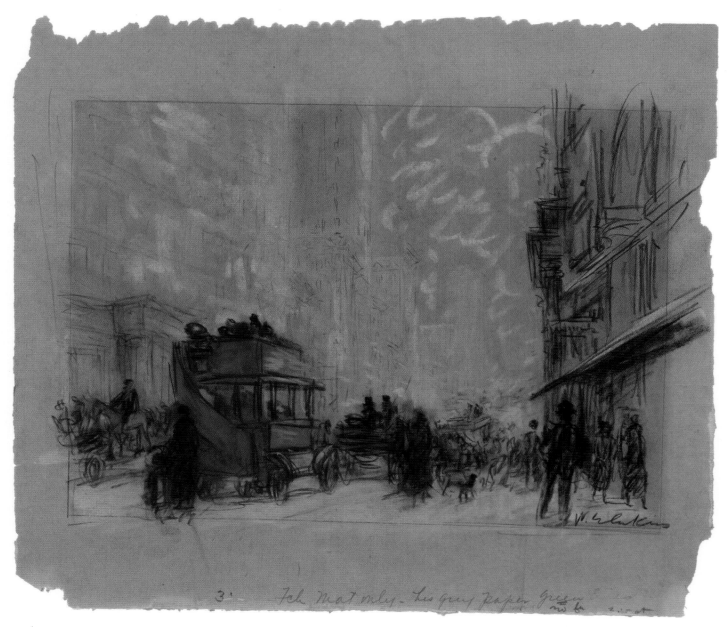

Ellen Eagle, *Mei-Chiao with Blue Ribbon*, 2002, graphite on Strathmore 400 Series Drawing paper, 6¼ x 5 inches (15.9 x 12.7 cm)

My black-and-white tonal study conveys my delight in the interplay of the dominant shapes—a series of triangles within the figure and the overall shape of the figure itself, as well as the background, because of the way in which the edges frame Mei-Chiao.

OPPOSITE:

William Glackens, *Bus, Fifth Avenue*, 1910, pastel on paper, 10⅝ x 12¼ inches (27 x 31.1 cm), collection of The Mead Art Museum of Amherst College, Amherst, Massachusetts, museum purchase, AC 1955.315

The artist's affection for the hustle and bustle of New York City is immediately apparent, particularly in the bus, which he ennobled in emerald green. Glackens's affinity for his materials is evident in the playful manner with which he applied the pastels. The paper itself provided the middle tones.

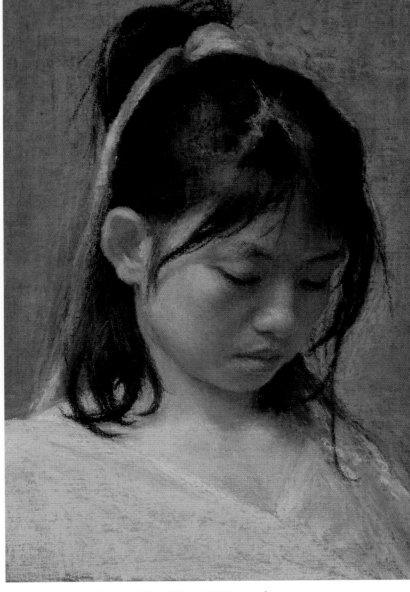

Ellen Eagle, *Mei-Chiao with Blue Ribbon*, 2002, pastel on pumice board, 8⅞ x 6¾ inches (22.5 x 17.1 cm)

The inward gesture of head to chest was beautiful to me, and the backward pull of the shoulders is balanced by the triangular opening blouse neckline. All the design elements I saw in the drawing were cohesive. In the painting, I maintained my initial motivation.

"I have the urge to paint but I don't know what I want to paint. By the time I graduated my significant program in art school, I was sick of the figure. What can a figurative artist do to nurture the artistic voice? How can I identify what is important to me?"

I wonder if you haven't had the opportunity to devote as much time to yourself as is necessary, past your formal training, to find your singular voice. Leaving the communal goals of a classroom and entering into solitude can be a shock, but solitude is essential to gaining insight into ourselves. It's important to paint alone, and to go to museums alone. Linger in front of paintings and sculpture, drawings and prints, artifacts of ancient histories. Which works of art resonate for you with pure emotion?

Expose yourself to the greatest works of art across fields: literature, dance, science, drama, natural formations. Stimulations and lessons are everywhere. Look at works from cultures other than your own. Do you begin to notice common threads running through the works to which you respond? And those you don't care for?

What fascinated you as a child, before textbooks, lecturers (and I) advised what is "important"? What paintings and drawings took your breath away? What other situations took your breath away? What, in your world, did you love to look at? What did you love to do?

When I was a little girl I sat cross-legged for hours on the floor by the living room bookcase. I was captivated by the reproductions of paintings and sculptures in my parents' art books. Most of all, I loved portraits. I was fascinated not only by the images themselves but by the power of the images to effect specific feelings in a viewer. The portraits in which the shapes and colors were greatly exaggerated, and so were unlike anyone I had ever seen, felt remote and untrue; those that seemed coldly perfect had the same effect. What was going on? I didn't have the vocabulary at that age to describe my feelings, but now I understand that the paintings I liked were those in which emotion and form bolstered each other. They felt complete to me. The ones I did not like were those in which emotion snuffed out the form or vice versa. Becoming aware of my likes and dislikes, through exposure and comparison, surely helped clarify my own direction.

It is possible that you are feeling overwhelmed by the notion of having to make a commitment to "important projects" of a specific style. I recommend that you carry a sketchbook so that if something catches your eye, you can draw it with spontaneity. Something unexpected may light you up—abstract shapes, a combination of colors, a posture, an interaction, a piece of music, a conversation overheard, a newspaper article. Be open and eager, not cautious. Don't press yourself to fulfill someone else's criteria. Value your own interests. They belong to you. It is impossible to foresee where they will lead you.

Don't evaluate with your intellect in the beginning of an idea or project. So much of the process is intuitive. If you shut off an idea that feels right because you fear it will be judged by others, you will never give yourself the chance to develop your unique viewpoint. This is not to say that every idea will stand up to your subsequent evaluation, but understanding why something doesn't work is invaluable to our development and understanding of our own priorities. Those understandings yield our next steps.

It is imperative to work with consistency, because long-term relationships reveal the complexities of our feelings and build our technical strengths. I am remembering countless movie scenes in which a prisoner chips away at a wall, a fragment at a time, before opening up a pathway out, into the light. In your case, you are opening up a pathway in, to your sensibilities, your light. You are mining areas you have not been to in a long time. The process can't be rushed and it has to be nurtured with hunger and patience. Your interests will evolve. What motivates you for some period of time will naturally lead to new discoveries and pursuits. I love E. M. Forster's phrase "Only Connect."

Ellen Eagle, *The Elements of Portraiture*, 2002, pastel on pumice board, 8 x 5⅞ inches (20.32 x 12.7 cm)
The painting is of me and my skeleton. As I do in all my subjects, I loved studying the light and color as they washed across the skeleton's forms. The elements of portraiture are form and feeling.

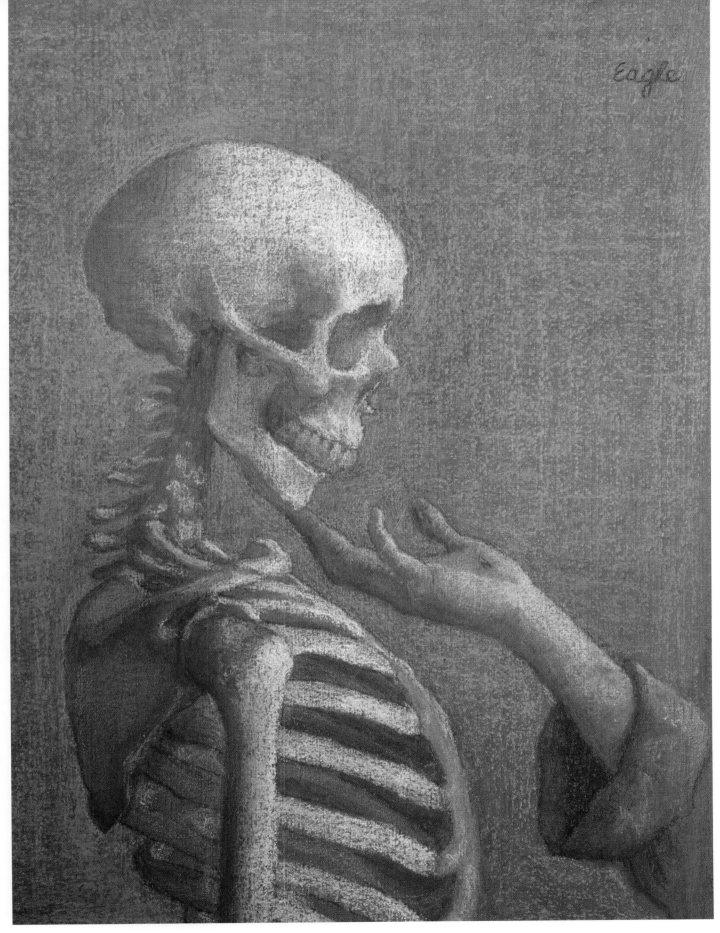

establishing proportion

I recommend drawing initially without formal methods of measurement. Jump in. Squint and compare one abstract shape in your subject to another by comparing distances of length and width and angles. Do your best to re-create the shapes on your paper. Put into your drawing only what you see when you squint. After drawing, using just sight, formally measure and compare the proportions in the subject to the proportions in your drawing. Eventually the process of using pure sight and following it with formal measurement will point out to you what you do very well naturally and where you have difficulties. These discoveries about your eye will help you to improve in a way that purely formal measurement cannot.

To formally measure proportion, most artists select a unit within the subject and compare all other parts to that base unit. In the human being, the unit is usually the length of the head. A time-honored method of measuring the proportion is to hold your pencil vertically with your arm fully outstretched straight ahead in front of your eyes. Keep your arm steady. Close one eye. If your subject is a person, align the tip of the pencil with the top of your model's head and place your thumb on the pencil to align with the base of the chin. Without moving the position of your thumb, lower your arm so that the tip of the pencil aligns with the chin. With what point on the body does your thumb now align? You have thus located two equivalent units. Without changing the position of your thumb on the pencil, repeat this all the way down the model, as far as you intend to include in your painting.

To find widths, again measure against the unit of the head length. With outstretched, steady arm, align the tip of the pencil with the top of the head and place your thumb on the pencil so that it aligns with the chin. Now turn your pencil from the vertical to the horizontal. How many times can you move that unit of pencil length across the body, shoulder to shoulder? Are, say, the shoulders equivalent to two head heights? Not quite? As you develop the figure, you will have more and more units to compare with one another. Then use the pencil measure in the same manner in your drawing. Do the units in the drawing correspond to the units in the model?

The size of the units you draw (for example, four inches for the head) does not have to mathematically equate to the actual figure. In other words, the proportions within your figure drawing (or any subject) are based upon the proportions in the actual subject, but there is no mathematical formula for translating the observed subject to the drawing. The size of the units in your drawing are determined by the size you want your drawing to be.

Holding up a pencil as a plumb line is also very helpful in attaining proportional accuracy. Again, holding your arm straight ahead, align the edge of your vertical pencil against any given feature. Glide your gaze down the edge of the pencil, noting what other features of the body touch the pencil edge. A horizontal plumb line is equally helpful in locating spatial relationships left to right, such as bottom of ear to base of nose; top of ear to eyebrow; corner of mouth to corner of jaw; armpit to swell of the deltoid muscle; and so forth. As one of my students pointed out, "It's like imagining a grid."

To help with proportional accuracy, I also visualize imaginary "intersection" lines. For example, if the angle of the inner section of the eyebrow in *Young Man in Profile* (opposite) continued, where on the back of the head would it intersect? If the little fold of skin at the corner of the mouth continued, where on the forehead would it intersect?

Ellen Eagle, *Young Man in Profile,* 2003, graphite on Strathmore 400 Series Drawing paper, 7⅜ x 7¼ inches (18.7 x 10.8 cm)
A horizontal construction line from neck to back of shoulder told me how far down the turn of the shoulder occurred. It also established the shelf-like form of the top of the shoulder. I compared the many angles in the head to help establish the likeness.

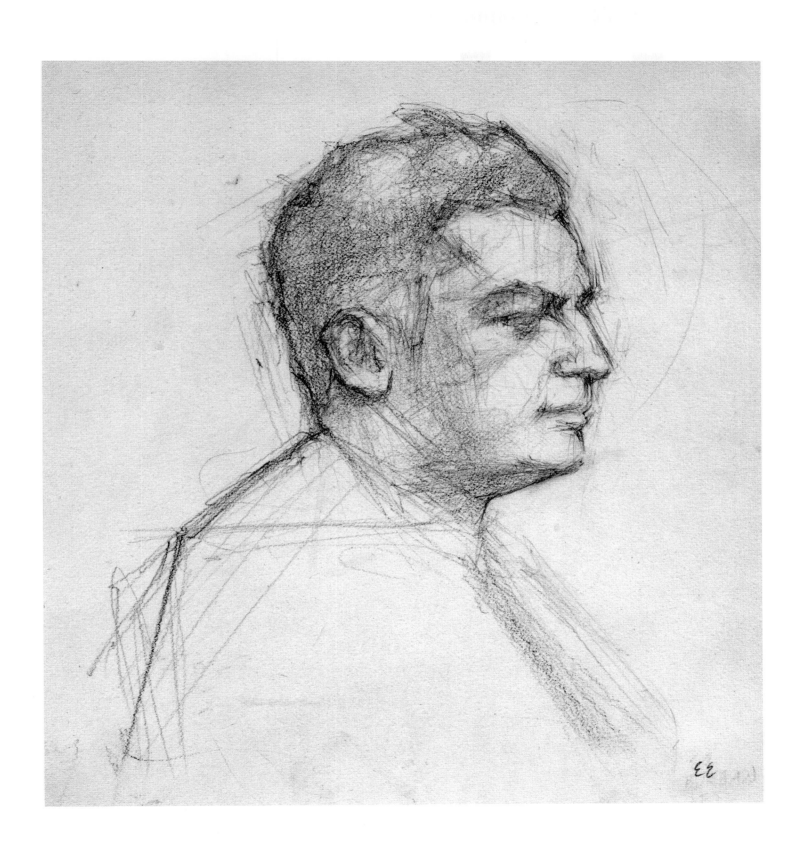

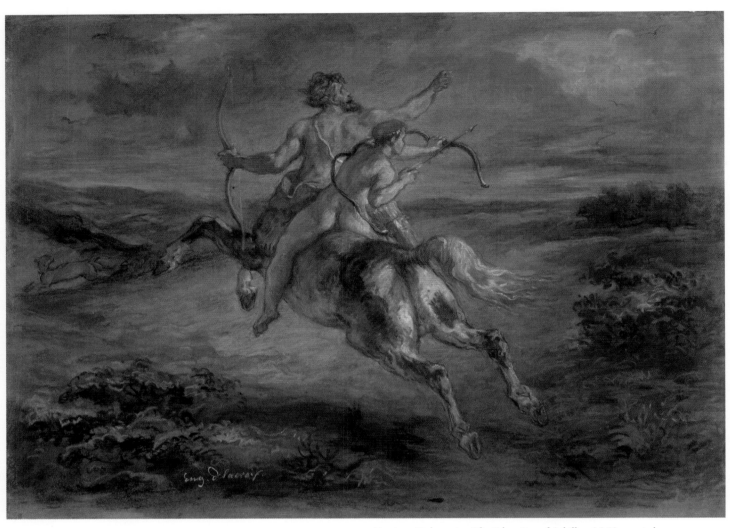

Eugène Delacroix, *The Education of Achilles,* 1862, pastel on paper, 12 1/16 x 16 1/2 inches (30.6 x 41.9 cm), collection of The J. Paul Getty Museum, Los Angeles, California, 86.GG.728

Delacroix originally created this mythological image in fresco form as one of a series of twenty for the Palais Bourbon Library in Paris. The gestures differ slightly between the two, and he made significant changes to the background. This pastel was done as a gift to his friend the writer Amandine-Aurore-Lucie Dupin, who published under the pseudonym George Sand.

capturing gesture

To understand gesture, you have to compare angles. To *really* understand gesture, you must understand anatomy. We exist from the inside out. Without knowledge of what is going on beneath the surface, it is not possible to understand and translate the dynamics of movement. Knowing *what* to observe on the surface is seriously compromised without some degree of anatomical knowledge.

Knowing anatomy allows us to grasp the minute information of the body. Along with the artist's feeling, at the bottom of every successful representational painting is sound drawing. Anatomical accuracy is not the same as good drawing. The ability to see, select, and unify shapes comprises good drawing. But we have to understand what to select *from*. If an anatomy class is not available to you, there are many excellent books on the subject. Richard Peck's *Atlas of Human Anatomy* (Oxford University Press) and Dr. Paul Richer's *Artistic Anatomy* (Watson-Guptill Publications) stand out. Engaging in anatomically oriented sculpture is also a great help toward understanding volume.

Angles can be challenging to pin down when they are not perfectly vertical or horizontal. Holding up a vertical or horizontal pencil to the angle you are trying to understand and comparing the two is helpful. You can also "mimic" the angle by tipping your outstretched pencil to the angle you see in the subject, and then, maintaining the pencil's angle, bringing it back to your canvas and drawing your line. As in all other considerations, compare one angle to another.

If you are doing a profile, for instance, compare the angle of the nose to those of the forehead, chin, neckline, back of head, upper and lower eyelids, lips, chest, ears, and so forth. Also imagine a line from the tip of the nose to the front of the chin. Note the angle of that imaginary line. Lightly sketch it in. Choose additional points and do the same. Don't run from point to point without looking back. No marks can be made without considering the location on paper of those you made before. Keep your eye moving all over your subject and your drawing so that what you are recording at any given moment is accurately in relation to the lines you have already drawn.

However, a great deal of refinement and adjustment is necessary from beginning to end of the drawing and painting process. In fact, I love to see the first, light, searching, construction lines in great drawings—the artist's excitement and pathway into the form remain visible. The living experience of the artist is there on the paper. All the lines are records of sincere search, and they are placed deliberately.

STUDENT INQUIRY

"When I start my picture, should I have an idea of how I want it to look when it is finished?"

This question addresses encounter, perception, and translation—the genesis of image making.

Often, from the first moments with my subject, I see a core design that supports and animates the entirety of the form and gesture. The arrangement that an artist sees is borne from the feeling that the subject stimulates in the artist. When my feelings are very strong, the design is crystal clear to me, and it is then not uncommon for me to envision the seeds of my painting before I pick up a pencil.

Once we do pick up our pencils, and progress through our study, our perceptions evolve. Sometimes, little-noticed qualities impress us anew. As we see our shapes forming on the canvas, our conversation with the whole process of perception and translation is made that much more complex: We are now not only trying to understand the form, color, light, and spirit; we are judging whether or not our picture verifies the way we see her, and if not, why not. Our paintings go through stages of harmony and disharmony as we search through the complexity of our subject bringing forth our own personal path of discovery and communion. Meaningful, powerful images that touch upon something deep within come from exactly that place—deep within.

When you are first learning, paintings can seem to morph in ways that feel beyond your grasp, and they can end up looking nothing like what you want to say about your subject. But it will get better, and you will find your way.

When you begin a painting you need to have some idea of what you want it to look like, because that guides your constructive steps. But the idea develops during the process of building the painting. Just as you remove the marks that you don't want, you will build upon those that feel right.

Your paintings are inside you. Open yourself to what you see in your subject. Your personal paintings will emerge, and you will see yourself in the images you create.

STUDENT INQUIRY

"I showed my painting to some friends and they said the model's Adam's apple was too pronounced for a woman. When I came into class this morning, I tried to de-emphasize the Adam's apple, but I feel really uncomfortable about doing that. It feels dishonest. I don't know how to feel about my friends' comments."

Artists are always editing. When the artist selects a pose, and a background color, and clothing, and the angle from which they want to paint, they are, in a sense, editing. And of course, we are not cameras. We extract the information we need to express our response to the subject. But your friends' comments suggest edits of a different nature, and they strike me as misguided and even cruel to the model. I empathize with your discomfort.

Who are we to say what someone's neck or arm or toe should look like? In fact, why look at a painting at all, if we already know what everything looks like? Your model is a physically beautifully strong woman who is heroically maintaining a difficult gesture that emphasizes that area of the neck. To play it down would be to disrespect and miss the strength, generosity, grace, and beauty of the model. Her neck is a perfect match to her thigh, to her foot, to her shoulders. The artist has to know what his or her purpose is in painting. I like paintings created out of awe and gratitude.

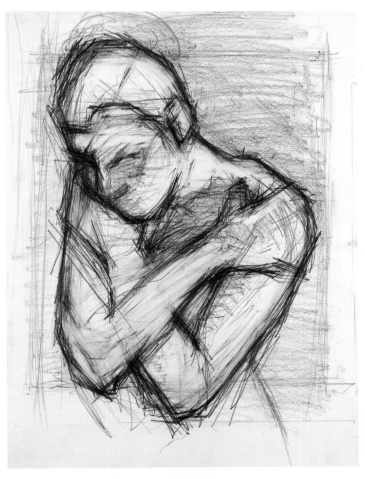

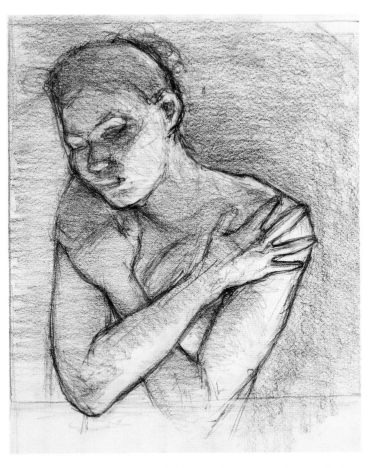

Ellen Eagle, *Gesture Study Two*, 2002, graphite on Strathmore Series 400 Drawing paper, 12 x 9 inches (30.5 x 22.9 cm)

In the second study, my interests expanded into planes, which I explored via light and shadow. By lifting the angle of the head, I altered the intensity of the gesture.

Ellen Eagle, *Gesture Study One*, 2002, graphite on Strathmore 400 Series Drawing paper, 12 x 9 inches (30.5 x 22.9 cm)

I was interested in evoking a body folded into itself and leaning into a wall. In developing the image, I compared all the main angles. Although I did this study several years ago, I can still remember pressing down into the lines, as I responded to the forceful diagonals.

OPPOSITE:

Ellen Eagle, *Gesture Study Three*, 2002, graphite on Strathmore Series 400 Drawing paper, 8¼ x 4¾ inches (21 x 12.1 cm)

In comparing this study to my painting, *Nude*, which is of the same model and which appears on page 129, two similarities come to mind. Both gestures have elements of symmetry and asymmetry, which impart a sense of lifelike flow of motion to the figures. Also, both figures lean forward and look inward.

articulating composition

Composition is inevitable, whether you pay attention to it or don't. In addition to looking at the shapes within your subject, you are relating them to the space around him, her, or it, and imagining how those shapes will look framed by the edges of the canvas or paper. This does not mean that you have to resolve all parts of the painting to the same degree in the end, but all the parts have to be considered, have to be included in your idea and plan. At the same time that you have to think about the whole from the start, remain open to changing direction if a superior option presents itself along the way. The Metropolitan Museum of Art has numerous Edgar Degas pastel paintings the dimensions of which he expanded by adhering additional sheets to his primary support. Maurice-Quentin de La Tour never hesitated to collage his pastel paintings. I would imagine Degas cut down as often as he added, as his excitement changed course.

The amount of space around the figure, or any subject, plays a huge role in the impact of the figure. A great deal of space around a figure might suggest a fragile, perhaps lost, person—one not in control. Very little space might suggest a powerful presence. In *My Portrait of Julie,* shown on page 58, I wanted to convey her warm engagement, so I brought her all the way to the fore.

Scale, too, is a major element. Some people feel a small scale is intimate. Other viewers feel it is hard to enter into a small painting; they prefer the experience of a large painting, one that almost surrounds them, so they feel closer to it.

For the past several years, I have done the great majority of my paintings on a small scale. I like to hold my paintings in my hands. Perhaps this relates to my first experiences of seeing paintings: sitting on the floor, cradling art books in my lap. Or perhaps it is an intrinsic extension of wanting to give care to the people I paint. An unanticipated reward to me is seeing people standing as close to the works to view them as I do to create them.

If you are not sure how you want to compose your painting, draw borders at different distances from the subject until all the shapes, corner to corner, are harmonious. Many artists find it helpful to use what is called a viewfinder. I make my viewfinders by simply cutting two L-shaped pieces from light gray foam core or mat board. Hold them as a frame, overlapping the Ls in different proportions to create different formats—horizontal, square, vertical—while looking at your subject. Another vehicle is to turn your back to your subject and your drawing (and painting) and look at them together in a mirror. The mirror enables you to see the subject and drawing as though you had never seen them before. The fresh view beautifully points out drawing errors and compositional imbalances. Turn the drawing upside down and look at it from a distance. The drawing transforms into a purely abstract design separate and apart from subject matter and clarifies if the arrangement of shapes is pleasing to you.

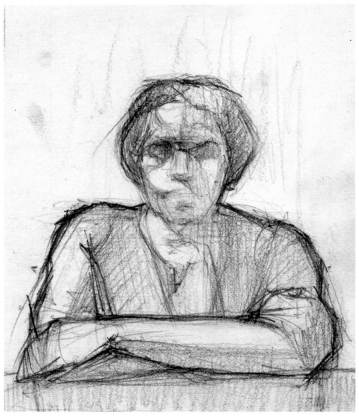

Ellen Eagle, *Donna,* 2002, graphite on Strathmore 400 Series Drawing paper, 6 x 4½ inches (15.2 x 11.4 cm)

My black-and-white tonal study is an assemblage of abstract shapes. As I looked at the drawing's composition, I was unhappy that the table imparted a formality and distance that I did not want, so I eliminated it, and the front arm, for the painting.

OPPOSITE:

Ellen Eagle, *Donna,* 2002, pastel on pumice board, 7¼ x 7½ inches (18.4 x 19 cm)

Now that I was including one hand only, I underlined the asymmetry by bringing the frame closer to the model and cropping the arms differently. As the model sat, gravity pulled her chin down a little. This change served the less formalized feel that I wanted, so I selected that aspect of the gesture.

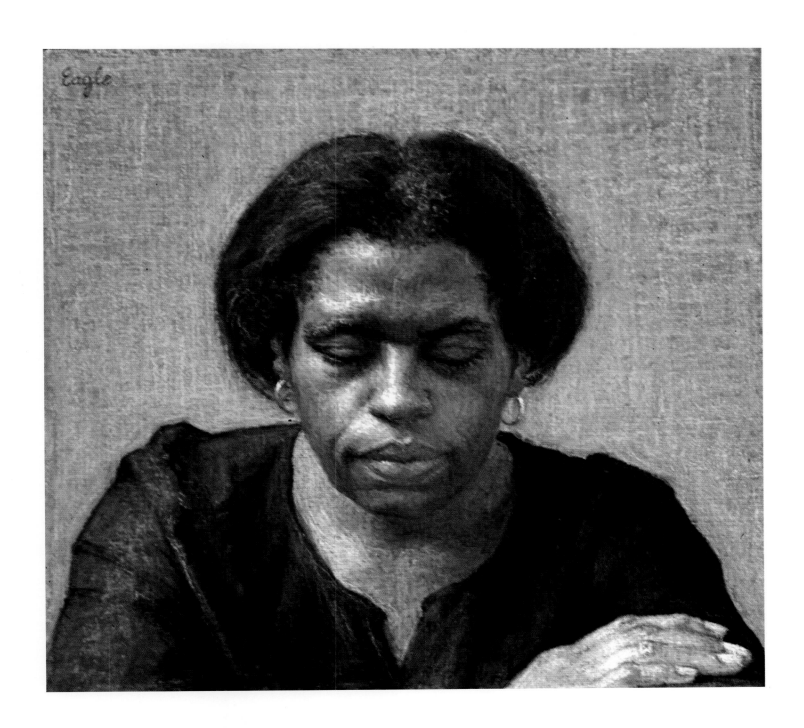

remembering that first impression

While I paint, the thumbnail sketch, as these small, black-and-white tonal studies are often called, continues to work for me. I often keep it with me as I paint. It serves as a reminder of my first impressions of my subject. It is easy to lose our way as we delve deeper and deeper into our painting, having to coalesce more and more information. Sometimes momentary fascinations distract us and lead us to create confusion in the painting. Looking now and again at the sketch can reunite you with your first excitement and guide you as you proceed along your path of ever-deepening investigation.

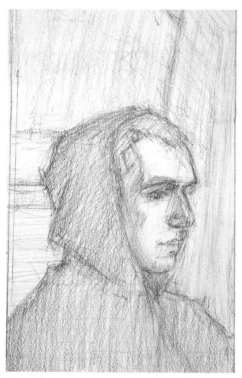

Anastasio in Crimson Cloak, sketch

I wanted to focus solely on Anastasio's facial features, so I asked him to bring a sweatshirt with a hood. When he put it on, the appearance brought to mind the robes worn by members of some religious orders. I placed Anastasio beneath a cathedral-like arch in the studio and arranged the strings of the hood to syncopate with the angles of the architecture.

RIGHT:

Anastasio in Crimson Cloak, 2011, pastel on pumice board, 9½ x 4½ inches (24.13 x 11.43 cm)

Because the red is so prominent, my first color move was to seek out and establish the relationship between Anastasio's fair flesh tones and the muted background colors. Throughout the course of creating the image, I was focused on the movement of the cheekbone shapes into the temporal bone, upward into the arch. Anastasio's slightly sideways and downturned gaze anchors all the movement to a central focus.

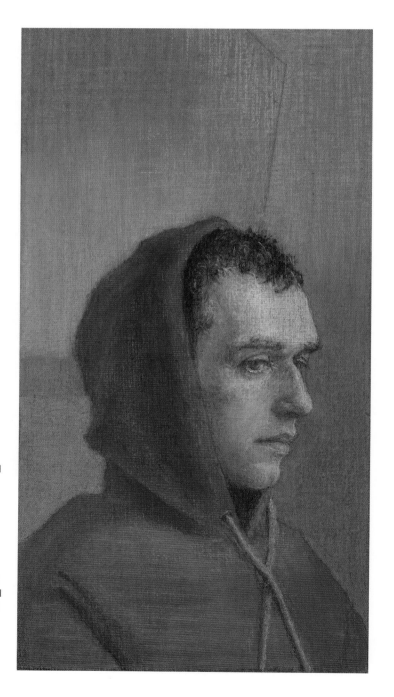

Ellen Eagle, *Miss Leonard in Profile,* 2011, graphite on Strathmore 400 Series Drawing paper, 6⅜ x 6 inches (16.2 x 15.2 cm)

The strength of the sculptural forms and pattern of light are primary in the geometric drawing. They form the foundation of the painting.

Ellen Eagle, *Miss Leonard in Profile,* 2011, pastel on pumice board, 6½ x 5¾ inches (16.5 x 14.6 cm)

As I developed the incremental color and value shifts of the light, I maintained my infatuation with the architectural forms and primary geometric design.

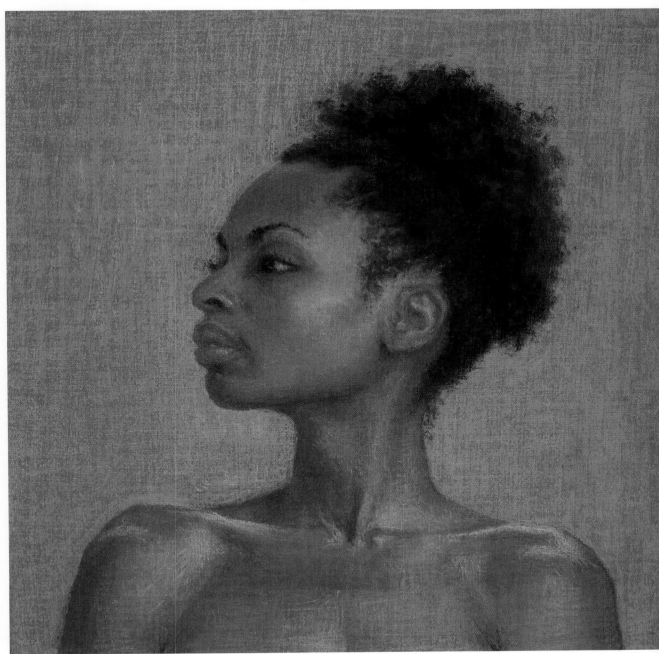

perceiving color

Color theory was not offered in my art school curriculum. And I never pursued it outside of class, beyond occasionally flipping through a book here and there. For a while, I worried that I had insufficient education. But I now find nothing more reassuring than knowing that my eye is my strongest tool. I believe in, and love, what happens at the easel. My work is experiential, not theory based, in terms of technique. My thinking happens on my paper.

Color is made of three components: hue, value, and temperature. Hue is the name we call a color: ocher, red, green, and so forth. Value refers to the color's degree of dark and light. A hue can come in any value, which is determined by how much black or white is added to the pure pigment. In a black-and-white reproduction of a full-color painting, the colors are translated into a range of grays. The grays correlate to the value, the relative degrees of dark and light, of the hues.

Temperature refers to warm and cool. Warm colors contain yellow, cool colors contain blue. Look into your box of pastels and see how clearly some colors are yellowish, others bluish. Even the grays are warm and cool. It is easier to see the differences among the grays by stroking their color onto paper than it is to see them in the sticks themselves. Combining a warm and a cool in equal amounts creates a neutral.

Nature's light bestows value and temperature on all form. If you are working indoors in natural light, in general, the planes that face away from the light and areas receiving cast shadows (in other words, all shadow areas) will be darker and warmer than the planes that face the light source. The planes that face the light source will be lighter and cooler than the shadow areas. However, subtle cool colors are interspersed throughout predominantly warm planes, and subtle warm colors are interspersed throughout predominantly cool areas. There are many components of color in any given area. Despite this, planes have dominant temperatures.

As an exercise to help you understand how colors, and strokes of pastel, impact each other, select a single stick and, on a gray support, make about ten squares with that color, using equal amounts of pressure so that you are creating the same tone in all the squares. Then choose ten different colors and lay them on top of each of the ten close-to-identical squares you initially created. Compare the resulting tones. Do this any number of times with any number of pastels, using a light touch, a medium pressure, and a heavier pressure, being careful not to go so heavy as to break the sticks.

STUDENT INQUIRY

"Should a painting include a full tonal range, from highlights (which if converted into a black-and-white scale would correspond to white) to the very dark darks (which would correspond to black), or is it a matter of choice? Can the tonal range be limited, or moved to one side of the tonal scale or to the opposite side?"

A painting should contain only the tones that represent the artist's perception of the subject. Compare the paintings of Caravaggio and those of Mary Cassatt. The tones are determined by the story the artist tells. Caravaggio used a full range of tones to convey his full-bodied, sometimes violent dramas, with danger lurking in the shadows. Mary Cassatt's high-toned paintings convey the gentle touch of intimacy. If Caravaggio's paintings are operas, perhaps Cassatt's are symphonies.

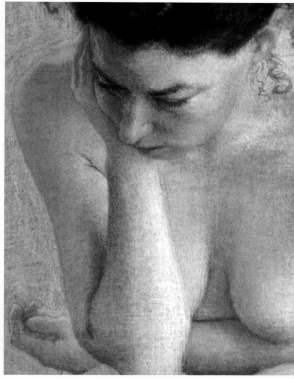

Ellen Eagle, *Nude* (detail), 2002, pastel on pumice board, 31½ x 13 inches (80 x 33 cm)

The full painting can be seen on page 129. Each color in this detail possesses a value, meaning a degree of dark or light on a scale of gray. The fullest possible value range, far wider than those possessed by the colors in this painting, begins with black, the darkest, and goes to white, the lightest.

Looking at the same picture translated into a black-and-white reproduction, you will see the range of the colors' values translated into shades of gray. Squinting when you look at the live model can help you to clarify the relative values of the colors in your subject.

STUDENT INQUIRY

"When I look at some pastel paintings, I often cringe from the jarring colors and combinations that, I assume, are inspired by color theory. The brightness pokes in the eye with greater force than those in oil paintings. Should the brightness be celebrated and monopolized on or does it require caution and discriminate handling?"

I am in love with color, especially when it is barely there. My color is always subordinate to value. Usually, a painting done in a range of restrained tones is more pleasing to my aesthetic than one done in bright colors. This is not a hard-and-fast fact, though. It depends upon the artist's intent and handling. Odilon Redon painted works of a Symbolist nature, and his color was appropriate to his vision. But I am a realist, mostly figurative painter.

Fire is bright. Autumn leaves are bright. Explosions are bright. Motorcycle headlights are bright. I need sunglasses when snow covers the ground. But flesh is quiet. Even if the sitter has warm flesh tones, cools are in there as well, and the transitions and range of values are subtle. I select the colors I believe I need for my particular subject. I do not care for color in paintings that is not recognizable as what I see in my world.

In a successful painting, the colors are well balanced and work together, be they loud or quiet. Within a single painting, if all the colors are unrestrained, they run the risk of drowning each other out. Something needs to be quiet in order for intensity to register as intense within the range of the painting. If all the colors are pale, perhaps the painting will look weak. Effective contrasts are important. Remember that everything works—or doesn't—in relation to everything else. In a painting done in tones of close values, a touch of dark will register more noticeably than if the same tone appears within a painting made of a broader range of values. Even paintings done in all gray contain warm grays and cool grays. Contrasts are crucial. I am hearing in my memory, now, the very affecting, quiet tones of Gregorian chants.

Yes, some paintings are certainly influenced by color theory, rather than by the observation of nature. I did not study color theory. I am sure it is a good idea to do so if one wishes to create paintings out of imagination. My color theory comes in the form of the person and environment in light that I am studying. In order to avoid overdoing the color, we have to vigilantly seek the nuances of color that exist throughout nature and be very aware of the quality of light. We have to observe the ways in which colors impact the appearance of other colors.

Complementary colors intensify each other's appearances. Similar colors tone the impact down. If your color gets too bright, look with acuity into the subject for subtleties that you have missed within the main color statement. If you are working with bright color, it is wise to pay great attention to value relationships so that you maintain order. The intense hues will then have a correcting anchor.

Ellen Eagle, *Rosangela*, 2001, pastel on pumice board, 16¼ x 10 inches (41.3 x 25.4 cm)

In Rosangela's flesh, I saw warm yellow-greens comingling with touches of cool violets and pinks. The planes that faced the light contained cool pinks, blues, and grays. Warm tones ran throughout the flesh. Warm, dark burnt siennas defined the depths of her eye sockets. Where the orange dress caught the light, the color took on a cool temperature. The weight of her clasped hands pulled the dress inward, causing a slight angle away from the light, and the cooler tones gave way to warmer ones.

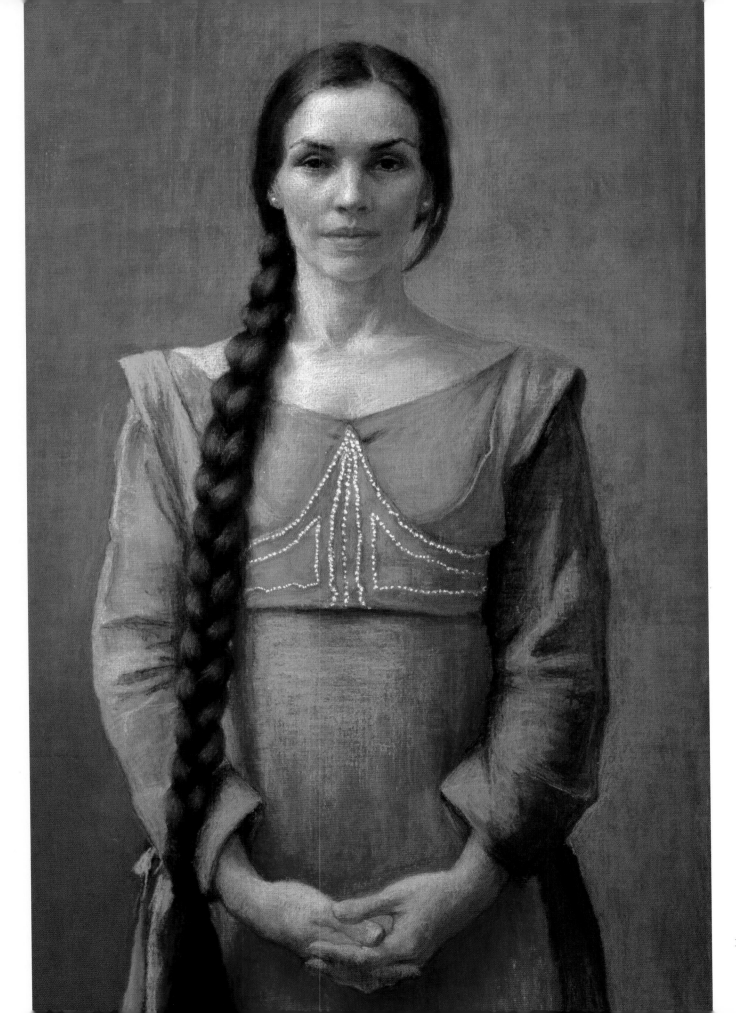

applying pastel

My approach to applying pastel is straightforward. I make all my strokes toward one goal—to create, in as simple an expression as possible, a representation of what I see. Whenever I am working, I am aware that I am the only one in the world seeing this subject, in this moment, in this spot on earth, in this light. I want to tell what I see. My feelings inform my strokes.

In building my paintings, I apply my first strokes lightly and space them airily. I hold the hard stick at the base so that the tip just grazes the surface. I stand a distance from the easel so my arm is almost straight. Later on, when I want to make heavier marks, I hold the stick more toward the center. The harder one presses with a pastel stick, the more it gives of itself. On my middle-tone boards, a light stick registers lighter when applied with more pressure, a dark, darker. In the early stages, I use both the tip and the side of the soft pastel, depending upon how much area I need to cover. I layer and weave colors from the start of the painting, intermixing my Rembrandts and Nupastels throughout. Later on, as the surface becomes more saturated with pastel, I am able to add softer sticks. A very light color massed in beneath a very dark color washes out the dark on top, robbing it of its intensity. Therefore, if I require numerous colors in one spot, I begin with the darkest and work toward the lighter ones. But I have found that making incremental changes from light to dark in one area is not problematic.

I work with an exploratory attitude throughout the development of the painting, especially in the beginning stages. My light application is consistent with this attitude. Rather than declaring a platform, I am inquiring, thinking, *Is this what I see?* The light application serves well my love of slow, sustained study, because I do not fill the tooth of the paper before I have fully inquired into my subject with layers and layers of color.

My strokes go every which way. It's not that I want to be messy, but my stroke is animated by my response to whatever area I am working on. One subject might summon faster, craggier strokes; another, more silken ones. Sometimes my strokes need to go in a direction that is physically difficult to do. At these times I turn the canvas sideways or whatever direction is called for, so that my natural motion records the strokes in the direction I need them to be.

When I have to cover a large area, I hope to find the color I need in a soft pastel, so that I can use the side of the stick to mass in. There are both broad masses of color, and thin, threadlike strokes within all my paintings. If I need to eliminate texture from an area, I gently smooth the strokes with my fingertip, but I do this sparingly and with light pressure. A pastel painting that has been rubbed through much of the painting can look either overly velvety or muddy, which is antithetical to the brilliant powdery body of our pigment. However, as evidenced in the works of Anton Raphael Mengs, smoothing pastel throughout the canvas, corner to corner, can generate breathtaking effects. If I need to remove texture from a tiny spot, I use a *torchillon,* but sometimes this lifts the pigment, rather than smoothes it.

By the time my paintings are finished, strokes and masses are visible everywhere. Strokes interweaving, sitting on top of masses, mass meeting mass. My goal is that the strokes and masses fuse together to create naturalistic form and value when seen from a distance.

The pressure with which we apply our strokes has everything to do with the character of the marks we make. It is important to keep our working hand from alighting into our surface, depositing oils into and smudging our work. Many artists use mahlsticks, a long wooden stick with padding at the tip, to steady their working hand and keep it from touching the surface of the painting. When I work on a small painting, I find the mahlstick to be ungainly. In those instances, I hold the right edge of my painting with my left hand and use my left wrist to support my working right hand.

Because of the influence of our pressure on the quality of our marks, it is important, if you are working on paper, to fasten your paper tautly to your backboard. It is not possible to register a strong, bold mark on flaccid paper. You do not want space between paper and board. Lay your board on a flat surface to fasten your paper, and then place your working surface on your easel. To prevent pastel granules from tumbling downward and coming to rest on lower regions of your painting, keep your easel perfectly vertical or tipped ever-so-slightly forward.

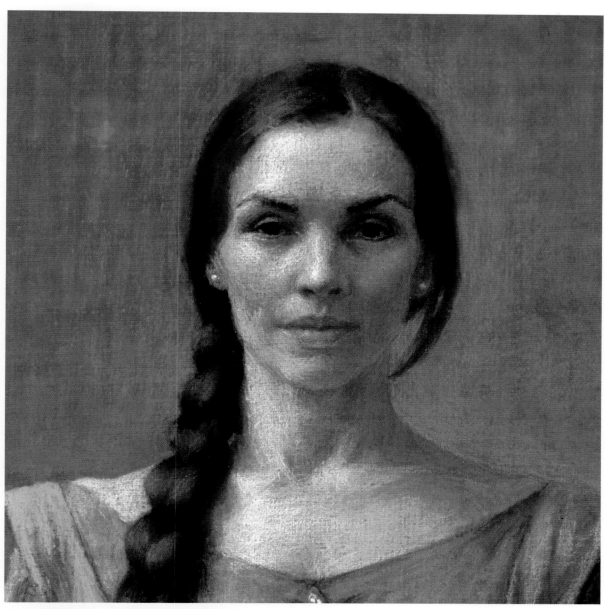

Ellen Eagle, *Rosangela* (detail), 2002, pastel on pumice board, 16½ x 10 inches (41.9 x 25.4 cm)

Rosangela, a dancer, stood symmetrically, with calm composure. My portrait of her called for silken strokes. The full painting can be seen on page 109.

LEFT:

In the top row, we see three colors next to each other and slightly overlapping. In the second row, we see how the same three colors, fully interwoven, modify each other. In the third row, we see the strokes laid in more heavily and more densely. Thus we see how the direction, density, and pressure of our strokes impacts the color and texture of our paintings.

STUDENT INQUIRY

"What are the criteria of differentiating well-handled pastel from bad work—separate and apart from drawing skill, realistic or nonrealistic rendering, degree of neatness or sloppiness, or other quirks of self-expression?"

In short, the effective application and interaction of colors. Does the approach to color enhance the shapes? There has to be a unity of approach throughout the canvas. By this, I do not mean that all the strokes should be the same, but that the strokes and masses should support one another, provide a contextual unity. If the rendering is nonrealistic, still, the painting must touch upon something, on some level, in nature.

To determine if your approach is working, ask yourself the following questions: Do the masses and lines render each other more beautiful, more effective, because of their interplay? Is there life and sensitivity in the strokes and masses?

Do we feel the artist encountering the subject? Do we feel the artist's excitement? Or are the strokes mechanical and repetitious and static? Is every shape of color essential to the whole? If the color is rubbed into the paper, does it retain its fresh quality or has it been deadened from excessive rubbing? Has aggressive layering and rubbing flattened the granules so that the color does not reflect light? Are there layers of color flaking off from too heavy an application and falling onto areas where it does not belong? Does the artist appear to be showing off what he or she knows, rather than sharing what he or she just discovered? Does the quality of the edges of form serve the concept? If the edges of the complete image bleed, rather than being contained by specifically ruled edges, does the image simply disintegrate, or are the edges harmonious with the interior shapes? Does the artist have an overall point of view?

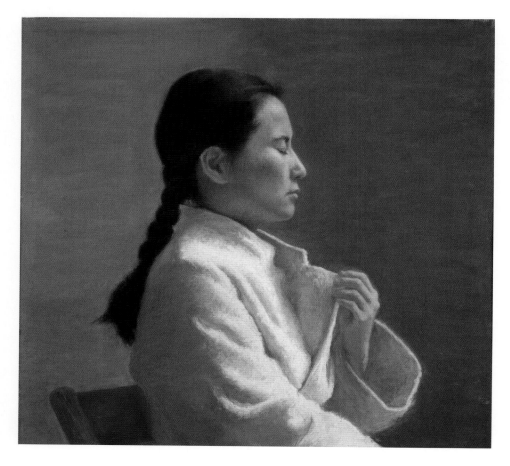

Ellen Eagle, *Maho*, 1998, pastel on pumice board, 13½ x 14⅛ inches (34.29 x 35.56 cm)

Maho's tiny frame and silent gesture, the touch of her soft robe, called for restraint. The result was the first small-scale pastel I had ever painted.

laying in the painting

A light drawing in charcoal is the first work I do on my painting surface. The charcoal lay-in serves as a blueprint, or map. It exists simply to tell me where to start placing my color. I rarely do any shading of values in this stage, as I have already worked that out in the drawing, and am eager to get to my color.

When one first studies color in a subject, it is possible to feel overwhelmed by the sheer volume of tones. I relate the experience to witnessing fireworks, each explosion of color beckoning our attention with equal urgency. Just as we do in our tonal studies, when we study color we do so by comparing one area of color and value to all the others we see. The practice of comparing is the first step toward achieving harmony and order in our paintings. Beauty is all about harmony and order.

Our first considerations are the dominant values and temperatures of the largest, and therefore fewest, abstract shapes in our subjects. These large color statements will describe the overall light and shadow patterns. Once established, they will unify the nuanced variations we create later on, within the large shapes, in the process of building form.

To find the dominant value and temperature relationships, squinting is of unparalleled value. Squint way down to divide the subject into the largest abstract shapes. Remove from your mind the name of your subject—potatoes on table, bottle of ketchup, David. Your subject is shapes of colors.

Include the background in your observation. The background tone is of equal importance to all the color considerations within your subject. Compare all the values to the background. Are the darks in the subject darker than the background? Are the lights in the subject lighter?

While squinting, compare the overall, general colors by flashing your gaze back and forth among those large shapes. What color quality does one area assume, in comparison to another? Which area is darkest? Which is lighter? Does one area seem orangey? Another, violet? When we squint, small bits of visual information will recede. The usefulness to you of the parts that recede are to be determined later on in your painting process.

The act of going back and forth is very important, especially in the early stages of the color lay-in. If you isolate one section and stare into it for too long in the attempt to read its color, you lose your basis of comparison. The appearances of colors are influenced by the colors that surround them. For example, a red will never look redder than when it is next to a green. This process of fast looking can be likened to seeing sequential still

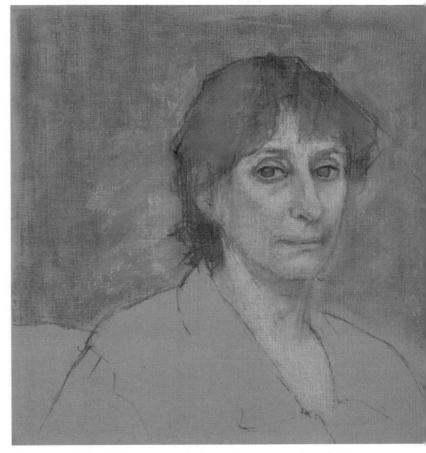

Ellen Eagle, *Julie*, 2006, pastel and charcoal on pumice board, 8½ x 8⅛ inches (21.6 x 20.6 cm)
This is the second portrait I did of Julie. (The first one is on page 58.) We were able to work only two sessions. What you see here are the charcoal lines of the shirt and chair and my first and only lay-in of color. The painting remains forever in initial, preparatory stage.

photography or sequential cartoon images, frame by frame, very rapidly. We become alert to important changes in the action—or value and temperature—via rapid comparison.

As I worked on my initial lay-in of *Julie*, I squinted to confirm where the hair tones were darker and where they were lighter. I looked to my sets and found the dark color I needed in the Nupastel set and the lighter in the soft Rembrandts. Notice that the strokes in the masses created with the Nupastels are more distinct and that the masses created with the side of the Rembrandt sticks are broader. In the skin tones, I layered different hues to create the colors I saw in Julie. Where the warms and

113

cools were intermingling, I applied those colors together before moving to the next area. I spaced my strokes airily.

Squinting helped me clarify the major shift in color of pink eyelids to ocher bone. A variety of greens, and ocher mingled with pink, establish the predominant colors of the neck and chest. In the background are several Rembrandt green grays. A lot of board shows through the strokes at the preliminary stage—especially, here, in the neck and chest.

The gray blouse and chair is actually fully exposed board. I always advise my students to leave no area untouched as a result of lingering in one area too long, because if you do, the area you think you have properly resolved for this stage will look very different once you apply color to another area. This is an important issue, especially when an artist is just beginning to study color. But the fact is there are times when I just need to investigate the human form to a certain degree before I move to the chair. Julie had brought so many great blouses, I had not chosen one by the end of our second session.

The first shapes I want to record are the dark ones. I work from the dark areas toward the light, working corner to corner of canvas. I make the dark areas a little larger than they need to be, and I later etch into the edges of the darks with my middle tones. I work with both Nupastels and Rembrandts in my first layers of color. I like to keep my pastels in front of me so that I can look directly from the subject to my pastel choices. Throughout the development of the painting, I work with as many sticks as I need to create the color I see. Usually I see more variety of color in my subject in the early stages of my study. As I work more and more on the painting, and study the color changes in the shifting light, my eye sees greater and greater harmony. I reach to create balanced value relationships from the start. I try to be as accurate as I can with the dark shapes, but the overall key becomes progressively richer as I work toward resolving my image with increasing layers of color. In the beginning stages of the painting, none of the edges should be hard.

At this stage, try to rid your mind of preconceptions about color. As you compare colors in your subject, you may see colors that surprise you. For example, you may see blue in flesh and hair. Reach for the colors that you see.

You may need one or two sticks for any given area, or you may need ten. There is no rule on how many colors to use. Simply focus on achieving the tone you are aiming for. Put in a few, openly spaced strokes. Compare the tone you have created with the tone you see in the subject. Are they alike? If not, in what way are they different? What do you see in the subject that you do not see in your painting? For example, is the color in your painting

too light in value? If it is way too light, lift the color with a chamois or kneaded eraser. (Do not rub the eraser on your paper surface. Use it in a blotting motion.) What darker hue do you see in the subject? Is it too cool? If so, what warm color do you see in the subject? Remember to be constantly looking at the overall subject in order to understand the area of color you are trying to resolve, always comparing it to the other areas. Look into your selection of pastels and pick up the color or colors you think you need to add to make your color more like what you see in the subject.

If you don't understand the colors you are seeing and therefore don't know what to reach for, try it the other way around. Hold your box in front of you. Look at the sticks first, and then look at the area you are trying to understand. Do you now recognize colors in your subject that you see in your box? If this still does not help, make your best guess and make a few strokes. This will give you something to look at on your paper and judge. You can then remove what you put in, or add other colors to it to achieve the color likeness. In short, the lay-in process involves comparing the colors we see, guessing which sticks we need, and then analyzing the result.

When I have covered all the areas of the painting in the first stage, I step back and look carefully at the arrangement of values, colors, and proportions in the painting. I have put the darks in first, before the middle tones and light tones. Now that they are all in, each area impacts the appearance of all the others. It is time to assess if they are working together, or if they need adjustments. I ask myself what the painting now needs in order to advance to the next stage, toward greater harmony. Has any part not been dealt with to the extent that the others have? My conclusions determine what I will address next. It is helpful to keep in mind that every step of the painting is preparatory for your next step. At the end of this stage, the edges should still be relatively soft. You are constructing.

Ellen Eagle, *Helen*, 2002, pastel on pumice board, 13⅛ x 6⅛ inches (33.3 x 15.6 cm)
With the initial lay-in I very broadly applied warms and cools. The colors of the hair trail right into the colors of the neck. I did not let the fact that "hair" and "neck" have different names interfere with the way I recorded what I saw. The shapes of color in the subject determined the shapes I made.

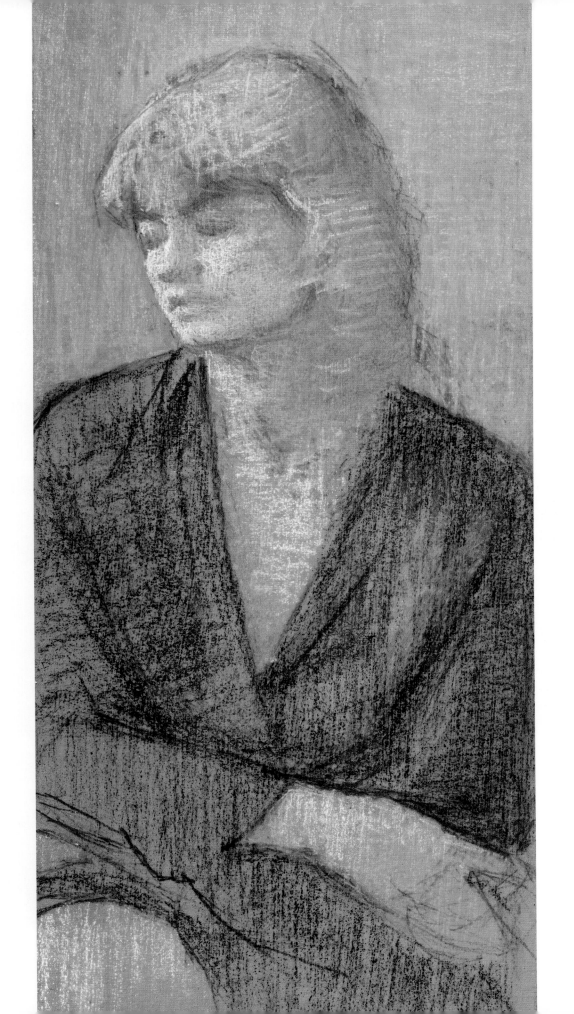

FOCUSING ON **SPECIFICITY**

He looks right out into the world. He listens. Nothing seems to escape him, and every clue tells him something about character. His strong brow and focused watch tell of his acuity.

She looks back in time, and cares for the present, to assure a future. The bone of her brow and cheek are continents, and her gaze crosses oceans, uniting civilizations. His work ethic insists upon sitting rock still for me, but his joie de vivre, warmth, and the stroke he had as a youth have indelibly animated his face.

These hands are clenched in nervous tension. That hand is poised in elegant repose.

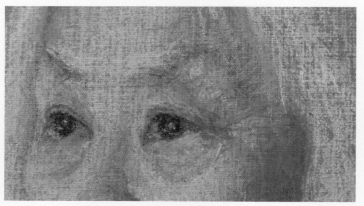

Specificity is the bedrock of characterization, across all genres. The qualities specific to form and gesture, in light, are completely engrossing, and seminal to the evocation of an individual, be it living or living-in-the-heart. Please observe the varieties of features you see on these pages. Each one solicited my complete attention, and held me in its trance until, and long after, my final strokes of pastel had been placed.

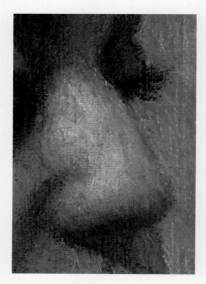

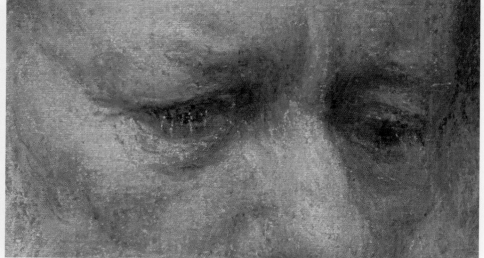

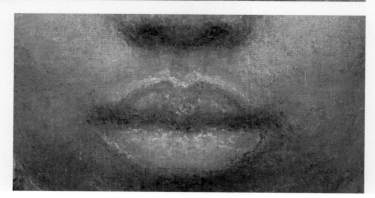

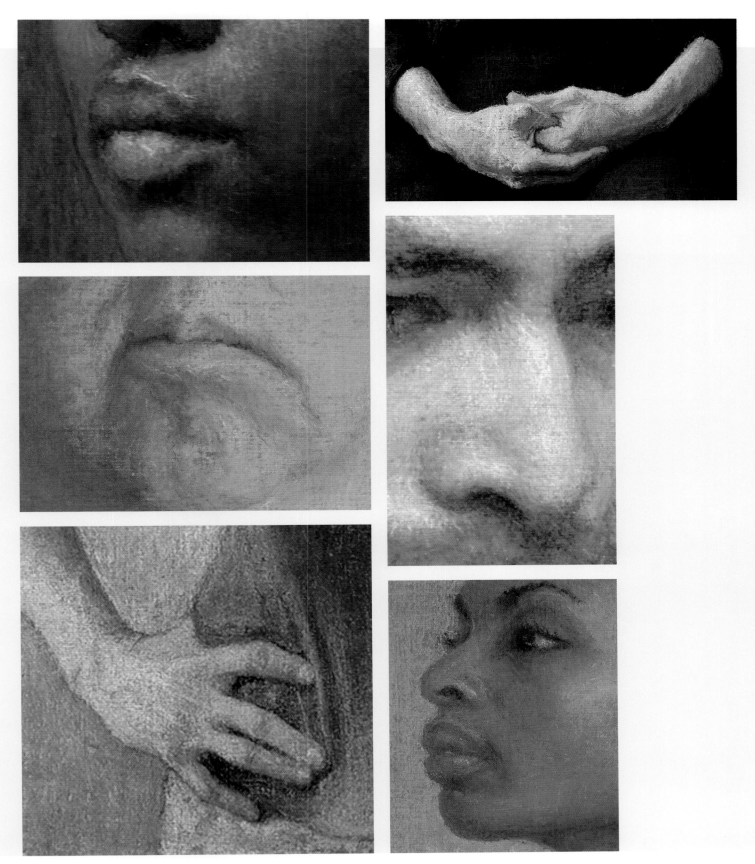

gradating tone

After I have described the large color relationships, I begin to look for the beautiful gradations of tone that mingle throughout nature. I want to hold those gradations within the brackets of the value and temperature relationships that I have established in the large shapes. If the values of the smaller areas are too light or too dark, they will describe the orientation of the planes to the light source improperly. This will cause the overall sculptural form to disintegrate. My goal remains—to describe the way light drifts across, and reveals, form.

A special note about backgrounds: It is common for students to undervalue the importance of the background or treat it in a manner disconnected to the subject of the painting. Bear in mind that we see our subject and the wall behind in one atmospheric condition. The air, light, moisture, and dust that are in front of the subject are also behind, and in front of the wall, chair, umbrella stand, and so forth. Perhaps thinking of the background as "context," a word that one of my students suggested, will help in conveying the background's proper importance.

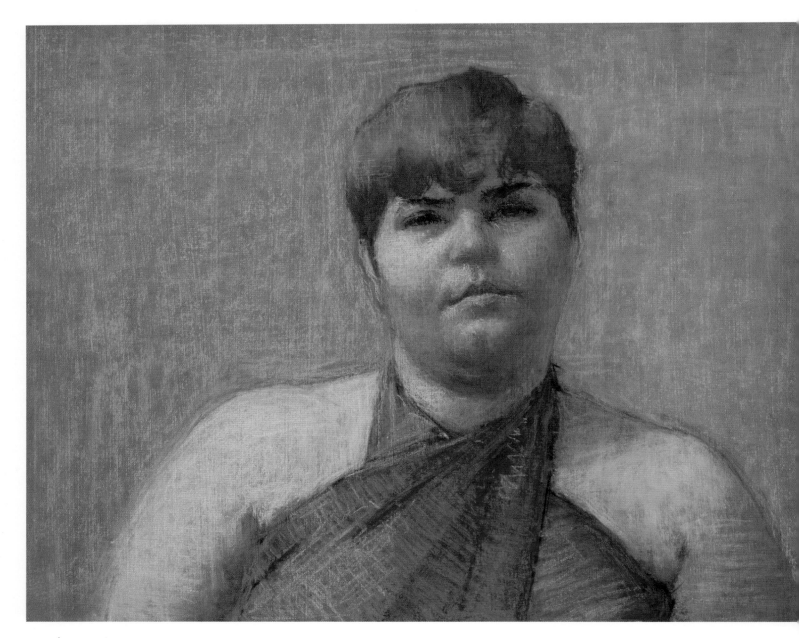

Ellen Eagle, *Young Woman with Braided Hair,* 2002, pastel on pumice board, 6⅛ x 4⅝ inches (15.6 x 11.7 cm)

This is a not-quite-finished painting. The edges of the loose hair need refinement, and even at the very late stage of working, I began to make an adjustment to the shape of the hair in the back.

OPPOSITE:

Ellen Eagle, *Patricia,* 2001, pastel on pumice board, 10⅛ x 13¼ inches (25.7 x 33.7 cm)

I had to stop work on this painting before I had planned to. I would say it is about three-quarters finished. The details, such as the lights of the eyes, remain in the value range of the larger shape, the sockets, and so describe the form. The nostrils remain in the shadow of the under-plane of the nose. The values are well calibrated, so the form describes the light.

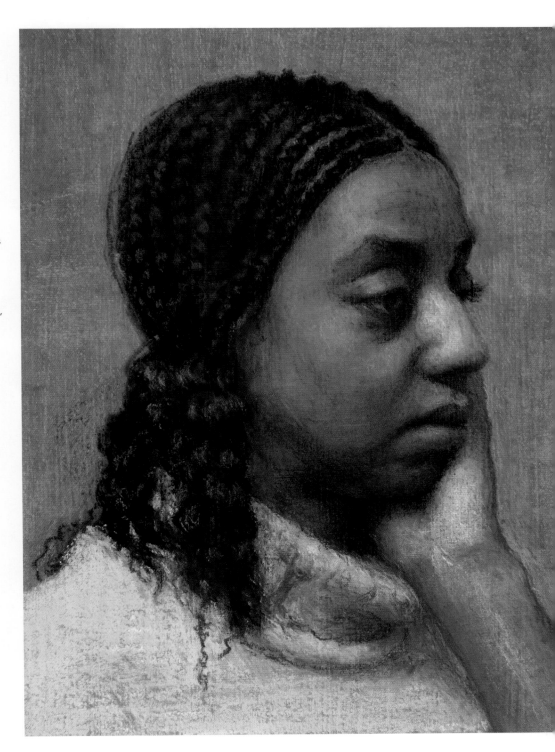

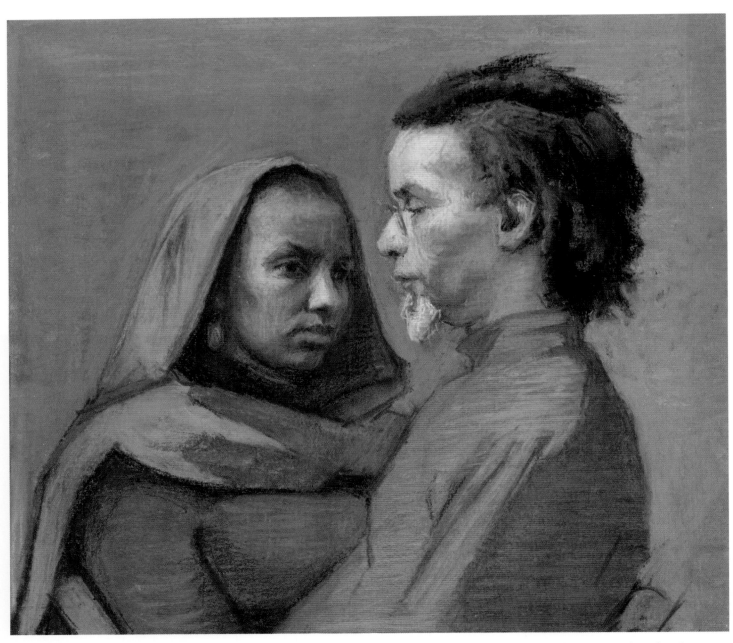

Ellen Eagle, *Two Figures*, 2002, pastel on pumice board, 8¼ x 9 inches (21 x 22.9 cm)

Though I have not yet dealt with the edges, the strong light on the man's face, in contrast with his dark hair, helps to bring him closer to the viewer than the woman.

OPPOSITE:

Ellen Eagle, *Phyllis*, 2002, pastel on pumice board, 11¾ x 7⅞ inches (29.8 x 20 cm)

In the hair, I first laid in the darks that are pulled tight against the head and worked progressively outward toward the light. I painted the shells of the necklace with a slightly diluted watercolor in order to achieve a solid and flat white. While the watercolor was still damp, I sliced the center crevices with a hard black pastel, sharpened to a very sharp point.

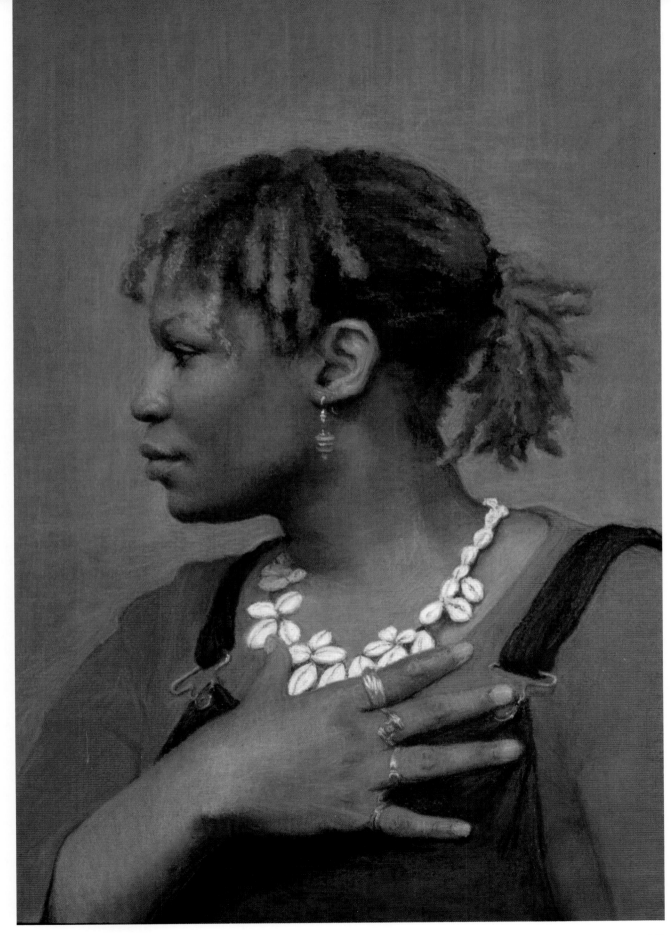

establishing whether the work is finished

The question, "Is it finished?" is huge. It can also be painful.

When you want to make a painting Even Better, it is so easy to go too far. If your big shapes are good, and you are adding insignificant details that do not contribute to the soul of the painting, you are going too far. If you are polishing, polishing, polishing without purpose, you are going too far. If your mind is wandering, you are not connected to a goal. You may be finished.

When I draw, I feel a direct, raw sense of harmony, peace, and joy. Painting, while joyful, on the other hand, is a complicated process. Our perceptions evolve as we investigate and find the construction of our subject and image. The painting transitions through stages of discordance. Perhaps the edges are not appropriately gauged. Perhaps one area is too warm in relation to another. Constant adjustments are required. Until I have reached complete harmony, there is no harmony. I internalize, I feel the disharmony, rousing an intense longing for a perfect, telling cohesion.

In my own work, I want to describe the radiance of light on form. I want light, form, and feeling to be as one. So I continue to squint, check my values, edges, warms, and cools. I check the transitions: Are they subtle enough here? Too subtle there?

More than anything, I look to my subject. The soul of the painting resides in how I feel when I look at my subject. Does everything in my painting tell of my feelings? My feelings are like an orchestra's tuning fork, a touchstone pitch to which all the notes must correlate. Perhaps when the mind is finally released back to the harmonious state in which it had been when I first drew my subject, the painting is done.

In the initial stages of *Each Time, and Again,* my right arm was at work on the canvas, and my left hand was extended, holding my pastels. (I do my self-portraits while looking in a mirror, reversing left and right.) The gesture was wide open and could have been seen as welcoming the viewer into my studio. While studying the painting's development, I saw myself in the mirror repeatedly fall into the gesture we see here. This gesture was far more revealing of my experience in the studio than my initial idea, so I changed course. The content of the painting became the constant questioning about the authenticity of the image each time I paint.

I thought I had finished *Each Time, and Again,* because I couldn't find anything else to address. The premise was genuine. The values seemed fine. The edges were fine. The form was

simple and architectural, just as I had wanted it. I loved that my beloved box of pastels was in the composition, along with my ever-present notebooks. But something was not quite right, and I was having difficulty identifying what was wrong. After I had the painting framed, I continued to study it. I then realized that, in the painting, despite my questioning stance, I looked unconnected to my canvas. This was terrible, because the painting is all about my relationship to my work. The painting you see here is unfinished. In the finished version that appears on page 192, you'll see that I added the two pieces of paper, with lightly sketched drawings, to the far wall, between me and the canvas. The drawings would act like thought bubbles in a cartoon, connecting my concentration to my canvas. I had the painting unframed and made the additions.

One of my favorite parts of the painting is the relationship of the piece of paper on the side wall to the left of my figure. It looks like the piece of paper is saying something to me, and I am listening. Now, through the two thought bubbles, I transfer what I hear to my canvas.

Adding the two sketches on the wall also improved the composition of the painting. The angles of the arms lead to my thoughts, then to the sketches, which lead to the canvas, which leads back to the arms. The circular nature of the composition evokes the back and forth of perception and creativity. The process of revising the painting was a living example of its premise—each time, and again.

Thinking about the question on another level, in some ways, a painting is never finished. The power of a great painting changes with repeated viewings. The more one looks at a painting, the more it becomes a part of the viewer, and the viewer brings that internal relationship to the next viewing. Each time I look at Jan Vermeer's *Portrait of a Young Woman* at the Metropolitan Museum, I am silenced anew by its sacred beauty, and I carry its miracle within me. But maybe that's because Vermeer stopped at the perfect moment. From another viewpoint, Degas returned to his paintings for years, to rework them. A painting might be finished for a while, and then not be finished at all.

Ellen Eagle, *Each Time, and Again* (unfinished), 2005, pastel on pumice board, 23 x 18 inches (58.4 x 45.7 cm)
I was worried about the painting, and probably stood in the same position I depict, while studying it.

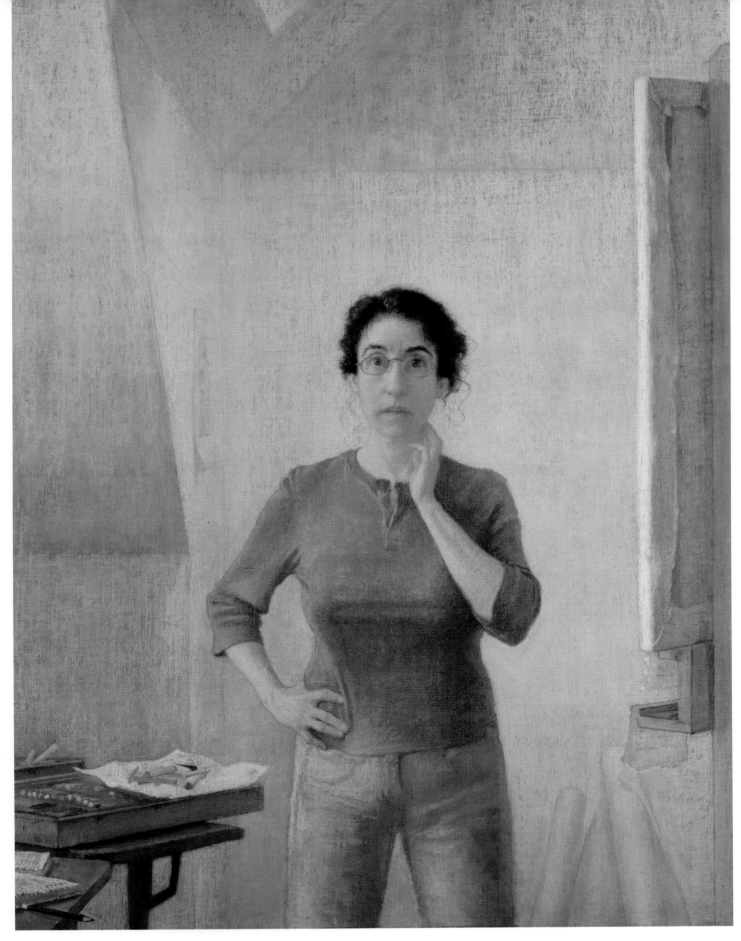

identifying problems

In representational painting, every element either solidifies or fractures the appearance of sculptural form. If, when you step back and look at your painting and your subject together, the image looks flat, check the variety of edges and the range of values against those in the subject. Are all the edges in the painting of the same quality? Or is there a proper variety? Are all the parts rendered to the same degree of emphasis, or does variation properly describe the light? If the gesture looks wrong, check angles and plumb lines. Check the proportions. Check the transitions from darks to middle tones to lights. Are the transitions nuanced enough? If the forms look swollen, the value transitions may be too great. You may have been isolating areas from one another when you were studying the subject and building the form. Do small areas of color and value jump out from those of the large planes in which they reside? If so, squint at the subject to find the correct value relationships of small to large areas. Are there too many color changes? Look throughout the form for the largest sweeps of color, colors that persist across regions while others change. A light application of the steady colors on top of the many nuanced changes will help unify the form. Or perhaps you need to stroke a neutral over all. Is it too cool? Do you need to stroke a warm over all? Does the degree of detail in one area make sense in relation to detail elsewhere? Remember, we don't see much detail in shadows or in very high-key lights. Do all the parts of the subject appear to have been observed under one condition of light? Are the marks mechanical looking? Is the texture created by the strokes true to the textures of your subject?

Look at the picture in a mirror to check your composition, proportions, and drawing. The mirror is very helpful when used throughout the course of creating the painting. Turn the work upside down.

Many problems are relatively easy to identify. Some are elusive. Perhaps the problem is one of premise. Is the idea behind the painting convincing to you? Is it genuine to your experience and perceptions? Much of the difficulty in identifying problems is the close proximity we have to the painting. The same mind that created the problems has to look at the painting from a different angle. At these times our thoughts may go around and around and lead us nowhere. We can become captive to confusion and anxiety. How does the mind now summon the clarity to self-critique?

It is sometimes best to turn the painting away for a while. One cannot force perception. Sometimes working on a different painting can be very helpful in dismantling the roadblock. When I need to get out of a knot, I sometimes change activities altogether. Once, after struggling at my desk for days to compose a few sentences, the words just floated to me while I was shoveling snow. Away from the turbulence of trying to pry open an answer, my quieted mind was receptive to a natural and good solution when it appeared.

Artists are constantly setting up new problems and finding ways to solve them. Each new painting presents a new set of problems. We have to love problem solving. And we have to know when to step out of our own way, in order to take care of

CRITIQUING YOUR **COLOR THEMES**

A number of my students have smartly commented to me that they tend to use the same colors over and over again in the flesh tones, and they wonder if this means they are not looking carefully enough at their subjects. I love this self-testing attitude. It precipitates advancement. One factor in color themes is the environment in which we work. My class works in a natural light studio. The walls are gray. Gray is always thrown into the flesh tones, fabrics, and elements in the arrangement. If the color of the fabric is, say, a violet, and similar in value to the wall, the gray reflected into the violet may be barely visible to our eye, because both colors have blue in them. If we place a red board or fabric behind

the model, the red will be thrown into the flesh tones and clothing. The model's clothing also throws colors into his flesh tones.

Though each person is unique, humans are more alike than different, and we will see familiar flesh tones throughout the course of our painting experiences. For example, Norwegians are said to have cool tones; Asians, warm. However, it is most fruitful—and joyous—to explore without presumption. Nature is nuanced, everywhere. Our attention to specificity, of both the large and the small, and the integration of all, is essential if we are to compose images that evoke life.

our work. Perhaps play basketball. Take a walk. Stir pudding. Read a book that is, or is not, related to art. A sentence, a word, can strike a chord and stimulate a revelation. Look in museums and books at art forms that might suggest an approach you had not considered. If you keep the problem at heart, remaining hungry and patient at the same time, you will be alert to potential solutions when they present themselves.

Ellen Eagle, *Mei-Chiao (Yellow Blouse)*, 2002, pastel on pumice board, 6½ x 6¼ inches (16.5 x 15.9 cm)

I loved Mei-Chiao's pale flesh tones and airborne hairstyle. In response to the delicacy and motion, I turned her body ever so slightly. The arcs of her twisted shoulder strap and her ponytails parenthesize the tilt of her head. The eyes glance sideways. All is in balance.

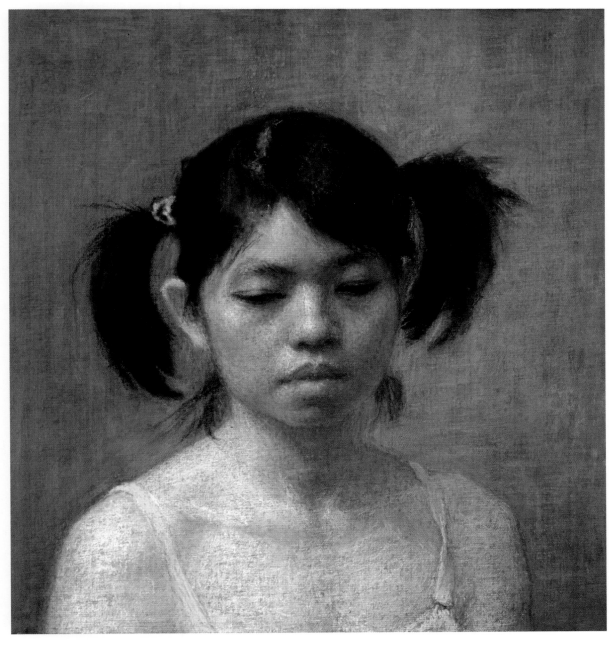

making corrections

Making corrections in pastel is much more possible than its reputation suggests. Options include pressing gently but firmly onto the pastel with a kneaded eraser. The kneaded eraser can be shaped to get into a tiny spot and will not damage the paper. Press only; dragging the eraser across the paper will only spread the pastel and push it deeper into the paper. Brushing the pastel with a firm brush, such as the Winsor & Newton Galeria, works nicely. The most effective material I have found for the removal of pastel is a chamois. It works best on pastel that has not been rubbed into the fibers of the paper, but instead rests lightly on the surface. One can also use the chamois first, and follow it up by dabbing with the kneaded eraser.

My painting *Nude* (opposite) required a massive revision. When I did my initial thumbnail sketch, I so loved the contour of the gesture, I barely made note of the dark wooden chair on which my model was seated. As the painting developed, of course, the chair imposed a major compositional factor, especially in the bottom third, where the chair legs framed the pale, cool flesh of the legs. I had to eliminate the dark shape of the chair. When my model came for the next session, I replaced the wooden chair with my piano bench, draped with white fabric. (The slight mound beneath her is bubble wrap under the fabric, to cushion her from the hard wood of the bench.) Using a kneaded eraser, I removed as much pastel as I could from the rendering of the chair (I was not yet familiar with the chamois) and carefully applied a layer of my gesso-pumice ground to the ghost of the chair shape. I then toned the area with acrylic to match the base color of the rest of the board beneath the painting, and I had a fresh, new surface upon which to create the quiet surrounding values I wanted. The removal of the chair restored my initial motive for this paint-ing: light drifting across the architectural forms of mostly cool colors and the silhouette of the gesture.

If you have layered pastel to the point that the surface will not accept any more pastel, working fixative can help. When used during the middle stages of the painting, a light spray of fixative isolates the pastel you have applied and creates a crisp surface for your subsequent layers of pastel. The spray has to be applied in a well-ventilated room or out-of-doors. Position yourself about five or six feet from the painting and aim the spray a bit to the left or right of the surface. Gradually cross the surface of the image and finish, again, beyond the edge. One or two light coats is better than blasting a heavy spray onto the painting. Be very careful when spraying on paper. Too much fixative can flood the paper and destroy both paper and image.

Also be aware that fixative almost always changes the colors you have applied—the darks become lighter and the lights become darker. This may not be a problem if you intend to do substantial fresh work on top of the fixed layers, but it is not wise to spray after the completion of a painting.

I once filled the tooth of a painting with pastel before I was finished modeling the form. The problem area was in the arm. I placed a piece of tracing paper over the whole painting, and traced the shape of the problem area. I then lifted the tracing paper, cut out the shape of the problem, and replaced the tracing paper on top of the painting. I then sprayed through the hole of the tracing paper. I was now able to layer more pastel onto the problem area, but I applied too much fixative, which roughened the texture of the area. Because of this, I abandoned the picture. In retrospect, I think I should have continued, but the uneven texture of the sprayed area bothered me.

Ellen Eagle, *Nude*, 2002, pastel on pumice board, 31½ x 13 inches (80 x 33 cm)

When I started this painting the model was sitting on a dark wooden chair. Fortunately, I was able to remove all evidence of the imposing furniture.

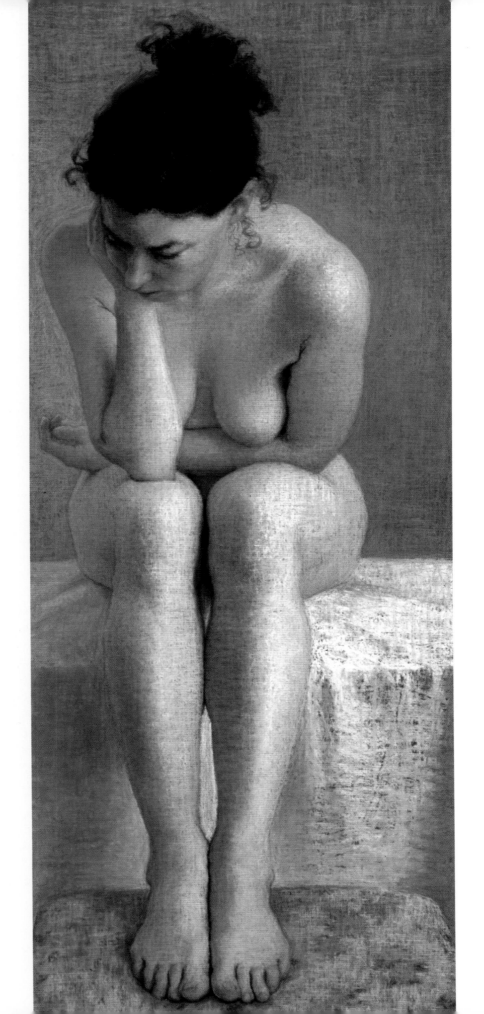

I met Maxine when we were both teaching in Assisi, Italy. I had read several of her books, and I had become enthralled with her through her writing. When I saw that we were both on the faculty at Art Workshop International, it took about half a second for my imagination to rocket to the idea of painting her portrait. One evening I gave a slide talk to the AWI attendees and faculty. In the audience were Maxine and her husband, Earll. I heard Maxine whisper to Earll something that ended with the words ". . . paint my portrait." When we returned to the States, I began a series of trips to the West Coast to paint her.

Prior to my first trip, I created a full set of hard pastels for travel by packing sticks tightly in two ArtBin boxes lined with paper towels. The two boxes provided ninety-six slots. I then selected a group of soft pastels that I anticipated needing—ochers, pinks, olives, warm browns, raw umbers, and a range of grays. Again, I packed them in ArtBin cases I lined with paper towels to eliminate empty space into which the sticks might otherwise slip and break.

When you travel to work, it is helpful to keep in mind your mode of travel and the environment in which you will be working. These circumstances may impact your choice of scale. I prepared several small gesso-pumice boards of various dimensions. I also gathered paper towels, charcoal, a charcoal sharpening pad, razor blades, and a handheld mirror, and shipped all of my materials to Maxine. The pastels arrived perfectly intact.

I spent the three or four afternoons we had together during the first trip drawing Maxine in graphite from a variety of angles and in a variety of locations in her home. I did this because I wanted to investigate different compositions, get to know the conditions of light, and find where I would be comfortable working in the unfamiliar environment. But I had the sense from the start that I wanted to paint her in three-quarter view. I was divided between doing something quite elaborate, including some family heirlooms, or focusing on the head and shoulders. I returned to New York still unsettled on my composition.

When I returned to Maxine five months later, I drew one more afternoon. The next day, in the south-lit dining room, I hung my red shawl behind her and began the painting. Painting Maxine was bliss; the majesty of her bone structure, like land masses; her flesh washing over the bone and muscle, like rushing water. The light from her garden outside the windows reflected in her eyes. The hook of her eyebrows, fastened to the cheekbone, the muscle rushing right into the mouth.

Maxine and I felt so comfortable together. We delighted in each other's perspectives and discovered many artistic values in common. At the time, Maxine was writing *I Love a Broad Margin to My Life* and she occasionally alluded to its content. Sometimes she stood up purposefully from her chair to write something down or to read something. At times, she went into her writing studio. This was fascinating to me. We were both working. I was seeing her stirring from her stillness, writing. As an artist, I was having an exceptional experience: I was invited into the everyday activities of my sitter. My decades-long notions of Maxine, the extraordinary writer and human rights activist, were now augmented by the personal realm. A gift bestowed.

Each afternoon, when we were finished for the day, I packed up my supplies to clear Maxine and Earll's dining room. Returning the pastels to their boxes, I turned the sticks I was using in the direction opposite that of the unused ones. The next day, seeing the turned-around sticks, and lifting them up to resume work, was a lovely step back into the vision that drove my work the day before. One day, Maxine and Earll expressed curiosity about the sticks, so I left them out for several days, along with one of the boards I had brought. Maxine, who paints landscapes, and Earll, an actor, made broad abstract shapes that conjured mountains and rivers with the same pastels that were recording tiny shifts of color in my portrait. We simply held the sticks differently. I used the points and corners, and they used the sides.

Our third and final session came fifteen months later. I was concerned that such a long gap might interrupt the perceptual connection that had been established and veer the picture onto a different path. So I was pleased to find that the work I had done previously provided a sound platform upon which I was able to build my image and continue to express my bliss in Maxine. I fell immediately into pace and resolved the painting, with clarity and calm. I believe the connection held because my response to Maxine was clear from the outset.

Usually I cover my canvas with color, corner to corner, to set the sitter in a specific (though not narrated) space. But the shapes of red behind Maxine suggested to my eye that she inhabits a space larger than the actual physical environment, and this was consistent with the far-reaching territory of her mind and her dedication to humanity, peace activism, and the written word. There is also a youthful aspect to Maxine's curiosity, humor, and physical activity that suggests to me an expanse of time greater than this moment.

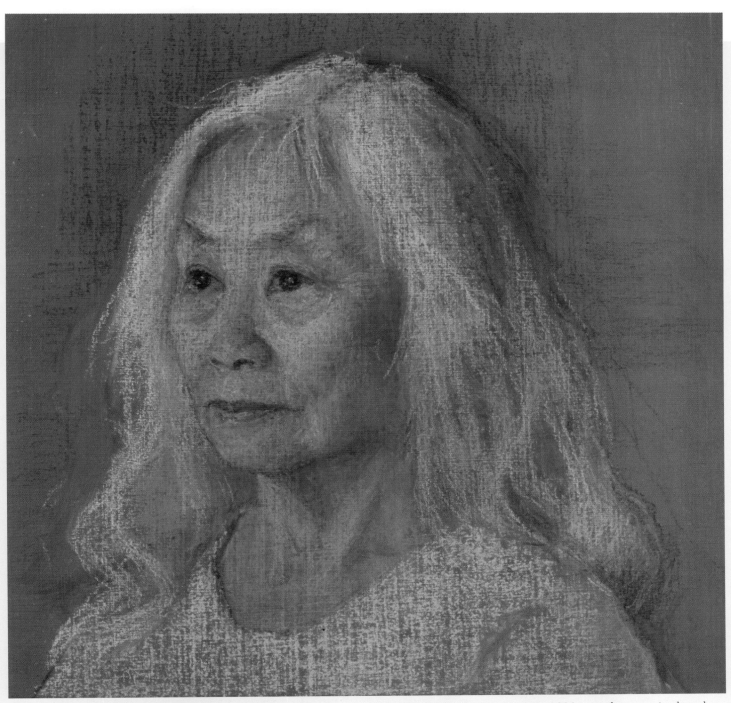

Ellen Eagle, *Maxine Hong Kingston*, 2010, pastel on pumice board,
6¼ x 6 inches (15.9 x 15.2 cm)

My first strokes, beginning with the black and white tonal study, were of
Maxine's majestic brow and cheekbones. These formations anchored the
entire structure of my painting.

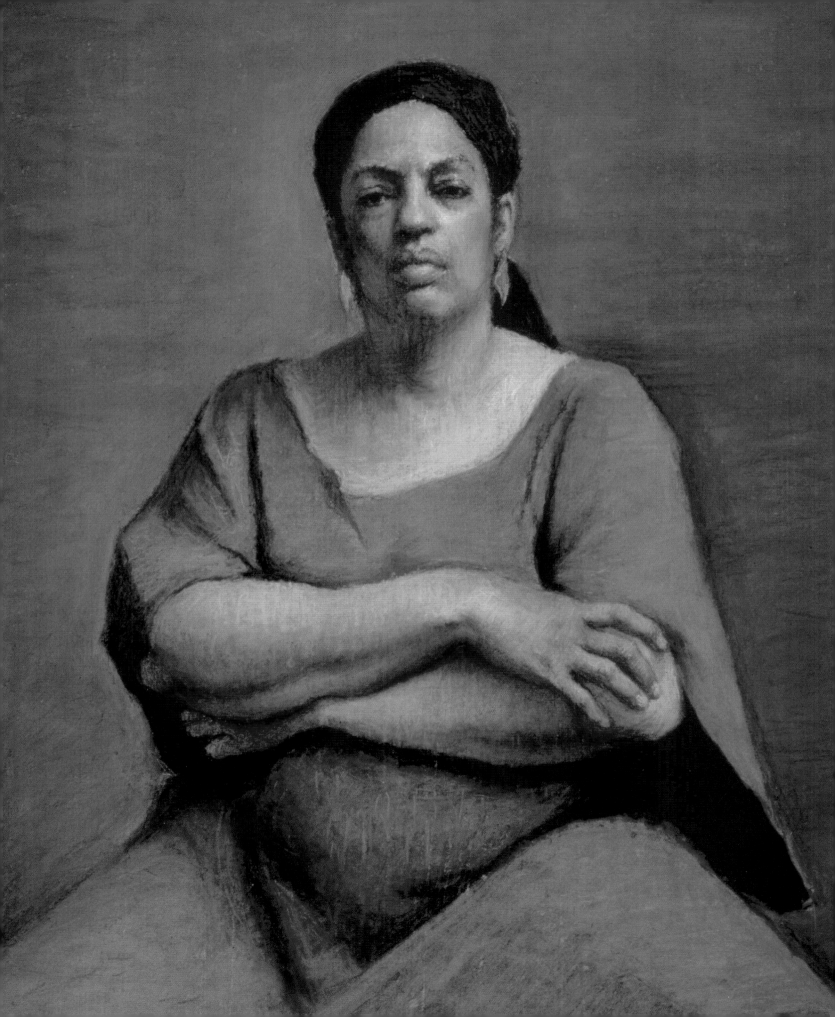

on my easel

Ellen Eagle, *Mercedes,* 2001, pastel on pumice board, 11 x 8¾ inches (27.9 x 22.2 cm)

This painting fell right into place. The weight, the resolve in the arm gestures, the slightly confrontational facial expression, the overall mountainous contour of the figure, and the simplicity of the draped clothing coalesced into a cohesive statement. The small scale of the painting expresses my sympathy for the model's inevitable human fragility.

I invite you to look over my shoulder as I paint a typewriter, a man, women, flowers, and garlic skins. In this chapter, I offer six paintings in progress—from first lines to completion. (Although, truth be told, I may not be entirely finished with one of them.) You will see my initial charcoal lines, searching into the essence of form and gesture; my first lay-ins of pastel, establishing the character of the paintings' color; and my steady buildup of pastel, developing the form and light to full expression. You will see first compositions sustained throughout the course of paintings, and you will see me add, subtract, and shift elements as my ideas evolve. You will see me strive to maintain simplicity and you will see intricate selections of pastel sticks used to create the paintings.

I invite you to read the notes I wrote, session by session, during the course of the paintings' development, and to listen in as my model and I conversed about our work. I describe both practical considerations and less tangible matters, such as inspiration and the synthesis of line, mass, color, light, and emotion, into unity. I share my excitement, my questions, and my doubts.

Sometimes students are surprised to hear that questions about working, and uncertainty, are eternal. Questions always give rise to new questions. I trust and embrace quandary, because it causes us to look deeply and honestly and leads to discovery. I love every aspect of the activity of painting.

pigeon glancing

I was painting my first portrait of Pigeon (see page 59) when I received the invitation to exhibit my works in China. I was also informed that I had to carry the twenty paintings I planned to show in my carry-on case. This necessitated that all the work I did between my notification and liftoff be small. The original composition of that portrait stretched all the way to Pigeon's calves and included her hands. I had to crop the painting in order to bring Pigeon to China. Fortunately, I loved the resulting composition in equal measure to the first one. But I was so sorry to lose her slender hands. They simply had to be featured in my second painting of her, *Pigeon Glancing*.

I also had the idea to paint her with a lovely headscarf, but when I saw how it looked, it did not work. I always abandon an idea if it does not look convincing to me. No matter how thoughtful the concept, it has to work visually.

session one

My first concern was establishing a pose that would exhibit Pigeon's grace. First, I had her sit facing me. Then I turned her, and asked her to bring her hand to her upper arm. Sometimes when I work with a model, I ask that he or she assume a series of gestures that come naturally. Sometimes I ask for specific gestures. The contour of this pose was so elegant, so striking. This had to be the painting.

Initially, Pigeon was wearing a tank top with slender straps. During a break, she put on a sweater. The idea of silhouetting her hand against the matte black sweater fabric was exciting. The fabric provided a simpler surrounding to her hand and wrist than had the light on the upper torso flesh and tank top. The radiance of the relationship between hand and head was now perfectly concise. I asked Pigeon to glance at me with her eyes only, but, worrying that that gesture could be physically uncomfortable for her, I withdrew my request.

session two

I began the charcoal lay-in with a few strokes, noting the relationship of the far shoulder to the chin and back of the neck and skull. In other words, I was trying to capture the way the form pushed outward into the space—the contour. The first elements that struck me about the gesture—the contour, my motive for the painting—told me where to begin. I then went directly to the interior forms—the interplay of line and mass. I was thinking of Hans Holbein. I love his combination of line and plane.

I stepped back from the easel to compare the shapes on my canvas to the shapes of Pigeon. I projected imaginary plumb lines and what I call continuity lines—imaginary arcs—onto her, in order to better see where one form was situated in relation to another form and to understand the overall three-dimensional construction. I noted that Pigeon's eyebrow is epic.

The elegance of Pigeon's contour called upon me to place a few outer lines first, in my graphite sketch and the charcoal lay-in (seen here). I then moved to interior areas. I was investigating how one shape nestles into and on top of another. I picked out the angles that were most important to me.

session three

I was very happy with the linear charcoal lay-in. Now I could swim in color. My goal was to set up the overall temperature and value relationships in a general, broad manner, and to address all the areas of my pumice board. I paid special attention to how the lights stacked above one another, and drifted down the head, neck, and hand. Beginning my pastel application in the shadow areas, I reached for an Henri Roché warm brown. This was the first Roché stick I ever used. I felt excited because, although it is a soft pastel, the granules beautifully held to the pumice board. I have a very light touch, but the Roché granules adhered with conviction.

It was hard to keep myself from registering the very subtle movement of light in this first stage of color and to stick with the big shapes only. Pigeon had pulled her hair back more tightly for this session, and the pattern at the hairline was spectacular. Something about the delicacy of soft individual wisps of hair resting on the flesh-covered bones of the skull strikes me as so touching.

During one of our breaks Pigeon and I discussed the relationship between artist and model. The model poses without posing. There is a fine line between maintaining composure and acting. She maintained composure for me, and I inquired into it.

Getting back to work, I laid a light layer of charcoal into the sweater area. I compared the colors I saw in the hair to those I saw in the flesh. I reached for a pronounced Girault violet, as a constructive tone, for the lights in the hair, intending to mute it down later. I used Girault browns and Nupastel goldens in the flesh, as well as violets, blues, and grays. I also began to see a lot of greens in the flesh.

I went into the sweater with Girault black, keeping the strokes a distance from the hand, because black is difficult to go over. I usually don't lay in much black in the areas where I need it until I know the exact shape I need. Rather, I often use a gray or charcoal until I am assured of the shape I will need.

I constantly stepped back, and looked in the mirror, checking my alignments and shapes before building on top of them. After Pigeon and I took a break, I took another look from a distance with a fresh eye.

In these beginning stages of the painting, I felt hopeful anticipation, excitement, and worry. Excitement can cause recklessness. Too much discipline causes disconnection. Excitement and discipline, back and forth, keep each other in check. Stepping back

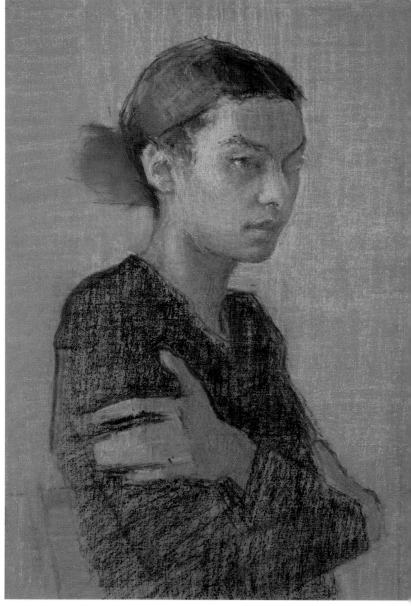

The first lay-in of color establishes the generalized, overall color character of the painting. Much of the board is visible at this stage.

and looking from a distance, and looking at the reverse image in the mirror, is essential to maintaining the balance.

Because my pastels were set up next to the window, I covered them when the session concluded to prevent them from fading in the sun. Later that night I looked at the picture and wondered, *Do I need to raise the eyes?*

session four

Before Pigeon arrived for our fourth session, I looked at the painting and felt troubled by what I saw. I had become too concerned with the details, and the transitions and edges suffered for that. The edges were too hard for this stage.

My first order of the day was to go back to the big shapes. This helped me simplify the form, and soften edges, thereby addressing the sculptural needs; it also allowed me to better see where the proportions were off. It is more possible to assess the proportions of the big shapes before details are in. Going back to the big shapes is invaluable. It does what nothing else can do—because a painting is, first and foremost, the big shapes.

When I looked more generally, rather than zooming in on the details, the forms coalesced. Do we sometimes zoom into details out of worry?

Though I worked more generally in the face, adding Henri Roché golden ochers throughout, and pale pinkish yellows in the lights, I became more specific in the hair and both hands. To the close hand I added Roché deep grayish violet in the shadows, and used golden ochers and pinks to define the fingers. In the hair I layered black, and introduced burnt siennas to tone down the violet. I darkened the sweater, and added light pinks and blue grays to the background.

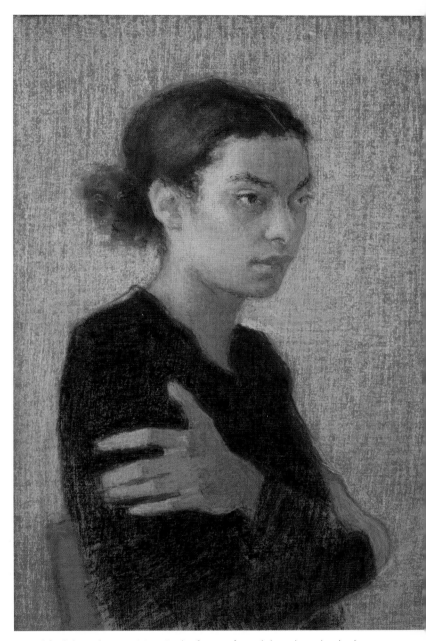

I simplified the color transitions in the face, softened the edges that had become too hard for this stage, and addressed the hair and hand with greater specificity.

137

sessions five through seven

Because the last session was Friday (three days ago), I took awhile to study my painting against the model before picking up my pastels. How luminous were Pigeon's colors! I saw that I needed to enrich the color overall. I wanted to define the forms more fully. I planned to do so by darkening the darks and paying careful attention to the value transitions throughout, and I would further account for the texture of the hair. I also noticed that the hair was shaped differently today, more like it was the first day—a graceful counter shape to the jawline. I decided to grab the opportunity to record the harmonious curves.

I began the day by reshaping the hair, layering Girault browns into the previously applied colors. I went back into the face with Unison deep gold, Nupastel deep red, and Cretacolor peach. To the hands I added Unison dark blue, dark gold, and Nupastel deep red.

The colors were now attaining a fitting richness that I saw in Pigeon. In the course of these sessions, however, I was not feeling as connected to the image as I wanted to be. In pondering why this might be, it occurred to me that my first instinct with the pose was to have Pigeon glancing toward me with her eyes, while holding herself. Though I had been connected all along to her coloration and the light that graced and revealed her elegant forms, and I had her beautiful hands, the heart of the matter seemed to have slipped away. I knew exactly what had happened. Pigeon was holding herself and looking away from me. In a sense, I had excluded myself from our relationship.

I asked Pigeon if it would be possible to return her glance toward me. We developed a wonderful syncopation. Pigeon glanced my way when she felt comfortable doing so, and then rested her eyes when she needed to. We were completely in tune with each other. As I was working on areas other than the eyes, I sensed when she turned her gaze to me, and I stopped what I was doing and worked on the eyes for the moments she was there. Our gazes were locked together. This effort, these moments, were a direct gift to me from Pigeon—above and beyond the magnificent presence she was already offering me—and the moments were infused with a heightened sense of silent beauty and gratitude.

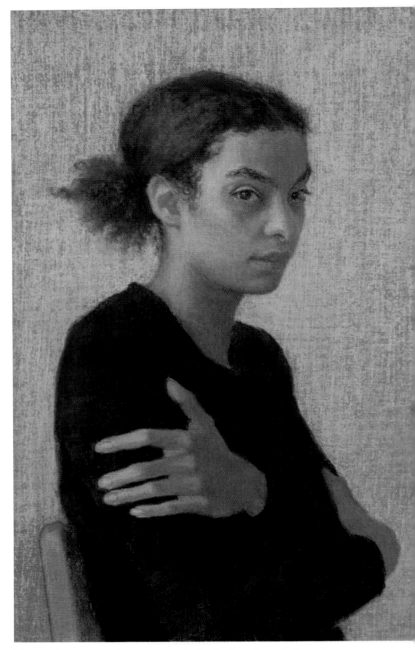

My complete connection was resparked with the return of Pigeon's glance.

sessions eight through ten

Fascinated by the exchange of energy between model and artist, I asked Pigeon to tell me her observations of the artist/model relationship. She told me that artists have different kinds of gazes, and studios have different atmospheres. She said the kind of gaze an artist brings to the studio brings out different aspects of modeling. This got me to thinking about how different artistic goals determine the manner of looking. What might it feel like to have a model pose a certain gesture for a narrative painting? For an idea beyond the depiction of an individual? Then again, one could say that what I do is narrative—my narrative is what I see in my model.

I continued to tune transitions and values. In doing so, I was adjusting the volumes of form. For example, does the shift of color and value down the light side of the cheek describe it as slender?

As the sessions accumulated, we had some cloudy, rainy weather. At these times, all the colors looked warmer. I decided to go with the warmer colors that the clouds presented. I added warms throughout the flesh. I saw some cool, gray textures in the hair. I deepened and refined the hand, sweater, and chair. I shortened the sweater sleeve to reveal Pigeon's slender wrist, revisited the far eye, and added a light to the outer corner of the lower lip. I warmed up the background with a Roché terra cotta–like color, folded blue into the sweater, and worked deeper ocher into the shadows of the flesh. I saw a great deal of texture in the hair, and I finished up the session by creating abstract shapes of light to Pigeon's beautiful hair.

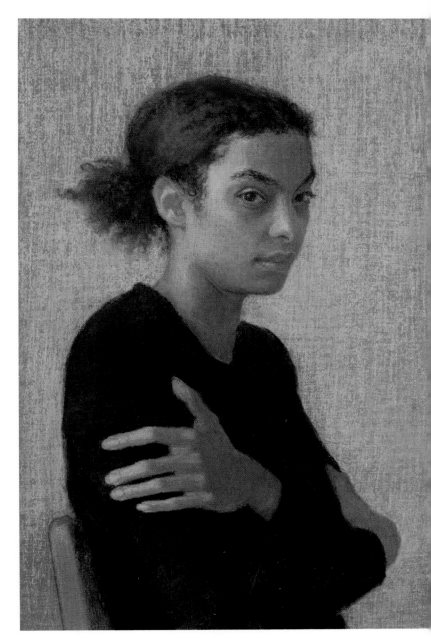

I checked to see if the values were properly describing the volumes and warmed up the colors a touch.

139

final session

On the final day I definitely wanted to work strategically and not get distracted by any new ideas that might, in effect, start the painting on a whole new path. My goal was to resolve the painting into complete harmony. My first concern was the hands. I wanted to maintain the simplicity and elegance of both hands and to describe the degree of light as it wraps around the arm. To help achieve this, I added cools to the thumb. I also worked on the edges of all the fingers. To the far hand, I added a touch more structure by indicating the wrist and bend of thumb, using just a touch of gray.

Next, I turned to the face. I added Henri Roché ochers to the forehead, and lightened the lights with a touch of pale violet. I also tried to better account for the very light ochers in the cheekbone. I added lighter cools to the lights on the nose.

I checked the movement and values of the eyebrow, the values of the eyes, and minutely changed the line of the crease above the close eye. I reviewed the values on the neck, just below the jawline. After adjusting the angle of the fold of skin, I modified a few values in the ear.

Because in the past I have noticed how easy it is to overstate changes of values in the hair, this time I had understated them. I was glad that I had held off, and now I enjoyed increasing the shifts from dark to light. As a final note, I slightly lightened the background. With these minor adjustments to fine-tune the harmony, my composition was complete.

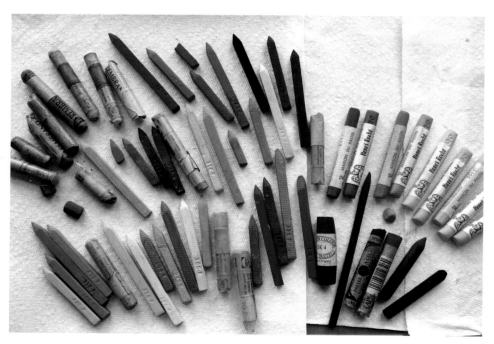

LEFT:

These are the pastels that I used for *Pigeon Glancing*. The challenge was to orchestrate all these colors, which spanned the color spectrum, into unity.

OPPOSITE:

Ellen Eagle, *Pigeon Glancing*, 2011, pastel on pumice board, 9¹¹/₁₆ x 6³/₈ inches (25.7 x 17.1 cm)

The final session should bring all earlier stages to a resolution. New ideas that arise at this late stage are often the wonderful first steps toward your next painting.

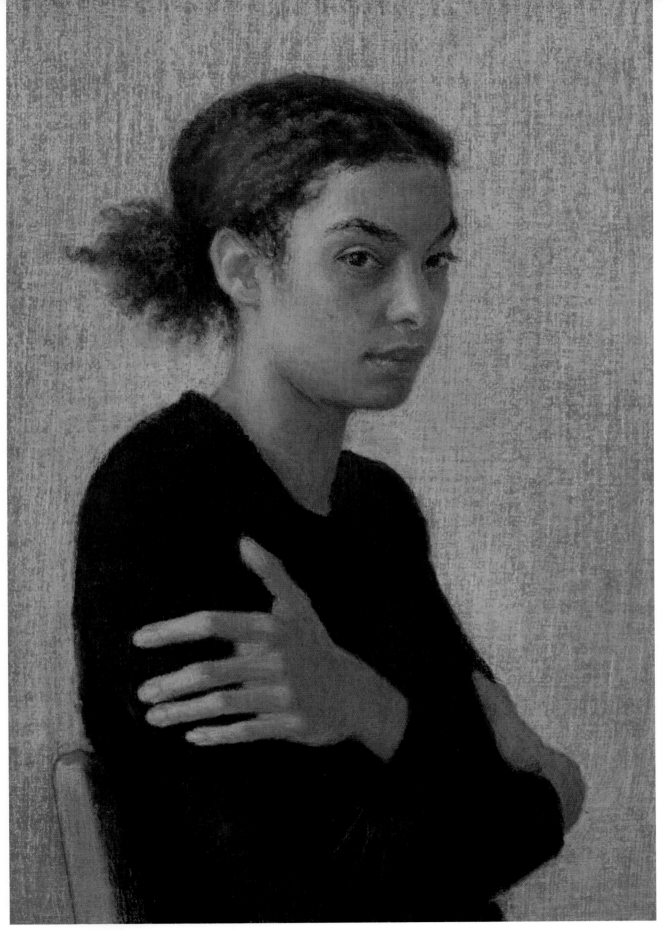

underwood

This still life began with the discovery of the typewriter on its way into my neighbor's trashcan. As compelling as I found the typewriter body to be, it was the ribbons hemorrhaging out of the body that were irresistible—suggesting activity, history, and the wonderful ravages of creativity. Intestines digesting. The keys were like broken teeth. I carried the exceptionally heavy machine up the stairs to my studio.

session one

I placed Underwood on the typewriter table, which, standing on two stacked model stands, raised it to eye level. I wanted to see the typewriter's face, as we see the face of a person who is speaking to us. The painting that I placed in the typewriter is *The Opera Singer* by Thomas Eakins. The tangle of typewriter ribbon suggested to me the gut excitement of artists' responses to

In my first stage, the charcoal lay-in, I established the basic structure of the typewriter and the rhythm of the composition.

OPPOSITE:
Whereas my initial lay-in was linear, my second stage took mass into consideration. The weight of the typewriter was beginning to be felt.

our subjects. The painting is the artist's voice emerging from that tangle. The angles of the items surrounding Underwood underscore his uncertainty and motion.

Because of the complexity of the composition, I knew my first stage would have to be set up with precision. I saw no need to lay it in twice—first, in my sketchbook, then on my pastel board. I went directly to the board with my charcoal. Sometimes I do a very light tonal lay-in with my charcoal, but because of the complexity of the machine, and the large expanse of almost-flat black, I felt it necessary to instead begin by pinpointing, in line, the locations of the parts. As I do with my portrait and figure paintings, I began with the most obvious, significant structural elements.

session two

I began to lay in the masses of color. I used solid, soft black for Underwood, with no modeling of form. Using Rembrandts and Giraults, I placed soft Indian reds, Mars violets, caput mortem reds, and ochers in the table. I colored the wall with soft blue and green grays.

My concern at this stage was the overall design of the painting. I eliminated the vertical shadow on the left, and the canvases on the lower right. I dropped the side of the table to balance the pieces of paper on the wall and because I felt the horizontal created too placid a feel for the chatter of the keys, and the whole tangle of digestion in the artist's/singer's pursuit of her key. Using Rembrandt and Nupastel ochers, I blocked in a small cluster of keys, and I eliminated the paper laying on the table.

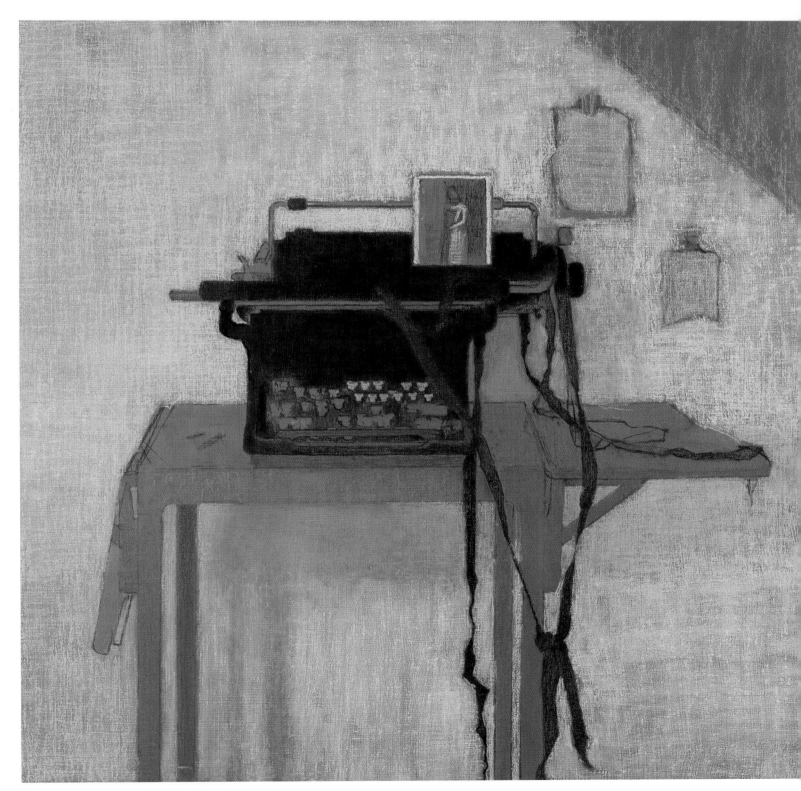

sessions three through six

I considerably lightened and cooled the wall shadow on the upper right with soft blue and green grays. I reinstated the paper on the table, and placed my eyeglasses and pastel sticks on top. Throughout the rest of the painting process, I repeatedly removed my glasses from the setup, put them on so I could see, and replaced them in the still life when I needed to paint them, doing my best to make out what they looked like.

I continued to particularize Underwood, using hard pastels to define the keys with more ochers, and then a pale yellow. I reached for high-key grays for the metal structures and very sharpened Nupastels for the thread-thin yellow markings that punctuate the front bar.

As the hours passed, the shape of the shadow on the wall above the eyeglasses morphed into a crisper shape, and, at times, it multiplied. I loved it. It reminded me of a typewriter in action, of hitting the return arm over and over, as ideas rush through the writer's mind, so I put it in.

I eliminated the lower piece of paper on the wall to grant space to the nervous shadow. I toned down the table's redness with ocher, umber, blue, and gray Rembrandts. I added the blue keys, developed the image of the opera singer, and added the reflection of light on the table to the left of Underwood.

sessions seven through nine

The composition was still feeling too calm for the content. I find the process of searching for a form that expresses my response to the subject to be endlessly fascinating. With all of the thinking I was doing about the energy of Underwood, I realized that I was calibrating every element of the painting, and now that thought came into the mix of building the image.

With the word *calibration* in mind, I recalled my folding ruler and placed it next to Underwood. In addition to its contextual contribution, I liked the way it balanced the *V* shape of the tumbling ribbon and the triangle of the table hinge on the right. I lightened the shadow on the wall. Wanting to break the horizontal behind the eyeglasses, I added the stapler, liking the idea of the crunching motion and sound that staplers make.

To de-symmetrize the table legs, to separate the typewriter ribbon from them, and to further represent cacophony of thoughts, I taped note papers to the table, and another to the wall. (As mentioned earlier, I have notes to myself all over the studio.) I also added my sketchpad with a self-portrait drawing. I loved the vertical these papers added to the composition. The self-portrait is executed in graphite in the painting, as it is in the sketchbook. I developed the letters *U-n-d-e-r-w-o*. The chattering shadow on the studio wall had lightened considerably, and I followed suit.

Though I had a strong design from the start, as my involvement with the painting grew, so did the composition.

OPPOSITE:

I loved the vertical movement of papers from the bottom to the top of the painting. They provided a great contrast to the weight of the typewriter. I also loved how perfectly the ruler was integrated into the composition, both contextually and visually.

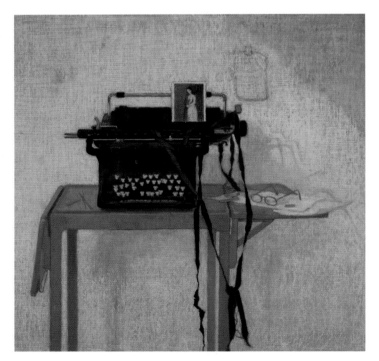

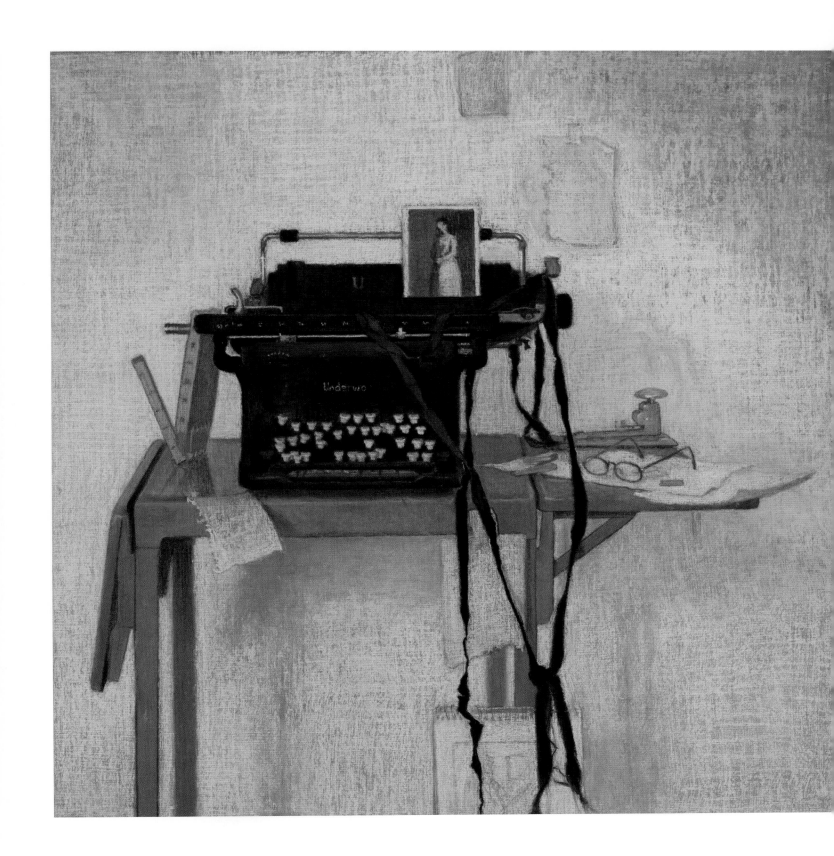

final session

I removed the lower sheet of paper under the eyeglasses and lengthened the top sheet. I added a few more worn-down and broken pastel sticks. I lightened all the lights—the keys, papers, singer's dress, and the wall, including the shadows. I finished the *Underwood* lettering.

I was satisfied that the composition represented my idea and the energy of the studio. I loved that the typewriter is an Underwood, and the singer, the artist, her single voice, emerges from under the surface, inside the tangled mechanism. I was really not certain that the painting was complete, but I felt if I were to continue working on it, I'd be going in circles, so I stopped.

postscript

I am looking at this painting again, afresh, ten months after "completing" it, and I am now thinking that I will unframe the painting to reinforce the shadow on the wall. Also, I had forgotten that Thomas Eakins worked on *The Opera Singer* for about two years. I remember now, reading that he had his poor model pose for . . . was it a hundred sessions? He was working to get the shape of the throat right. The vocal chords. Another fit with the concept of Underwood.

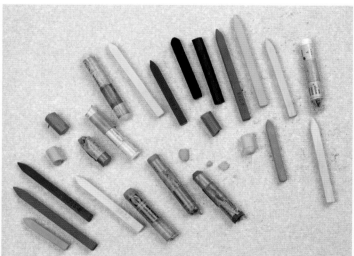

These are the pastels I used in *Underwood*.

Ellen Eagle, *Underwood*, 2010, pastel on pumice board, 19 x 18½ inches (48.3 x 47 cm)

I wanted the contrasts to be strong, so in the final session I lightened all the lights. It seemed complete, but, underneath my satisfaction, I worried that the image had become a bit too tidy.

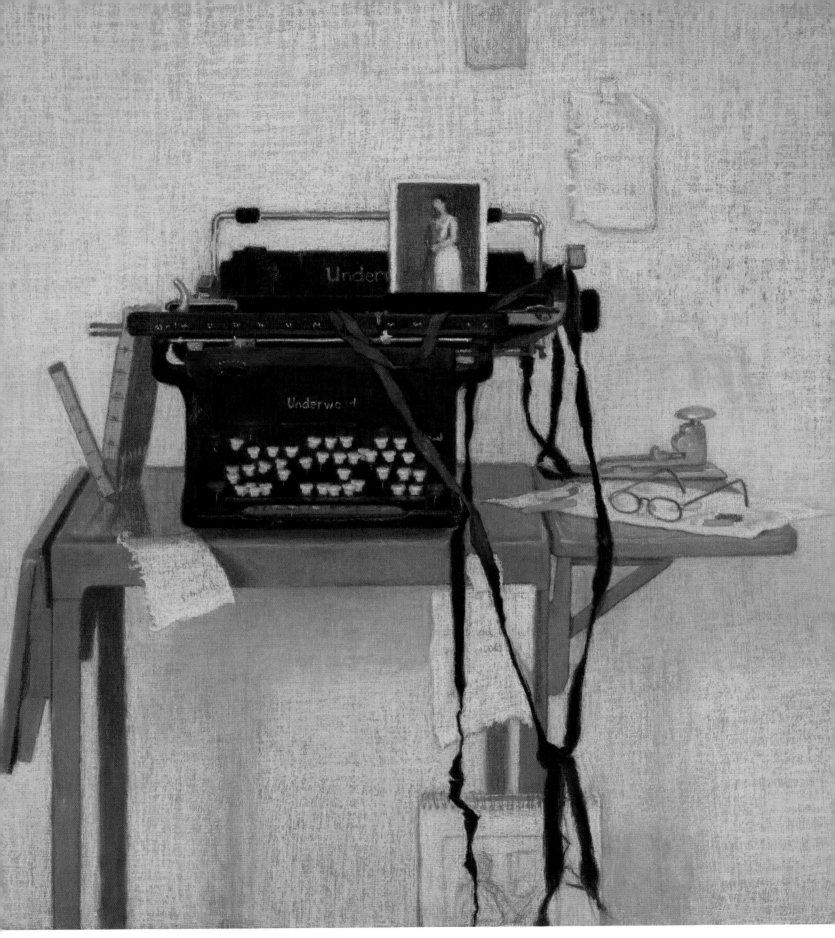

anastasio with pillow

There is a nook in my studio. I love the shape and intimate scale of it. Because it is set back 26 inches (66 cm) from the main space and is framed on top by the steep angle of the roofline, this nook is always in a little bit of shadow, even though it faces my bank of windows. It was a perfect space for this painting set up of a bed-like scene.

My friend Anastasio is an actor. He regularly poses for me, and, while in the studio, we have great conversations about the process of painting and his experiences in the theater. He is extremely observant and very curious about what I am doing at the easel, so, in three of the four paintings I have done of him so far, I have him looking directly at me. In *Anastasio* (see page 1), I focused exclusively on his powers of observation.

Beyond his alert mind, the initial motivation for *Anastasio with Pillow* was the variety of whites and grays in the clothing, walls, and sheets. We tried out a number of gestures. At one point, he was standing, holding the pillow. I loved it, but I wanted to try out some other possibilities. When I saw this pose, it had to be the one. I loved the diagonal angles of torso and limbs, and the legs open in contrast to the clasped hands on the pillow. The corner, the wall on which he leans, seems protective, as does the way he holds the pillow. The concurrence of openness and protection intrigued me.

session one

I stood quite a ways back from my easel as I laid in my charcoal lines. Reaching with my whole arm, I drew long lines. This is an example of internalizing the model's gesture in my own body— the reach of the body and limbs across the bed. (The bed was actually my piano bench set up on a model stand.)

Because Anastasio was facing the light source, the angles and contours of the forms were predominant over the light planes' incremental shifts into high-key shadow. I very much wanted this high-relief type of description, as opposed to the strong light and shadow patterns in, for example, my portrait of Maurice (see page 8), whose topography was fascinating to me. Once I had achieved this broad lay-in, I was ready to move into the color.

session two

At this stage, I was just stating the main differences between one large area and another, noting where it was cooler and where it was warmer. Although there were warms in the setup, the overall composition was cool. I used Rembrandts and Grumbachers to broadly mass in these warms and cools. Specifically, I used olives in the wall shadows and shirt shadows, cool blue in the jeans, raw umber in the hair, light English reds in the lights of the flesh, and light gray in the shirt lights.

I noticed the colors and values of the wall shadows frequently changed color. Shadows on white walls reflect the color of the object throwing the shadow. In this case, the shirt was white. The wall was warmer in the shadow areas than in the areas that were mostly free of shadow. There was a back-and-forth between flesh tone shadow, flesh showing through the shirt fabric, hair color, and pillow colors. All of these tones were in the mix in the wall shadow.

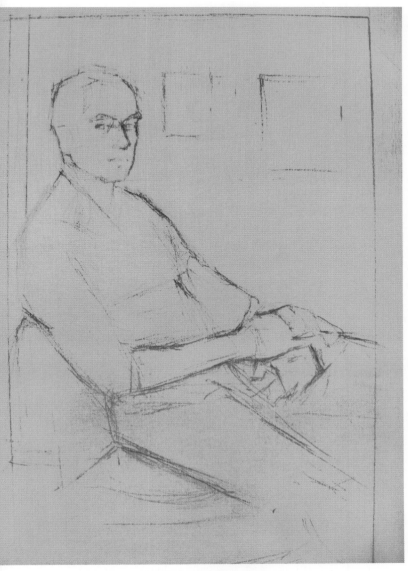

The diagonal angles and Anastasio's proportions were my first concerns. I needed no more detail than this in my charcoal lay-in. I was completely taken with Anastasio's hands.

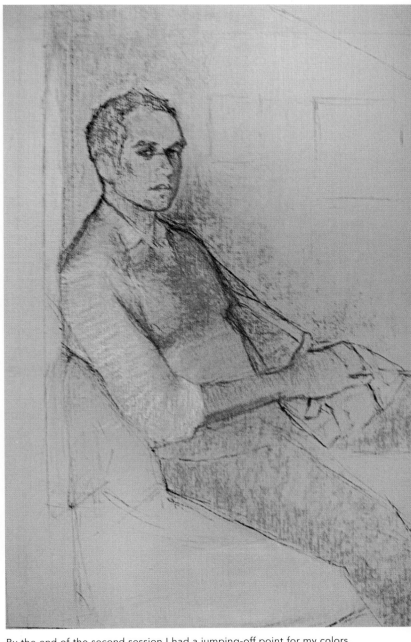

By the end of the second session I had a jumping-off point for my colors. This allowed me to develop the forms by applying fuller layers of color and to move toward more specific value relationships.

sessions three through seven

Anastasio and I share a love of music. We listen whenever we are working together. We very often tune in to Radio Swiss Classic. The announcers speak in German. We don't know what they are saying except for the names of the composers whose works they are about to play. Consistent with the great scope of Anastasio's insights, he weaves stories about the announcers' moods, based on the inflections of their voices. His mind is highly animated, and his engagement with his environment stimulates the way I see his posture and his face. I had pretty much nailed down the expression in his face in my initial charcoal sketch, and so at the beginning of the third session I just needed to build the form with my color.

I went into the head with raw umbers, English reds, permanent reds, light blues, and violets. I added green grays and blue grays in the walls, very light burnt umbers and yellow ochers in the bedsheet, and a green gray in the rolled-up pillow behind Anastasio. I added yellow grays in the worn areas of the jeans, warm brown and raw umbers in the hair, raw umbers and red violets in the shirt, and both reds and raw umbers in the pillow that Anastasio holds.

The varieties of textures were important to me. The shirt is cotton, and ever so slightly transparent. I had wrapped a thin, matte gauze around the pillow that Anastasio holds, in order to tone down the floral pattern of its casing. I loved the gauze, and the worn jeans. I loved everything about this setup.

I was astonished when Anastasio told me, based on the color of the pastel stick I reached for, what area of the painting I was working on. *You're working on the ear. You're working on the eyes.* He always got it right, though he had not looked at the painting.

Then I began to articulate the fingers. The deep rust color at the lower right is the model stand. I liked the pull of the fabric upward, but the dark shape suggested a floor, and that would not make spatial sense. I preferred the precariousness of the diagonal leg against the light tone that was so much a part of my first excitement. I thought about how to handle that.

I asked Anastasio how to say "see" in Greek, and he also told me how to say "paint." I wrote them down and taped the paper to the wall. I continued to enjoy and compare the varieties of grays throughout the setup.

The colors were fully fleshed out at this point. All the tones were in the gray family, except Anastasio's warm flesh and hair and the touch of wood on the lower right. I had been paying a great deal of attention to the textures.

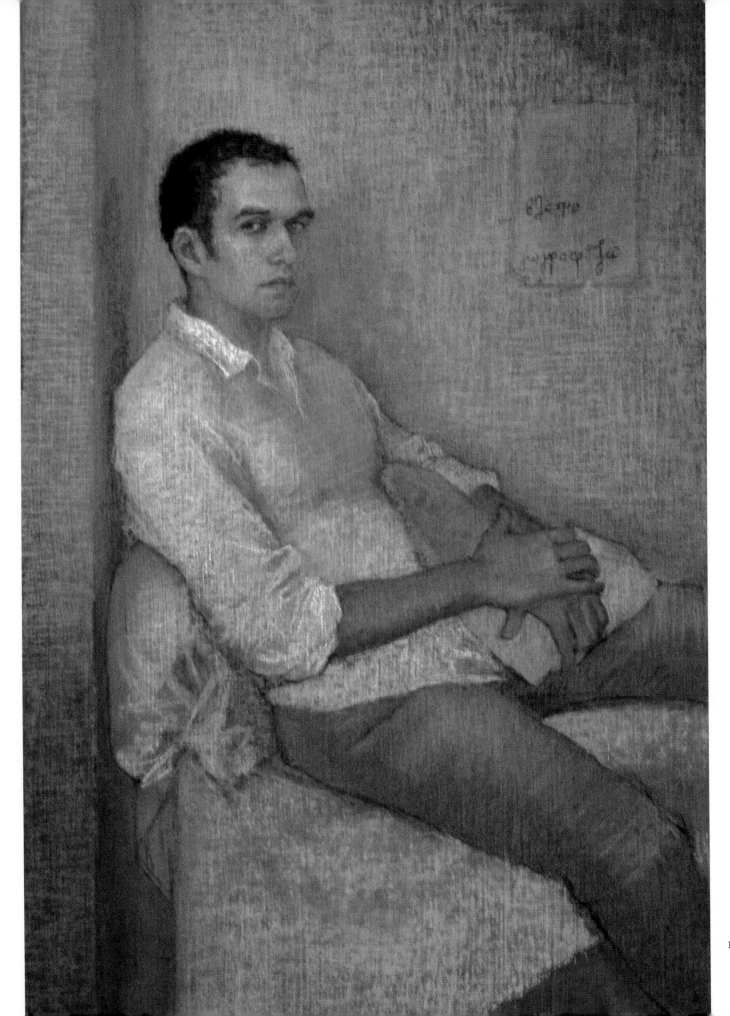

151

final session

I lightened the shirt shadows and toned down the violets with raw umber. I got further into the texture of the jeans. I loved rendering the rips. Then I heavily layered the bedsheet, angled the left edge, and reworked the folds of the rolled up pillow, which reminded me of the top of a Greek column. I removed the Greek translation from the wall by dabbing the surface with a kneaded eraser and did the same to the dark model stand in the lower right. I provided for the angle I had just removed by moving and reshaping the fold in the fabric beneath the leg. I lowered the value of the wall and lightened the wall shadow in the upper right. I added activity to Anastasio's hair.

Anastasio saw the painting at this point and loved it. He looked at my pile of pastel sticks on the table. He guessed how many I used for the painting, and then he counted them. His guess was off by just four sticks.

Take a careful look below at the palette that I used for this painting. Note the brilliance of many of the colors, and yet how high-key and subdued the painting color is. This difference is a matter of the degree of weight with which I press my color onto the board and the overlapping of colors to modify each other, creating new tones.

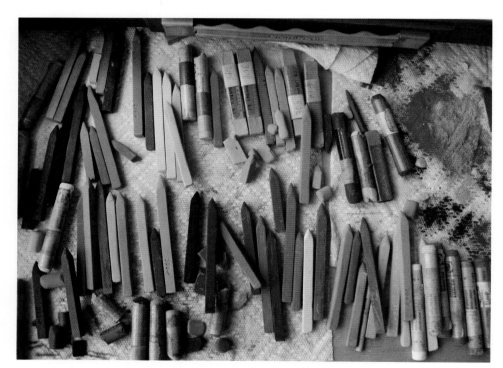

These are the colors I used in *Anastasio with Pillow*. By the end of each painting session, the sticks are piled in mounds. Before the next session begins, I order them into families. When the painting is completed, I place them back into the boxes in the order in which they were arranged by the manufacturers.

OPPOSITE:

Ellen Eagle, *Anastasio with Pillow,* 2010, pastel on pumice board, 18½ x 11¾ inches (47 x 29.8 cm)

When all the tones in the painting express what I love about the setup, when all the forms are developed as far as I want them, the painting is finished.

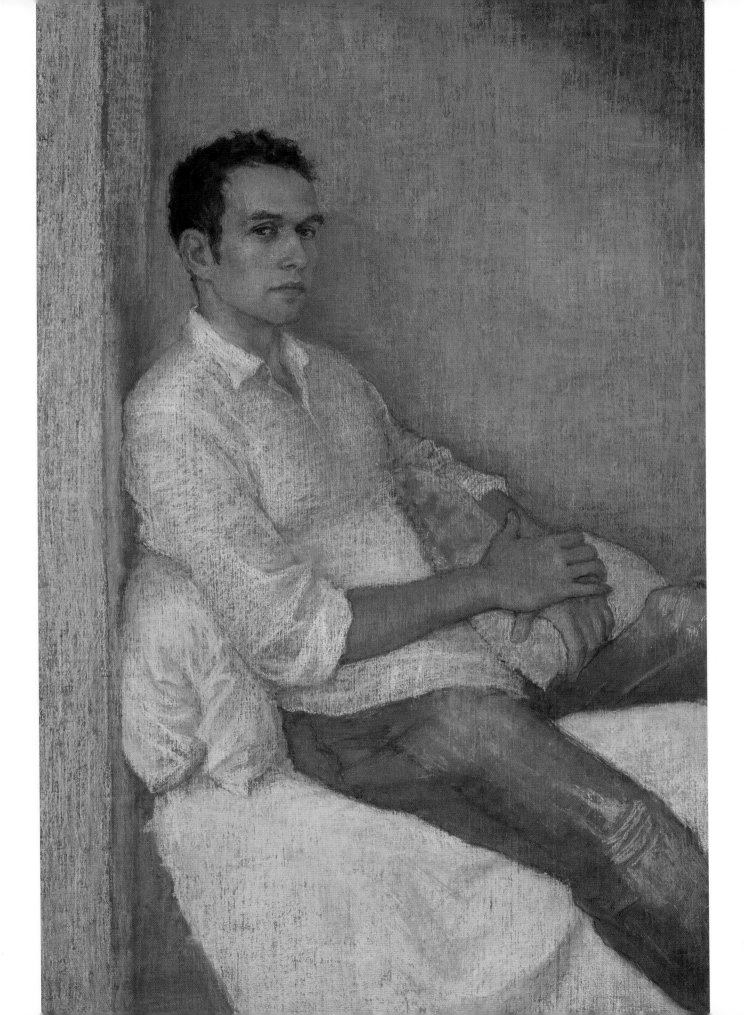

dried flowers, garlic skins, fabric, and threads

I collected the flower petals and held them in a studio corner along with the garlic bulbs for quite a while. I love combinations of very close colors, and the transparency of these particular textures. The background of this image is an old ledger book that used to be my father's. The dry, rough texture and matte colors of the cover relate to what I love about pastel. The threads and fabric belonged to my mother.

Ledger books are where people keep track of things and make them add up. With her fabric and threads, my mother created new things—beautiful pillows, draperies, tablecloths, wedding dresses, and nightgowns. I loved the shapes of the threads, so like the flower stems, and the *V* shapes of the fabric, garlic, and flowers. I also loved the airborne arrangement and the caring presence of my parents.

session one

One of the best questions I have ever been asked by a student was "What are you thinking about when you start a portrait?" I was reminded of that question as I contemplated this still life. What comprises a credible composition? In this case, the parts came together perfectly without my thinking. It began with texture. My parents' textures permeated the arrangement with warmth, and in this context, the translucent flowers and garlic skins danced across the surface in the light. It felt completely credible.

As I began to draw the shapes, my eye became increasingly sensitive to the graceful arcs, petal to petal. I found many points in the arrangement of items to calibrate positions and sizes—parts of petals touched by light, shapes between the objects created by their contours. As the shapes of the petals developed in charcoal, the flowers began to remind me of birds in flight. The charcoal lay-in conveyed a sense of delight.

At this stage I was working only with contour. I turned a few of the flowers in the setup to attain the background shapes most pleasing to me.

session two

I loosely laid in the shadow shapes and saw the subtle temperature differences in the shadows of the flower petals and the garlic skins—both so thin and crystalline against the dark linen. By beginning to deal with the shadow shapes, I transitioned from the purely flat linear design of the contours into depth and space.

Next, I started putting in touches of light, particularly in the center flower, which presented a whirling shape. The flowers were now beginning to look as though they were being tossed by a breeze. This idea deeply resonated with me, as it contrasted with, and therefore reinforced, the forever history of my parents.

I chose pink, blue, and ocher to create the subdued colors of my father's ledger book and worked toward the glistening flowers and garlic with warm shadows and cool lights.

The character of the movement changed when I applied the touches of light to the petals. The change had a major impact on the meaning of the painting.

session three

I began this session by substantially rebalancing my blue, pink, and ocher combination of the ledger. Its cover is quite worn and, therefore, the tones vary. For my painting, I wanted a steady tone as a backdrop to the action, and I decided that the bluer aspect of the linen was probably closer to its original hue. This proved also to be a more eloquent base upon which to express the golden tones of the flowers and garlic, and of course, my mother's fabric and threads.

I then moved to the flowers. Picking up my greens and deep ochers, I laid in shadow colors throughout the petals. For the lights, I layered pale yellows on top of the shadow colors. My intention was that the shadow tones beneath the lights would provide a solid ground and hold the complicated patterns of light and dark in unity.

session four

It had been several weeks since I had worked on the painting, and seeing it anew, I was struck by the fact that the arrangement of warms and cools was not unlike that in *Peter's Grandfather's Camera* (on page 72).

I squinted at my still life and saw that the contrasts between shadow and light needed to be greater. I went into the shadow shapes. I started with the greens, but found they were not dark enough, so I selected a shade of warm gray to lower the value of the green. I then went back into the lights with a heavier application of the pale yellows I had worked with in the previous session. The heavier application registered the yellow lighter than the preceding layers. This was good. The complicated textures were working out.

In the days I had been working on this painting, I noticed that in the latter part of the afternoons, the lights in the garlic skins shifted from a pale gray to a pronounced turquoise. I did a quick visual roundup of all the colors in the arrangement when the turquoise returned. I made slight adjustments to all the tones to be in accordance with the turquoise light and checked my Nupastels and Rembrandts for the lightest turquoise available. I did not see anything light enough. It was time to open my Sennelier collection.

I noted that the flowers were crinkly, like papery skin. I thought about my mother's tissue paper patterns on the dining room table. I loved her fabrics, her tissue paper shapes, and the pencil marks she made on them. I love that she undertook to make patterns and chose fabrics with proper and loving consideration. I have some of her patterns and fabrics here with me. Soon I will do a painting of her papers and pencil marks.

I found that I was loving creating depth for objects that measure 1/8 to 1 inch (.3 to 2.5 cm) thick. Rendering minutely receding spaces involves the same issues as depicting a skull, a torso, a typewriter. The theory of relativity.

session five

At the beginning of this session I studied the painting with a fresh eye. I realized the garlic bulb was too small, and it was placed too close to the bottom edge. I needed to move it up, and enlarge it, but that changed the composition. Working on a pumice board means that there is no problem at all in removing pastel marks from the surface. For a pastel artist who works for several weeks and sometimes months on a single painting, in the changing natural light, and only from life, being able to make changes is critical. Our materials have to cooperate with our goals. Pastel is widely appreciated for the opportunity it offers for rapid application. However, those of us who work not on rapid studies but on extended explorations value the ability of pastels to be scraped out, allowing ideas to be restated and our perceptions to develop so that our work can benefit from full investigation.

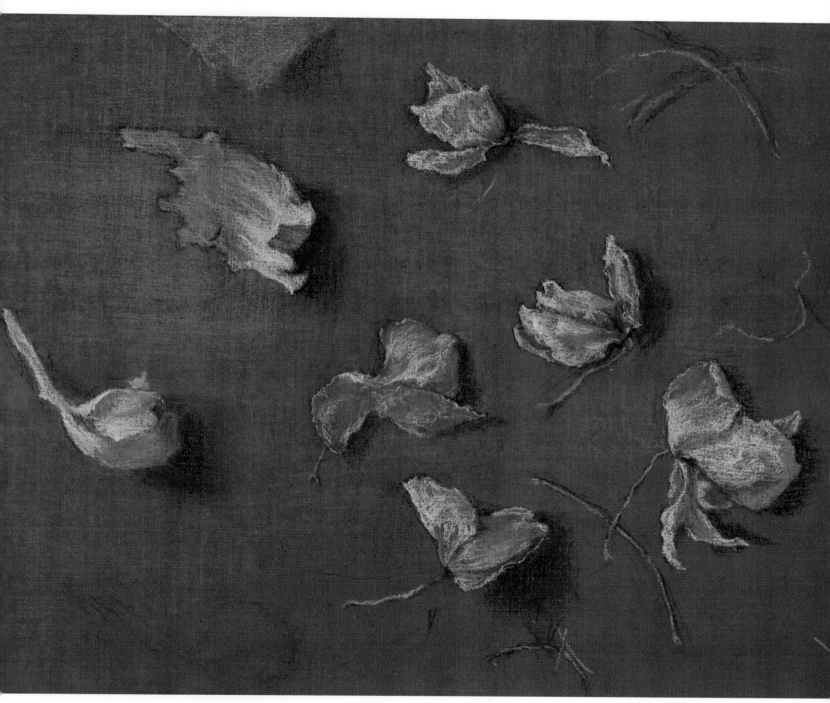

By session five, the forms had been fully considered and the placements of warms and cools had been fully designated. My pumice board allowed me to make a compositional change with no damage to the surface or image. The textures of the flower petals suggested an idea for a future painting.

session six

Once again, I had been away from the painting for months. It was raining, and, therefore, very dark in the studio. After being away this long, it was hard to know where to start. So I squinted in order to identify any glaring errors in shapes and values. I saw that the lights had to be lightened. I also had to think about edges.

session seven

As I developed the intricate textures I had to be careful not to lose the overall movement of light that united the petals and garlic skins. I wondered about how far I wanted to take the rendering. Did I want to record the fullest possible contrasts of darks to lights? Or did I want the closer range that I sometimes see? I thought about the interest I have in painting paper towels, which are vessels for light and shade, as simple as can be. What was most important to me about these garlic skins and flowers? What condition of nature did I most respond to?

final session

To bring the painting to a resolution, I cooled down the garlic skin on the upper left, using Nupastel light blues and grays, in order to distinguish those tones from the warmer flowers. I lightened the ledger, and all the light shapes, simplifying as I went along. I eliminated linear edges where there should be none. I added the threads and reinforced the swatch of fabric.

These are the pastels that I used for *Dried Flowers, Garlic Skins, Fabric, and Threads,* except for the Sennelier, which I had put back in the box for safe-keeping. The top row contains the cool colors; the bottom contains the warm colors.

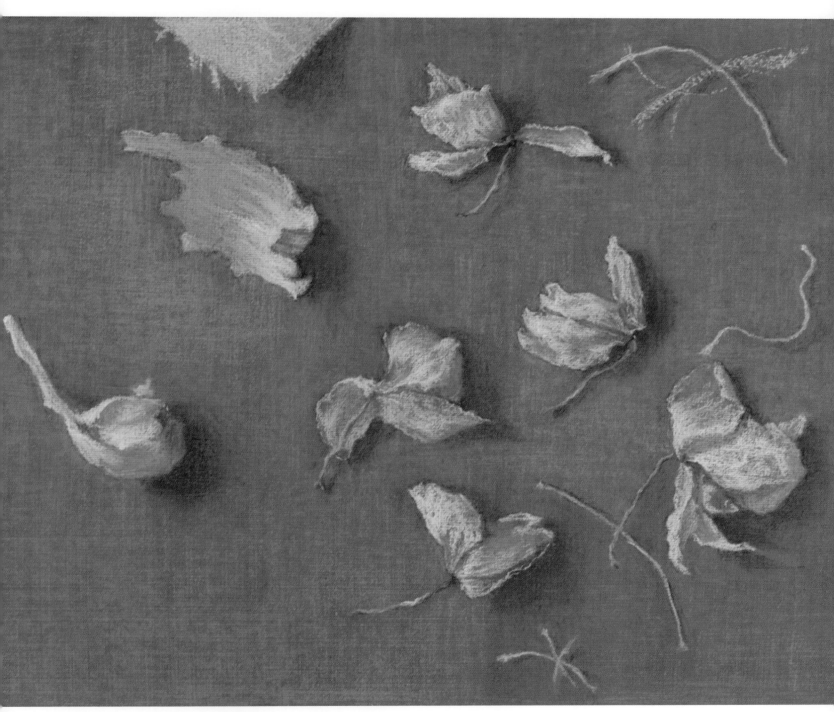

Ellen Eagle, *Dried Flowers, Garlic Skins, Fabric, and Threads*, 2012, pastel on pumice board, 6¾ x 8¼ inches (17.2 x 21 cm)

This may appear to be a lighthearted still life, but the arrangement elicited a great deal of feeling as I worked on it.

bee balm

Despite my appreciation for flora in the cultivated garden and those that ramble wild across the landscape, until recently I had never felt enticed to paint a flower. I've always responded to a certain contrast of qualities that coexist within a subject and that catalyze each other in a kind of tension. In flowers, I generally feel pure peace, which does not call upon me to pull elements together into harmony. It was not until I discovered monarda, or bee balm, that I found a flower whose body offered such contrasts of form and texture that its complexity bid my desire to study its personality.

session one

I had selected seven bee balms from the garden. Excited by branching out into flora, I first set up an arrangement of all seven. But the more I looked at the flowers, the more I wanted to zero in on the specifics of an individual flower. Which one, then? They were all in slightly different stages of bloom, and they were of different colorations. I chose one that was reddish, rather than purple, and seemed to be curtsying. I squinted to find the main structural segments. Using charcoal I laid in my first lines, seeking to capture the gesture in as simple a statement as possible.

Into the center leaves, I layered Nupastel olive green and Grumbacher cadmium orange, which has a golden tone, and then, Nupastel lemon yellow. I then laid in the background with a very light gray. The color of my backdrop was vastly different than my gesso-pumice support and all the parts of the flower. The dark flower was silhouetted against the light backdrop. I stroked the background color a distance from the petals at this stage because of its light value. Light colors dilute much darker colors that are laid on top of them. I wanted to be sure of the petal shapes before committing my light gray very nearby.

The goal of my first lines was to capture the overall proportion and outward reach of the petals and leaves. I also loved the slightly precarious tilt of the stem.

OPPOSITE:
My initial color concern was to establish the dark floral silhouette against the light value background.

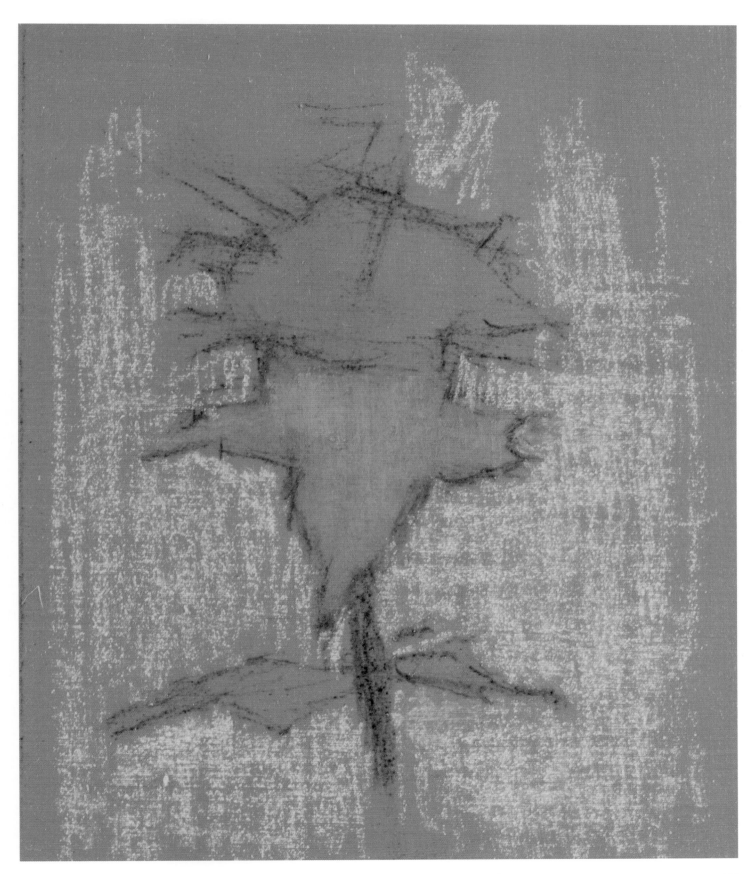

session two

I went in with deep reds and violets, slic-
ing the petals outward and chopping in
with the background. I saw many color
shifts, particularly in the center ball form,
and the leaves. My priority at this stage
was to get the general color character of
each main segment, so I maintained the
mostly golden-green for the center form.
I began to state the outreach of the petals.
I had placed the flower in a plastic water
bottle and I wondered whether I wanted to
include the top of the bottle neck.

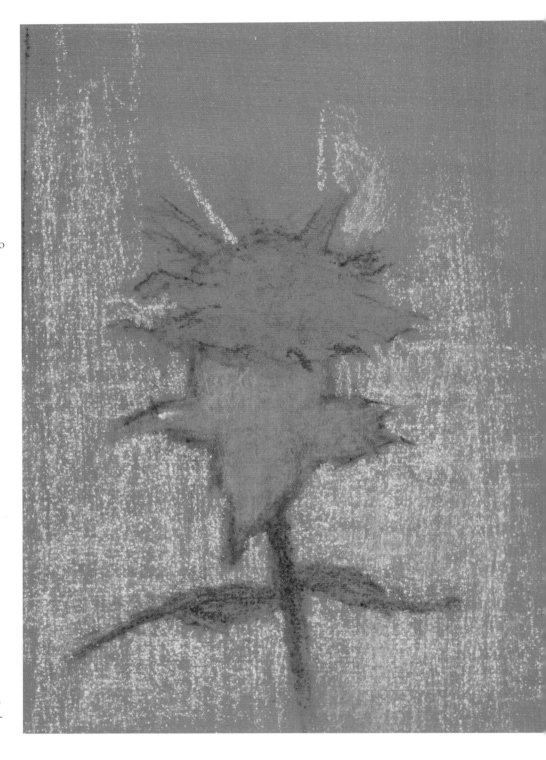

Now I was ready to explore and distinguish the
varieties of warm tones, forms, and growth pat-
terns throughout the bee balm.

session three

My fascination in the intricacies of bee balm was sustained as I saw the light infuse the translucent petals and wrap around the central ball. The variegated textures and the contrasts of shapes were becoming even clearer, displaying the tension to which I always respond. Using a variety of light greens and ochers, and a deep purplish red, I began to fashion the tiny mounds that dotted the central core. I distinguished the green in the leaves from those in the central ball and from that of the stem. I began to specify the very top petals. These were the petals on the far side of the flower, and they were quite sharply delineated against the light background.

I was amazed to observe the bee balm gradually withering hour by hour as I painted. Gravity pulled each petal outward and down, and the contour of their grouping was becoming spikier as the petals separated from one another.

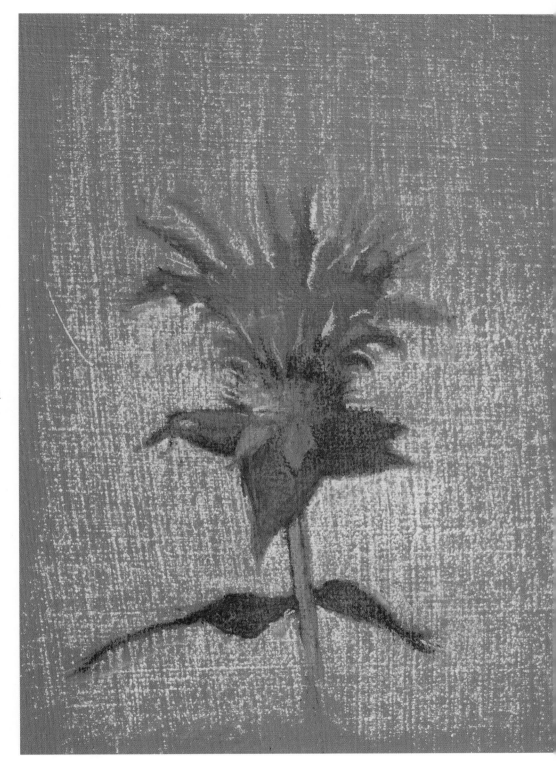

The changing light was revealing increasing intricacy of form and texture, and the shape of the flower itself was shifting. It was fascinating to watch.

These are the pastels that I used in *Bee Balm*. Because the forms were so tiny and had sharp edges, I primarily used hard pastels.

final session

Knowing I had to work quickly, I now fully developed the forms. I was attentive to the petals closest to me as well as to those on the far side. I applied several kinds of reds and violets throughout the flower, except for the stem, and I added a deep blue green to darken the leaves. Using a cool gray, I considerably built up the background layers, and then I applied a touch of yellow to its upper area.

I opted to maintain the little triangle shape of pumice board exposed at the base of the stem. It feels graceful, and I like the way it works with all the forms above.

The six bee balms that I did not paint remained in my studio for the duration of my study. I noted that each one withered in its own sequence, petals and leaves dangling and then falling off, leaving behind a cluster unique to its own body. The shapes remained amazing throughout their life cycles. My bee balm curtsied almost to the end. I am grateful that pastel, my dry medium, allowed me to work quickly and see it all the way through.

OPPOSITE:

Ellen Eagle, *Bee Balm*, 2012, pastel on pumice board, 4⁹/₁₆ x 2¹³/₁₆ inches (11.6 x 7.1 cm)

My extremely simple lay-in, in which I approached only the largest forms, permitted a necessarily rapid resolution of the complex arrangement.

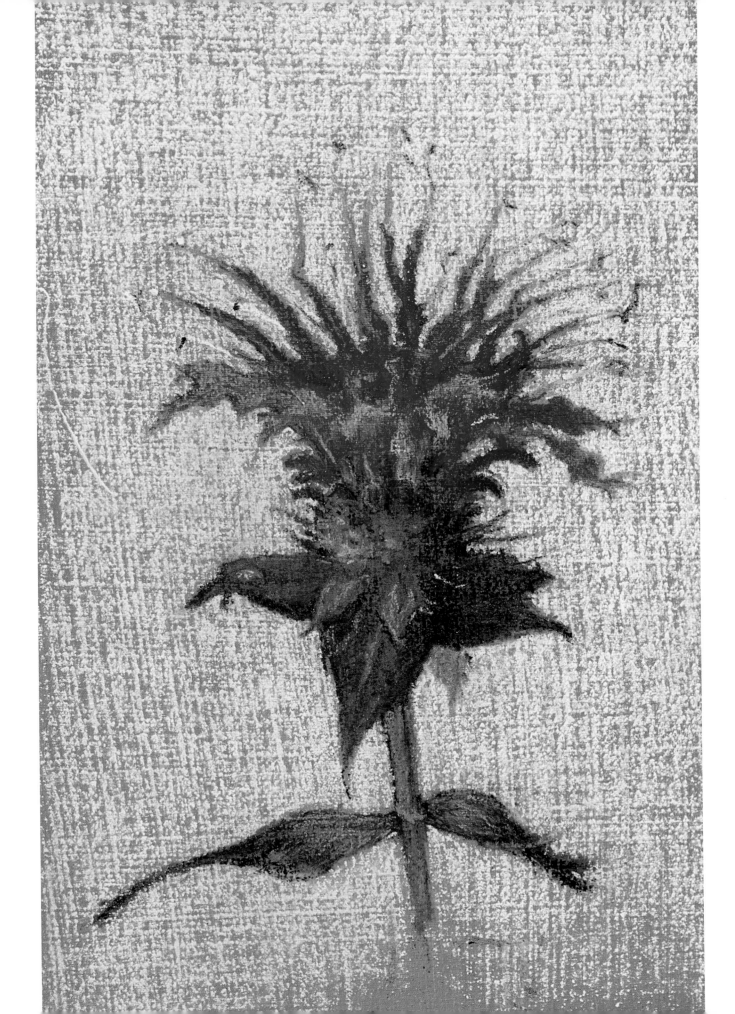

emily in profile

Captivated by the strength of Emily's upper facial features, the softness of the lower facial features, and the design of her hair, I set her in profile. From the start, I was aware of an inner life that was clearly conveyed in her posture, eyes, and mouth. Throughout the development of the painting, I was excited about the contrast between the strong edges of the profile form and the subtle color shifts in the flesh.

session one

I did a quick exploratory drawing to familiarize myself with Emily's proportions. In the first stage I begin to really absorb the characteristics of my model. Though I was working only in graphite, my eyes were already registering information about her coloring. Emily is a writer. I thought that the drawing captured the sense of her active mind, and that was as far as I wanted to take it.

session two

After laying in my charcoal map, in which I made the shadow shapes very light, I quickly established the warms and cools throughout Emily and the background. I used soft Rembrandts, Grumbachers, and Art Spectrums and hard Nupastels and Creta-colors. The image had a geometric quality at this stage, due to the clear boundaries of the colors abutting adjacent areas of different colors.

It was important to me that the image clarify, from the start, the position of the light source. Emily was facing the light. All of her front planes would, therefore, be lighter than the planes that face away from the light. However, if I did not feel I had tapped into something internal, nothing else in the picture would matter to me. Every part of the image was in the service of something interior.

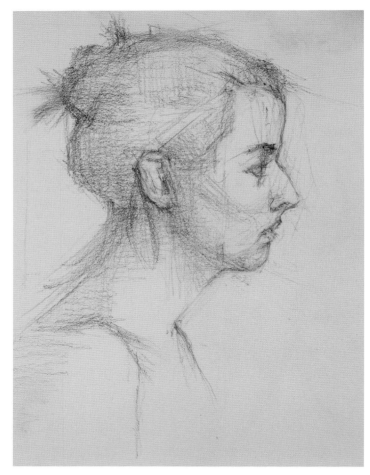

Working on Strathmore 400 Series Drawing paper with graphite, I found the proportions and summarily indicated the shadow shapes and light planes.

OPPOSITE:

To begin the color, I established the major warm shadows and the cool planes that faced the light source. I worked in all the areas of the image, including the background.

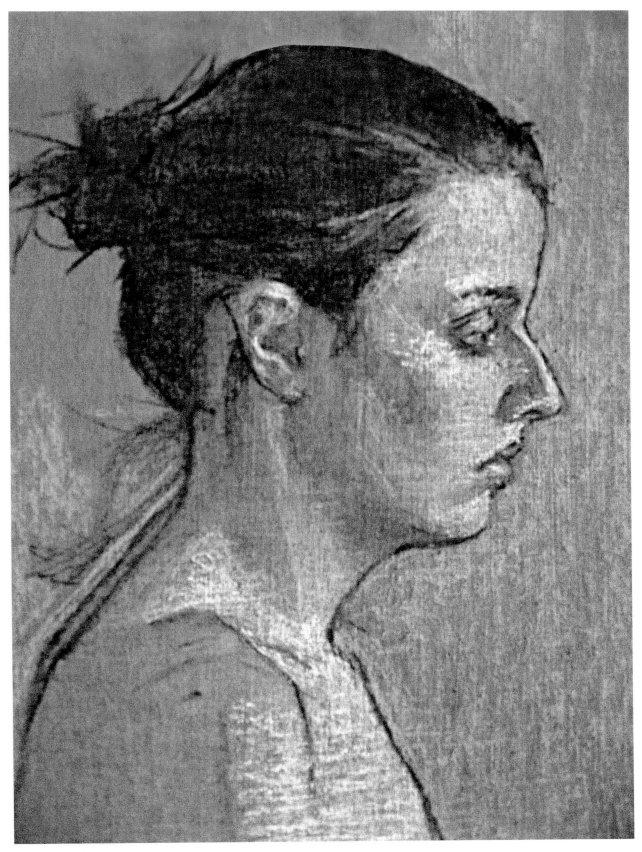

session three

I often make charcoal drawing lines on top of my pastel when I want to reaffirm to myself a structural feature. In this case, I especially wanted to emphasize the jawline and the neck. I love doing this. It feels like an acknowledgment of my commitment to the painting.

I developed the planes of the head by adding lighter burnt siennas to the top of the hair, and restructured the shoulder and angle of the chest. Feeling I had gone too far with the ear, I simplified it, with only the light in mind, and the blush on the outer rim.

I was in awe of the powerful bone structure and musculature that lay under and shaped the delicate flesh into planes. Emily's moist eyes and ever-so-slightly parted lips spoke so eloquently of feeling.

sessions four through six

I decided to lift Emily's chin, to inject a bit more of her cultivated, elegant manner. This required a great deal of work. All the alignments had to be adjusted ever so slightly. Again I redrew the angle of the upper chest. I began to coalesce the colors into a much greater harmony. Losing some of the charcoal edges permitted me to move toward depth of form. I studied the ways in which the hair at the roots divided into sections as it traveled back toward its gathering place.

I made some adjustments to the drawing, reaffirming some of the bone structure.

OPPOSITE:

I lifted the chin to emphasize Emily's elegance. I advanced toward a more sculptural whole by eliminating some of the charcoal lines and further integrating the colors.

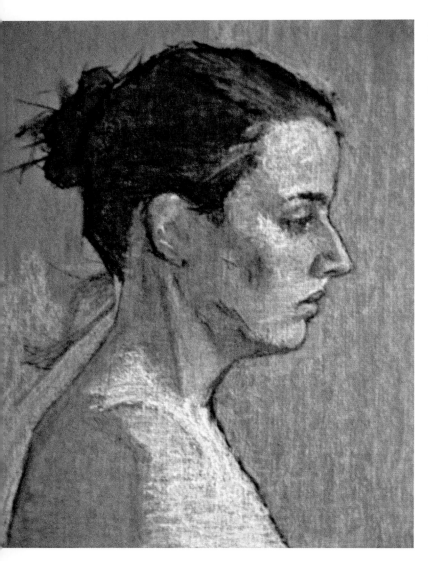

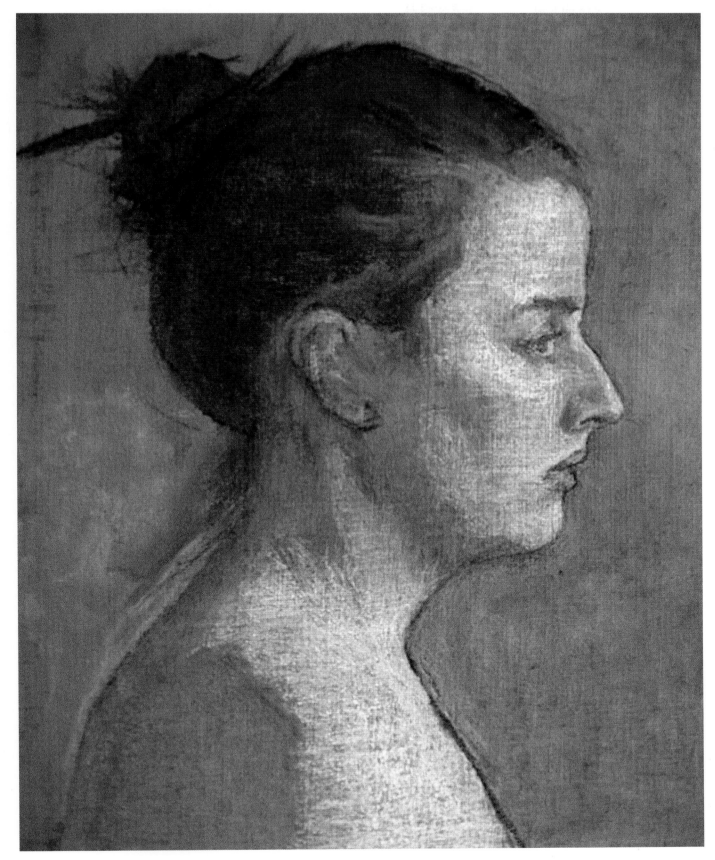

sessions seven and eight

I continued to harmonize the colors, adjusting transitions. I looked with great concentration at the forms of the ear, being sure to light it properly, and at the divisions, twists, and bumps in the hair. I studied the colors of the hair at the hairline and reached for my charcoal once again, to restate the shape of the bottom of the upswept hair, the back, and, yet again, the upper chest.

I articulated the eye and softened the lips. Once I was basically satisfied with the tones of the cheekbone, jawline, neck, and shoulders, I allowed myself to add the large, reverse comma of hair draping from behind the ear that was present from the first day.

final session

From our first session through to the final, as Emily sat for me, she was often in deep, silent conversation with herself. Sometimes her lips parted. At other times, they firmly pressed together. The parted lips struck me as in perfect accordance with her partially open eyes and heavy lashes. As simple and elegant as the light is on the complex form, the vitality of Emily's mind and spirit is where the drama resides.

Having established the large shapes, I honed in on specifics that were smaller but equally important to my portrait of Emily.

OPPOSITE:

Ellen Eagle, *Emily in Profile*, 2008, pastel on pumice board, 7¼ x 7 inches (18.4 x 17.8 cm)

My goal was to capture the sense of Emily's active mind, her powerful bone structure, and delicate skin tones. The simplicity of the shoulders and neck present, and elevate, Emily's regal face and stirring hair.

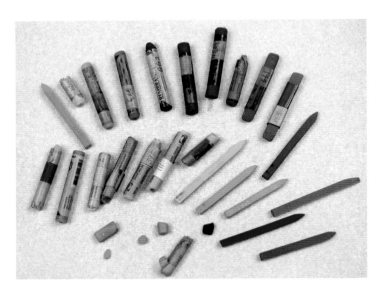

These are the pastels I used in *Emily in Profile*.

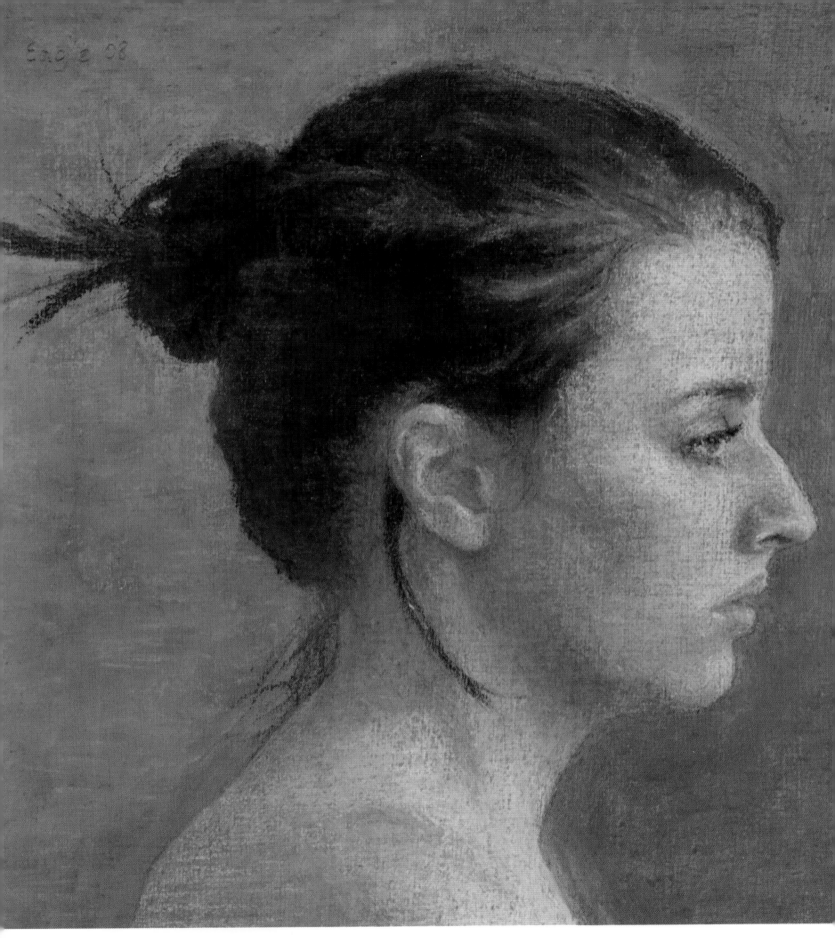

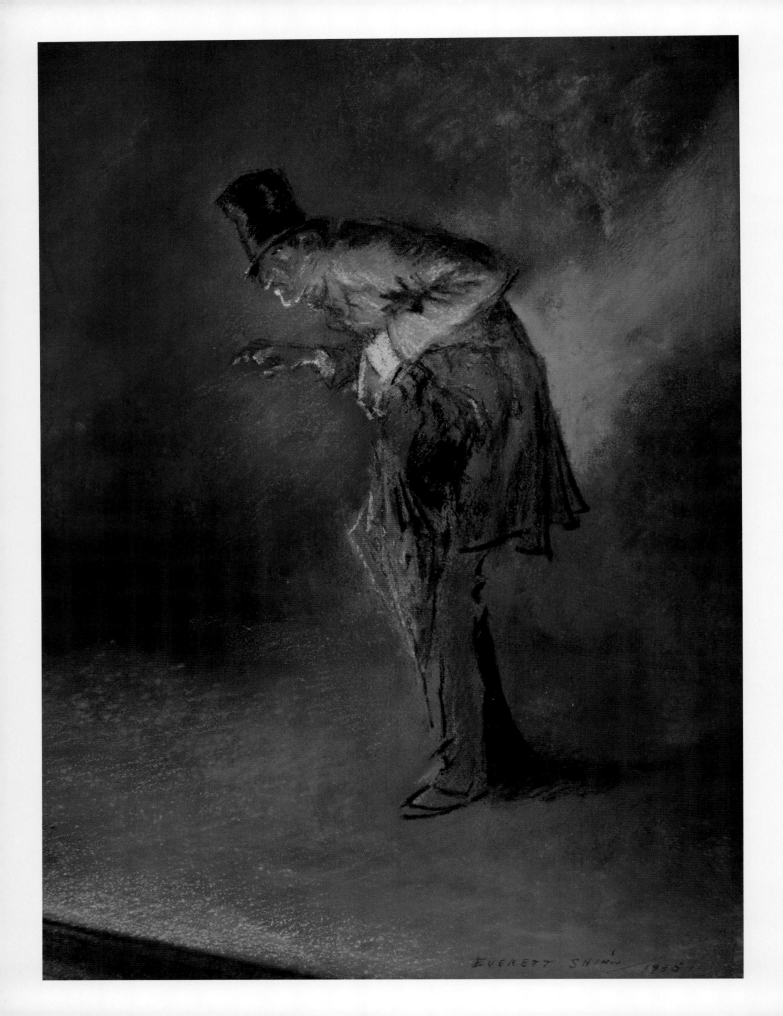

display and handling

Everett Shinn (American, 1876–1953), *Vaudeville,* 1935, pastel on board, 14¾ x 11⅜ inches (37.5 x 28.9 cm), collection of The Mead Art Museum at Amherst College, Amherst, Massachusetts, museum purchase, AC 1951.157

With broad sweeps of vibrating colors and contrasts that suggest artificial light, Shinn evokes an audible theatrical atmosphere. It appears as though the lighting director is moving the lights and changing the colors as he syncopates with the dancer's gestures across the stage.

Many artists refer to their paintings as their children. We bring them into existence and give our all that they may fulfill their potential. At some point, they are ready to stand on their own, and we need to know that we have prepared them to safely go out into the world and make their mark.

It is sometimes difficult to part with a painting to which we feel particularly close. Yet these are the paintings we may be most eager to exhibit. Exhibit requires the works to be framed, and often, the works must travel. Just as we studied nature and our environment to construct our imagery, so must we be aware of the effect that environment has on the bodies of our paintings.

This chapter addresses the pastelist's primary concerns once the painting leaves its home on the easel: proper framing, storage, display, and preparation for transit. These issues are so important that museums and galleries employ staff members, called art handlers, who are entrusted exclusively with the tasks of storing, packing, and moving the works; shipping boxes exist specifically to house paintings; moving companies who specialize in works of art have temperature-controlled cabs; and exhibition spaces carefully monitor light and air quality. The care that they, and you, provide, assure that the love and craft inherent in your works will be preserved and viewed to their fullest potential.

caring for pastel paintings and drawings

When a museum curator considers the acquisition of a pastel painting, a conservator examines the work. The authenticity of the painting must be confirmed. To this end, the identification of specific pigments can locate the time and place in which the painting was created. The conservator is looking for evidence of prior restoration and hopes to find minimal, if any, intervention. In the past, conservators were more aggressive and invasive with works of art, often altering the original content of the work in the name of "restoration."

Today, the finest conservators seek to maintain the integrity of the artist's intentions. They do only what is necessary to maintain the work's stability and to protect it from further damage. Today's conservators are willing to do only what is reversible.

The structural integrity of the painting and mounting is very important. If the painting is vulnerable to rubbing up against its glazing, it will have to be remounted. The conservator might recommend a deeper frame to keep the paper at a distance from the glass. Can the painting be safely moved? Is there gouache in the painting? Is it flaking or is it stable? Great care must be used in the handling to prevent tearing the support or dislodging pastel and gouache granules.

One of the most pervasive problems that a curator finds in works on paper is mold. Pastel, the papers on which they are applied, and the adhesives used in the framing can all be vulnerable to molds if the moisture levels in the environment are too high. Mold can grow quickly, sometimes becoming visible only in a matter of days. Humidity can also cause paper to expand and contract, however slightly, or cause the paper to ripple. If this happens, the paper could touch the glass, damaging the pastel application. Conversely, if the environmental moisture level is too low, the paper support can dry out. A temperature range of 68–72° F (20–22.2° C), and a 48–52 percent humidity level is ideal to prevent the development of mold.

Once a painting has been acquired, the museum will store it in an upright position or lay it down, with air spaces between it and the adjacent paintings. The main consideration is to prevent the painting from being vulnerable to vibration.

Pastel paintings are kept in darkness until they are mounted for exhibition. A small "foot" at each back corner allows air to flow behind the painting, once it is installed for exhibition. The air space prevents humidity from becoming trapped behind the painting.

The conservator may adjust the lighting in the galleries in which the painting will be mounted. This is in the interest of the paper pigment, as well as the pastel pigment. Pastel paintings in which much paper is revealed need particular protection from the light, because many papers are toned with fugitive dyes, not permanent pigment. Fugitive dyed papers were used widely in the nineteenth century. After pastel paintings have been exhibited for a few months, the color is measured, and any change is noted. Color does not rejuvenate, and light damage is cumulative.

During a visit to the Metropolitan Museum's magnificent exhibition *Pastel Portraits: Images of 18th-Century Europe,* one of my students pointed out how rich the color has remained for two hundred and fifty years. With the technological advancements in examination techniques, the modern conservator's attitude of nonintervention, and the care with which pastelists know to handle their supplies and works, pastel paintings can maintain their brilliance for a virtual infinity.

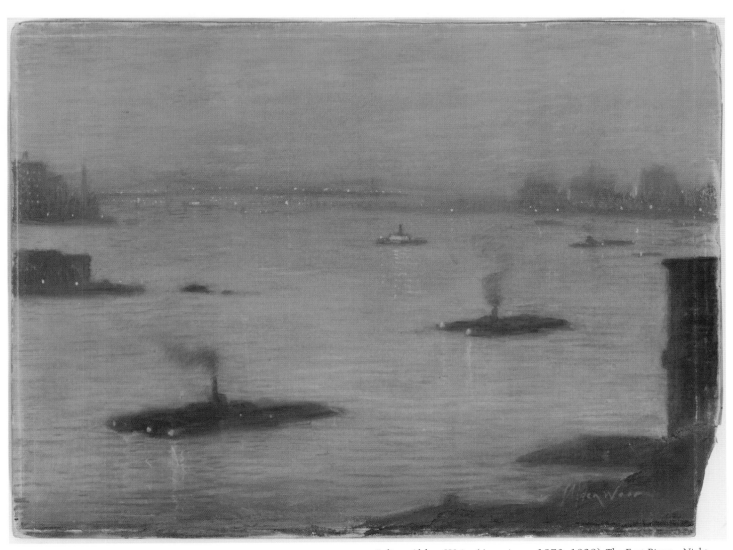

Julian Alden Weir, (American, 1870–1938) *The East River—Night Scene,* date unknown, pastel on board, 12 x 16 inches (30.5 x 40.6 cm), collection of The Mead Art Museum at Amherst College, Amherst, Massachusetts, gift of Hall and Kate Peterson in memory of Mrs. Barbara Babbott (Mrs. Edward F. Babbott), AC 1978.33

Improper handling at some point in the painting's life caused the support to tear. By using muted colors and many horizontal (or close to horizontal) shapes, Weir creates a quiet atmosphere. At the same time, by including the lights on the distant bridge and beyond, he suggests the electricity of the city, out of earshot. The near quiet and the far activity intensify each other's power. I grew up on Staten Island and saw Manhattan from across the harbor, so this painting resonates for me as absolutely true.

175

framing pastel paintings

We frame our works not only to enable their exhibition, but to preserve their safety. Only acid-free materials should be used because acid releases gasses that break down paper particles and damage pigment.

From front to back, the pastel mounting consists of the following elements: frame, glass, mat, spacer (optional), artwork, backboard, protective paper, rubber discs, and hooks and wires.

The frame has to be deep enough to encase all the other elements of the mounting. When the artwork is on a board rather than on paper, the frame has to be that much deeper. The glass should always be ultraviolet. The size of the mat, from its cut opening to where it meets the frame, depends upon the dimensions and compositional design of the artwork itself. The mat overlaps the four edges of my small paintings by ⅛ to ¼ inches (.3 to .6 cm). Large paintings require more overlap.

I began to use spacers behind the mat when I noticed that, in a few of my framed pieces, small amounts of pastel powder drifted downward and settled on the mat. With the spacer in place, if there is any floating of powder, it will come to rest behind the mat. The spacer and mat keep the surface of the painting ¼ inch (.3 cm), or more, away from the glass. The backboard provides a rigid support for the painting. The protective sheet of paper, whose four edges are glued to the back lip of the frame, assures a complete encasing of the artwork. This is essential in order to protect the painting from humidity, dust, and pollution. At each corner, a small rubber disc keeps the back of the painting away from the wall and allows for proper air circulation, preventing a humidity trap behind the painting that could then damage the support and artwork.

The color and size of the mat and frame are determined by the colors and size of the painting. The choices are determined by the artist's aesthetic. One very prominent contemporary pastelist prefers a mat in the midtone range of his painting so that the darks and lights of the painting remain the darkest and lightest of the presentation. I think this is a very sensible approach. When I had my first pastel framed, I did not want a mat at all. My framer objected, but I was stubborn. When I look at it now in its frame, the figure filling the paper, the image seems confined, pushing out against the dark frame. I now generally use a light-toned mat, often a warm or cool gray, which I feel grants the painting breathing space. The light color feels clean, and it nicely isolates the image. I often choose a mat that has a very slight texture because flat mats reflect light a little more than the textured surface, much the way straight hair appears shinier than wavy.

In general, I favor wood frames over metal. A simple grainy wood is consistent with pastel's matte, powdery, and earthen textures. To my eye, shiny metal is discordant with these qualities. However, it could certainly be that a painting done in fully saturated colors, with many smoothed out passages, might find a perfect fit with a metal frame. Each painting requires its own solution, and it helps to look at several choices of mat and frame against art.

Glass comes in a variety of properties. My works are framed under Museum Glass, which blocks 99 percent of indoor and outdoor ultraviolet light rays. Ultraviolet light rays cause pigments to fade. Fading is both cumulative and irreversible. Ultraviolet protection is a relatively modern innovation and permits the exhibit of pastel paintings for a longer period of time than was historically possible. Museum Glass does not reflect other items in the room in which the painting is installed, so the full painting is clearly visible. I do not care for what is called non-reflective glass, which contains a kind of dulling haze. Do not use acrylic in place of glass. Acrylic has a static factor and will "vacuum" pastel particles from the work and onto itself.

Glass may be cleaned by spraying a small amount of glass cleaner in a microfiber cloth. Never spray a cleanser directly onto the glass, as it could drip down behind the frame and spread into the mat and artwork. I have also used a dry microfiber cloth.

Usually a spacer is made of strips of mat board placed along the back side of the front mat, or it can be a full mat cut with a wider opening than that of the front mat so as to not be visible.

In my opinion, the purpose of the mat and frame are to protect the artwork and make it possible to hang the painting on a wall, period. The purpose is not to dress up the painting. My taste runs to the simple. On the other hand, museums clearly exhibit paintings in elaborate and often exquisite frames that somehow do not take away from the art. I conjecture that this is especially true when the frame is original to the time of the creation of the painting. I recommend keeping your choices simple. You can always get more elaborate as you experience seeing your works mounted over time and notice which framing approaches you respond to in museums, and why.

Pastels can also look elegant when framed "floating." This is a particularly nice method to use when the edge of the paper

support is deckled or slightly scalloped, as some heavy papers are. In the floating method, the painting is mounted on a larger sheet of paper. The larger back paper creates space around the painting the way the mat does in the traditional method. The frame has to be somewhat deep so that the glass does not come into contact with the painting.

One final consideration: Framing for an exhibit is different from framing for private home display. A group exhibit of wildly varying frame types can look haphazard, cheap, and distracting. Simple frames all around keep the focus on the art. And often, collectors reframe the works they purchase and bring home.

Maurice Prendergast, (American, 1859–1924), *Country House in Autumn Foliage,* c. 1910–1913, watercolor, pastel, and pencil on paper, 12⅛ x 17⅞ inches (30.8 x 45.4 cm), collection of The Mead Art Museum at Amherst College, Amherst, Massachusetts, gift of Mrs. Charles Prendergast, AC 1991.22

This painting immediately evokes stained glass windows because of the predominantly flat geometric shapes of brilliant color. The warmest colors are in the top half of the picture. Hoisted up on mid-toned vertical trunks close to the value of the roofs, the warm colors float above the light grays of the house, imbuing the composition with an airy feel despite the density of the foliage. I would choose a wood frame for this painting, to harmonize with the natural elements depicted.

traveling with pastel paintings

When shipping framed pastels, it is best to pack them in boxes specially lined with Ethafoam. The Ethafoam has a well cut out in the center, in the dimensions of the framed painting. The painting is inserted into the well, with the glass facing upward. Sometimes tape is placed in an X formation across the glass to further ensure that it does not shatter. A second piece of Ethafoam is then placed on top of the glass, so that the painting is protected on all sides. There are shipping companies that specialize in fine art whose trucks are temperature and humidity controlled.

When I drive short distances or travel on the New York City subways with my paintings, I wrap them in bubble wrap with the bubbles facing outward.

I recently had to travel with twenty unframed pastel paintings from New York to China. I sandwiched each painting (on gesso-pumice board) between two pieces of foam core, taped securely closed. My framer prepared the works for transit by wrapping bubble wrap, bubbles facing outward, around each painting. I placed the paintings into my carry-on bag (all the paintings were small) and filled the empty spaces with towels to prevent the packages from shifting. I carried them back home in the same packaging. They made both trips perfectly safe and sound.

Dawn Emerson, *Energy Field*, 2011, mixed media on Rives BFK paper, 20 x 20 inches (50.8 x 50.8 cm)

The artist evokes the commanding presence and velocity of the horses by employing what appears to be quickly, broadly, and boldly slashed in pastel. The movement is emphasized by the variety of directions in which the horses run. Despite the apparent speed of the pastel marks, their placement strongly captures the structures of her subjects.

afterword

When I first arrived in China, I saw a sign that was written
in both Chinese and English. It said "Exit." I studied the two
Chinese characters that accompanied the English. One character
looked like a highly abstracted depiction of a person—two legs,
shoulders, and head. The other had vertical lines topped with
horizontal lines; it looked like a doorway. Exit. The brushes used
in traditional Chinese painting and calligraphy are the same, and
the Chinese characters for painting and calligraphy are almost
identical. As you and I prepare to exit this book and embark on
new voyages into ourselves and the brilliance of pastel, I know
that new discoveries await us. I welcome you into the rich and
luminous tradition of pastel painting. I wish you ever-deepening
insights and the greatest of joys.

Ellen Eagle, *Mei-Chiao*, 2000, pastel on pumice board, 13 x 7¼
inches (33 x 18.4 cm)

When I painted Mei-Chiao, she had only recently arrived in the United
States. She did not yet speak English. I was enthralled by the thought
of her tremendous life transition, by the courage it must take to leave a
place of birth and immerse oneself in a foreign culture. I placed the back-
board behind her to suggest deeper layers, places she had come from
that led her here, and closed her eyes to suggest that there was much
about her that I could not know.

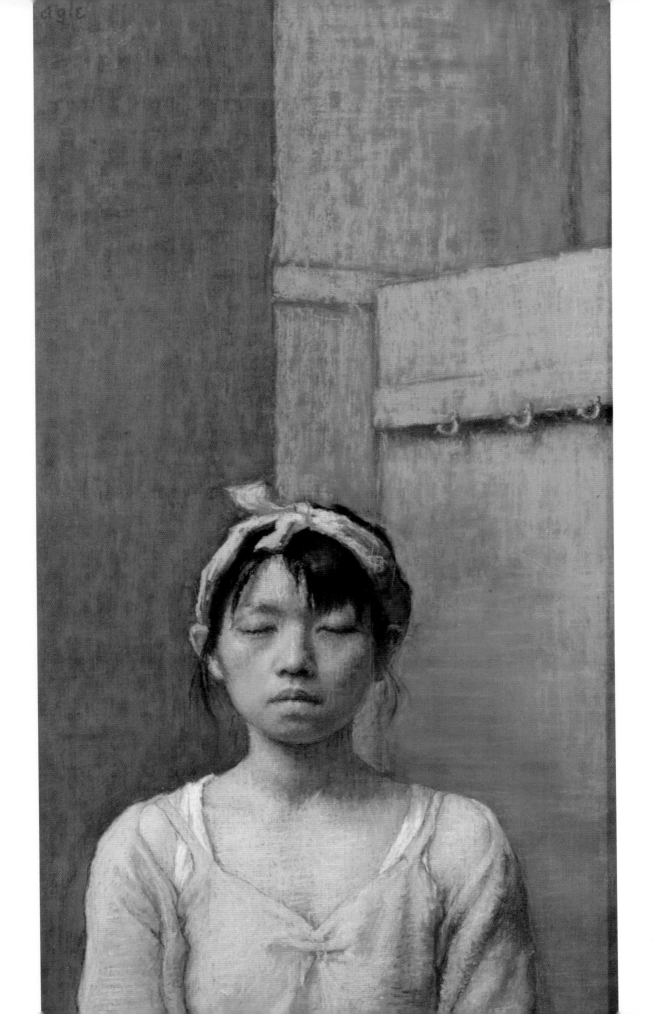

notable public collections of pastel paintings and drawings

As sophisticated as reproduction techniques have become, and as much as we love to regard images of works we revere during our everyday lives, prints of paintings can only offer hints of the greatness of the originals. When we look at reproductions, we are looking at translations of pastel, or paint, into printers' ink. The ink cannot reproduce the body, depth, and texture of the painter's materials. In reproductions of pastel paintings, particularly, the light-reflecting quality of the granules is missing. The image flattens, because the ink and paper are flat. Often, the colors and values are way off. The scale of the print almost always differs from that of the painting. And it is not always easy to find a quiet place to sit with a book or print, away from environmental distractions. All of these factors limit the symbiosis that occurs when we stand before a painting and open ourselves to its grandeurs.

Please look closely at as much original work as possible. The composition, colors, textures, and scale will teach you about the artist's spirit, how she applied pastel, how he told his story, your own values, and most important, your own heart. Following is a list of museums with particularly notable collections of pastel paintings and drawings. It is, however, not exhaustive. Please use it as a springboard for your own, personal explorations and discoveries.

ART INSTITUTE OF CHICAGO
(Chicago, IL)

Federico Barocci (Italian, circa 1535–1612)

Jack Beal (American, born 1931)

Pierre Bonnard (French, 1867–1947)

Louis-Marin Bonnet (French, 1736–1793)

François Boucher (French, 1703–1770)

Eugène-Louis Boudin (French, 1824–1898)

Georges Braque (French, 1882–1963)

Rosalba Carriera (Italian, 1675–1757)

Ramon Casas (Spanish, 1866–1932)

Mary Cassatt (American, 1845–1926)

Jean-Baptiste-Siméon Chardin (French, 1699–1779)

William Merritt Chase (American, 1849–1916)

John Constable (British, 1776–1837)

Charles-Antoine Coypel (French, 1694–1752)

Salvador Dalí (Spanish, 1904–1989)

Edgar Degas (French, 1834–1917)

Willem de Kooning (American, 1904–1997)

Eugène Delacroix (French, 1798–1863)

Maurice Denis (French, 1870–1943)

Martha Mayer Erlebacher (American, born 1937)

Henri Fantin-Latour (French, 1836–1904)

Janet Fish (American, born 1938)

Jean-Louis Forain (French, 1852–1931)

Paul Gauguin (French, 1848–1903)

Eva Gonzalès (French, 1849–1883)

Vincent van Gogh (Dutch, 1853–1890)

Hugh Douglas Hamilton (Irish, circa 1739–1808)

Paul César Helleu (French, 1859–1927)

William Penhallow Henderson (American, 1877–1943)

Helen Hyde (American, 1868–1919)

Yvonne Jacquette (American, born 1934)

Paul Klee (Swiss, 1879–1940)

Wolf Kahn (American, born 1927)

Maurice-Quentin de La Tour (French, 1704–1788)

Jean-Étienne Liotard (Swiss, 1702–1789)

Édouard Manet (French, 1832–1883)

G. Daniel Massad (American, born 1946)

Jean-François Millet (French, 1814–1875)

Berthe Morisot (French, 1841–1895)

Georgia O'Keeffe (American, 1887–1986)

Walter Launt Palmer (American, 1854–1932)

Jean-Baptiste Perronneau (French, 1715–1783)

Pablo Picasso (Spanish, 1881–1973)

Camille Pissarro (French, 1830–1903)

Maurice Prendergast (American, 1858–1924)

Odilon Redon (French, 1840–1916)

Pierre-Auguste Renoir (French, 1841–1919)

Georges Rouault (French, 1871–1958)

Théodore Rousseau (French, 1812–1867)

Gino Severini (Italian, 1883–1966)

James Sharples (American, 1751–1811)

Irene Siegel (American, born 1932)

Frances Hopkinson Smith (American, 1838–1915)

Everett Shinn (American, 1876–1953)

Alfred Sisley (French, 1839–1899)

Théophile-Alexandre Pierre Steinlen (French, 1859–1923)

Sir John Tenniel (British, 1820–1914)

Wayne Thiebaud (American, born 1920)

Henri de Toulouse-Lautrec (French, 1864–1901)

Maurice Utrillo (French, 1883–1955)

Suzanne Valadon (French, 1865–1938)

Simon Vouet (French, 1590–1649)

Édouard Vuillard (French, 1868–1940)

James McNeill Whistler (American, 1834–1903)

Joseph Wright (British, 1734–1797)

BOWDOIN COLLEGE MUSEUM OF ART
(Brunswick, ME)

Robert Carston Arneson (American, 1930–1992)

Rick Bartow (American, born 1946)

Norman Bluhm (American, 1921–1999)

John Appleton Brown (American, 1844–1902)

Mary Cassatt (American, 1844–1926)

James Wells Champney (American, 1843–1903)

Christo (Bulgarian, born 1935)

Barbara Cooney (American, 1917–2000)

Kenyon Cox (American, 1856–1919)

Johannes Garjeanne (Dutch, 1860–1930)

Walter Griffin (American, 1861–1935)

William Hamilton (British, 1751–1801)

Yvonne Jacquette (American, born 1934)

Eastman Johnson (American, 1824–1906)

Joseph B. Kahill (American, 1882–1957)

Anna Elizabeth Klumpke (American, 1856–1942)

Maurice Prendergast (American, 1858–1924)

Elizabeth Bradbury Robinson (American, 1832–1897)

George Segal (American,1924–2000)

Elihu Vedder (American, 1836–1923)

Abraham Walkowitz (American, 1878–1965)

BROOKLYN MUSEUM
(Brooklyn, NY)

Edward Mitchell Bannister (Canadian, 1828–1901)

Antoine-Louis Barye (French, 1795–1875)

Walter Otto Beck (American, 1864–1954)

J. Carroll Beckwith (American, 1852–1917)

Robert Frederick Blum (American, 1857–1903)

Eugène-Louis Boudin (French, 1824–1898)

Mary Cassatt (American, 1845–1926)

William Merritt Chase (American, 1849–1916)

Charles Caryl Coleman (American, 1840–1928)

Lilian Haines Crittenden (American, 1858–1919)

Arthur Bowen Davies (American, 1862–1928)

Edgar Degas (French, 1834–1917)

Robert De Niro Sr. (American, 1922–1993)

Thomas Wilmer Dewing (American, 1851–1938)

Preston Dickinson (American, 1891–1930)

Bailey Doogan (American, born 1941)

Charles Henry Fromuth (American, 1861–1937)

Paul Gauguin (French, 1848–1903)

William James Glackens (American, 1870–1938)

Marsden Hartley (American, 1877–1943)

Richard Haas (American, born 1936)

Childe Hassam (American, 1859–1935)

Wolf Kahn (American, born 1927)

Paul Klee (Swiss, 1879–1940)

Georgia O'Keeffe (American, 1887–1986)

Robert Philipp (American, 1895–1981)

Odilon Redon (French, 1840–1916)

James Sharples (American, 1751–1811)

Everett Shinn (American, 1876–1953)

Isaac Soyer (American, 1902–1981)

Raphael Soyer (American, 1899–1987)

Joseph Stella (American, 1877–1946)

John Henry Twachtman (American, 1853–1902)

Agnes Weinrich (American, 1873–1946)

CARNEGIE MUSEUM OF ART
(Pittsburgh, PA)

Robert Frederick Blum (American, 1857–1903)

Sir Edward Coley Burne-Jones (British, 1833–1898)

Edgar Degas (French, 1834–1917)

Preston Dickinson (American, 1891–1930)

Arthur Dove (American, 1880–1946)

Childe Hassam (American, 1859–1935)

Henry Varnum Poor (American, 1887–1970)

Maurice Prendergast (American, 1858–1924)

Everett Shinn (American, 1876–1953)

John Henry Twachtman (American, 1853–1902)

Benjamin West (American, 1738–1820)

James McNeill Whistler (American, 1834–1903)

CLEVELAND MUSEUM OF ART
(Cleveland, OH)

Mary Cassatt (American, 1845–1926)

Edgar Degas (French, 1834–1917)

Odilon Redon (French, 1840–1916)

Charles Sheeler (American, 1883–1965)

DETROIT INSTITUTE OF FINE ARTS
(Detroit, MI)

Rosalba Carriera (Italian, 1675–1757)

Mary Cassatt (American, 1845–1926)

Charles Caryl Coleman (American, 1840–1928)

Edgar Degas (French, 1834–1917)

Thomas Wilmer Dewing (American, 1851–1938)

Jean-Étienne Liotard (Swiss, 1702–1789)

Édouard Manet (French, 1832–1883)

Jean Valade (French, 1710–1787)

FINE ARTS MUSEUMS OF SAN FRANCISCO
(San Francisco, CA)

Edmond François Aman-Jean (French, 1860–1936)

Albert Besnard (French, 1849–1934)

Emil James Bisttram (American, 1895–1976)

Nicholas Blakey (Irish, circa 1711–1758)

Richard Jerome Bogart (American, born 1929)

Muirhead Bone (British, 1876–1953)

Ray Scepter Boynton (American, 1883–1951)

Robert Brackman (American, 1898–1980)

Morris Broderson (American, 1928–2011)

Christopher Brown (American, born 1951)

George Burk (American, born 1938)

Theodore Butler (American, 1861–1936)

Luigi Calamatta (Italian, 1802–1869)

Charles Carrick (British, active 19th century)

Rosalba Carriera (Italian, 1675–1757)

Mary Cassatt (American, 1844–1926)

Jules Chéret (French, 1836–1932)

Judith Spector Clancy (American, 1933–1990)

James Henry Daugherty (American, 1889–1974)

Arthur Bowen Davies (American, 1862–1928)

Edgar Degas (French, 1834–1917)

Alfred Dehodencq (French, 1822–1882)

Maynard Dixon (American, 1875–1946)

Bernard Dunstan (British, born 1920)

Jean-Baptiste Armand Guillaumin (French, 1841–1927)

Marsden Hartley (American, 1877–1943)

Kawase Hasui (Japanese, 1883–1957)

William Fowler Hopson (American, 1849–1935)

Vladimir Ivanovich Jedrinsky (Russian, 1899–1974)

Franz Kline (American, 1910–1962)

Félix-Hippolyte Lanoüe (French, 1812–1872)

Max Liebermann (German, 1849–1935)

Léon-Henri Lievrat (French, 1854–1913)

Norman Lundin (American, born 1938)

Eric Spencer Macky (American, 1880–1958)

Martha Miller (American, born 1954)

Claes Oldenburg (American, born 1929)

Nathan Oliveira (American, 1928–2010)

Jean-Baptiste Perronneau (French, 1715–1783)

Maurice-Quentin de La Tour (French, 1704–1788)

Odilon Redon (French, 1840–1916)

James Sharples (American, 1751–1811)

William Strang (Scottish, 1859–1921)

Édouard Vuillard (French, 1868–1940)

Julian Alden Weir (American, 1852–1919)

FOGG MUSEUM
(Cambridge, MA)

George Bellows (American, 1882–1925)

Rosalba Carriera (Italian, 1675–1757)

Jean-Baptiste-Siméon Chardin (French, 1699–1779)

François Clouet (French, circa 1516–1572)

Edgar Degas (French, 1834–1917)

Thomas Wilmer Dewing (American, 1851–1938)

Maurice-Quentin de La Tour (French, 1704–1788)

Édouard Manet (French, 1832–1883)

Jean-Baptiste Perronneau (French, 1715–1783)

John Singer Sargent (American, 1856–1925)

James McNeill Whistler (American, 1834–1903)

Sarah Wyman Whitman (American, 1842–1904)

THE FRICK COLLECTION
(New York, NY)

Daniel Gardner (British, 1750–1805)

Jean-Baptiste Greuze (French, 1725–1805)

James McNeill Whistler (American, 1834–1903)

FRYE ART MUSEUM
(Seattle, WA)

Robert Brackman (American, 1898–1980)

Marsden Hartley (American, 1877–1943)

Everett Shinn (American, 1876–1953)

Bettina Steinke (American, 1913–1999)

Timothy Stortz (American, born 1952)

GALLERIA DEGLI UFFIZI
(Florence, Italy)

Giovanni Antonio Boltraffio (Italian, 1467–1516)

Rosalba Carriera (Italian, 1675–1757)

Hugh Douglas Hamilton (Irish, circa 1740–1808)

Jean-Étienne Liotard (Swiss, 1702–1789)

Benedetto Luti (Italian, 1666–1724)

Robert Nanteuil (French, 1623–1678)

Jean-Baptiste Nicolas Pillement (French, 1728–1808)

Sir Anthony van Dyck (Flemish, 1599–1641)

Joseph Vivien (French, 1657–1734)

Simon Vouet (French, 1590–1649)

J. PAUL GETTY MUSEUM
(Los Angeles, CA)

Rosalba Carriera (Italian, 1675–1757)

Francis Cotes (British, 1726–1770)

Edgar Degas (French, 1834–1917)

Eugène Delacroix (French, 1798–1863)

Adélaïde Labille-Guiard (French, 1749–1803)

Maurice-Quentin de La Tour (French, 1704–1788)

François Le Moyne (French, 1688–1737)

Jean-Étienne Liotard (Swiss, 1702–1789)

Anton Raphael Mengs (German, 1728–1779)

Francesco Paolo Michetti (Italian, 1851–1929)

Jean-François Millet (French, 1814–1875)

Robert Nanteuil (French, 1623–1678)

Odilon Redon (French, 1840–1916)

Charles Le Brun (French, 1619–1690)

Joseph Vivien (French, 1657–1734)

HOOD MUSEUM OF ART AT DARTMOUTH COLLEGE
(Hanover, NH)

Ivan Albright (American, 1897–1983)

John James Audobon (American, 1785–1851)

José Maria Sert y Badia (Spanish, circa 1874–1945)

Peggy Bacon (American, 1895–1987)

Robert Brackman (American, 1898–1980)

Mary Cassatt (American, 1845–1926)

Edgar Degas (French, 1834–1917)

James Wells Champney (American, 1843–1903)

Howard Norton Cook (American, 1901–1980)

John Singleton Copley (American, 1737–1815)

Preston Dickinson (American, 1891–1930)

William James Glackens (American, 1870–1938)

George Overbury Hart (American, 1863–1933)

Philip Leslie Hale (American, 1865–1931)

Robert Henri (American, 1865–1929)

Wolf Kahn (American, born 1927)

Walt Kuhn (American, 1877–1949)

Dorothea Litzinger (American, 1889–1925)

Joan Mitchell (American, 1925–1992)

Diego Rivera (Mexican, 1886–1957)

Everett Shinn (American, 1876–1953)

Joseph Stella (American, 1877–1946)

Frank Wilbert Stokes (American, 1858–1955)

Anton Weber (Austrian, 1858–1942)

MEAD ART MUSEUM AT AMHERST COLLEGE
(Amherst, MA)

Edwin Austin Abbey (American, 1852–1911)

James Carroll Beckwith (American, 1852–1917)

Beverly Buchanan (American, born 1940)

Bryson Burroughs (American, 1869–1934)

Arthur Bowen Davies (American, 1862–1928)

Thomas Wilmer Dewing (American, 1851–1938)

Michael Mazur (American, 1935–2009)

David Nash (British, born 1945)

Maurice Prendergast (American, 1858–1924)

Alexander Schilling (American, 1859–1937)

James Sharples (American, 1751–1811)

Everett Shinn (American, 1876–1953)

Dwight William Tryon (American, 1849–1925)

John Henry Twachtman (American, 1853–1902)

Julian Alden Weir (American, 1852–1919)

James McNeil Whistler (American, 1834–1903)

METROPOLITAN MUSEUM OF ART
(New York, NY)

Jacopo (Giacomo) Bassano (Italian, circa 1510–1592)

Louis-Marin Bonnet (French, 1736–1793)

Ford Madox Brown (British, 1821–1893)

Rosalba Carriera (Italian, 1675–1757)

Mary Cassatt (American, 1845–1926)

John Singleton Copley (American, 1737–1815)

Charles-Antoine Coypel (French, 1694–1752)

Edgar Degas (French, 1834–1917)

Domenico Fetti (Italian, circa 1589–1623)

Marcia Lane Jarret Foster (British, 1897–1968)

Mary Frank (American, born 1933)

Paul Gauguin (French, 1848–1903)

Henrietta Johnston (American, circa 1674–1729)

Adélaïde Labille-Guiard (French, 1749–1803)

Maurice-Quentin de La Tour (French, 1704–1788)

François Le Moyne (French, 1688–1737)

Benedetto Luti (Italian, 1666–1724)

Anton Raphael Mengs (German, 1728–1779)

Jean-François Millet (French, 1814–1875)

Claude Monet (French, 1840–1926)

Jean-Baptiste Perronneau (French, 1715–1783)

Jean-Baptiste Nicolas Pillement (French, 1728–1808)

Pierre-Cécile Puvis de Chavannes (French, 1824–1898)

Pierre-Auguste Renoir (French, 1841–1919)

Jean-Baptiste Claude Richard (French, 1727–1791)

Georges Rouault (French, 1871–1958)

Peter Paul Rubens (Flemish, 1577–1640)

John Russell (British, 1745–1806)

Alfred Sisley (French, 1839–1899)

Louis Comfort Tiffany (American, 1848–1933)

Édouard Vuillard (French, 1868–1940)

James McNeil Whistler (American, 1834–1903)

Joseph Wright (British, 1734–1797)

MORGAN LIBRARY AND MUSEUM
(New York, NY)

Cavaliere d'Arpino (Italian, 1568–1640)

Giovanni Francesco Barbieri (Italian, 1591–1666)

Gian Lorenzo Bernini (Italian, 1598–1680)

François Boucher (French, 1703–1770)

Vittore Carpaccio (Italian, circa 1460–1525/26)

Louis Carrogis (French, 1717–1806)

Jacopo Chimenti (Italian, 1551–1640)

Edgar Degas (French, 1834–1917)

François-Hubert Drouais (French, 1727–1775)

Gerbrand van den Eeckhout (Dutch, 1621–1674)

Jean-Baptiste Greuze (French, 1725–1805)

Jacob Jordaens (Flemish, 1593–1678)

Sir Peter Lely (British, 1618–1680)

Charles-Joseph Natoire (French, 1700–1777)

Jacques-André Portail (French, 1695–1759)

Pierre-Paul Prud'hon (French, 1758–1823)

Odilon Redon (French, 1840–1916)

Antoine Watteau (French, 1684–1721)

MOUNT HOLYOKE COLLEGE ART MUSEUM
(South Hadley, MA)

Paul Henry Brach (American, 1924–2007)

William Merritt Chase (American, 1849–1916)

Sandro Chia (Italian, born 1946)

Edward Corbett (American, 1919–1971)

Stuart Diamond (American, born 1942)

Edwin Romanzo Elmer (American, 1850–1923)

Nancy Graves (American, 1939–1995)

Wolf Kahn (American, born 1927)

Piero Guccione (Italian, born 1935)

Max Liebermann (German, 1847–1935)

André Masson (French, 1896–1987)

David Nash (British, born 1945)

John Newman (American, born 1952)

Auguste Pégurier (French, 1856–1936)

Irving Petlin (American, born 1934)

Maurice Prendergast (American, 1858–1924)

Doris Rosenthal (American, 1889–1971)

Georges Rouault (French, 1871–1958)

Jaune Quick-To-See Smith (American, born 1940)

Scott Tulay (American, born 1970)

Robert Strong Woodward (American, 1885–1957)

MUSÉE D'ORSAY
(Paris, France)

Albert Besnard (French, 1849–1934)

Pierre Bonnard (French, 1867–1947)

Eugène-Louis Boudin (French, 1824–1898)

Louise Breslau (German, 1856–1927)

Leonetto Cappiello (Italian, 1875–1942)

Mary Cassatt (American, 1845–1926)

Edgar Chahine (Viennese, 1874–1947)

Pierre-Cécile Puvis de Chavannes (French, 1824–1898)

Jules Chéret (French, 1836–1932)

Charles Cottet (French, 1863–1925)

Pascale Dagnan-Bouveret (French, 1852–1929)

Honoré Daumier (French, 1808–1879)

Edgar Degas (French, 1834–1917)

Léopold Delbeke (French, circa 1866–1939)

Maurice Denis (French, 1870–1943)

Giuseppe DeNittis (Italian, 1846–1884)

Philippe Félix Dupuis (French, 1824–1888)

Henri Fantin-Latour (French, 1836–1904)

Jean-Louis Forain (French, 1852–1931)

Paul Gauguin (French, 1848–1903)

Joan González (Spanish, 1868–1908)

Fernand Le Goût-Gérard (French, 1856–1924)

Paul Helleu (French, 1859–1927)

Beatrice How (British, 1867–1932)

Auguste Lepère (French, 1849–1918)

Émile Lévy (French, 1826–1890)

Lucien Levy-Dhurmer (Algerian, 1865–1953)

Charles Lucien Léandre (French, 1862–1934)

Aristide Maillol (French, 1861–1944)

Édouard Manet (French, 1832–1883)

Émile-René Ménard (French, 1862–1930)

Claude Monet (French, 1840–1926)

Berthe Morisot (French, 1841–1895)

Alphonse Osbert (French, 1857–1939)

Camille Pissarro (French, 1830–1903)

Odilon Redon (French, 1840–1916)

Pierre-Auguste Renoir (French, 1841–1919)

Juan Roig y Soler (Spanish, 1835–1918)

Ker-Zavier Roussel (French, 1867–1944)

Leon Spilliaert (Belgian, 1881–1946)

Édouard Vuillard (French, 1868–1940)

MUSÉE LOUVRE
(Paris, France)

Jacopo (Giacomo) Bassano (Italian, circa 1510–1592)

François Boucher (French, 1703–1770)

Rosalba Carriera (Italian, 1675–1757)

Jean-Baptiste-Siméon Chardin (French, 1699–1779)

Antoine Coypel (French, 1661–1722)

Charles-Antoine Coypel (French, 1694–1752)

Jean-Baptiste Greuze (French, 1725–1805)

Adélaïde Labille-Guiard (French, 1749–1803)

Maurice-Quentin de La Tour (French, 1704–1788)

Charles LeBrun (French, 1619–1690)

Jean-Étienne Liotard (Swiss, 1702–1789)

Benedetto Luti (Italian, 1666–1724)

Robert Nanteuil (French, 1623–1678)

Jean-Marc Nattier (French, 1685–1766)

Jean-Baptiste Perronneau (French, 1715–1783)

Jean-Baptiste Nicolas Pillement (French, 1728–1808)

Pierre-Paul Prud'hon (French, 1758–1823)

Mme Alexandre Roslin (née Marie-Suzanne Giroust) (French, 1734–1772)

John Russell (British, 1745–1806)

Cornelis Troost (Dutch, 1696–1750)

Louis Vigée (French, 1716–1809)

Élisabeth Vigée-Lebrun (French, 1755–1842)

Joseph Vivien (French, 1657–1734)

MUSEUM OF FINE ARTS, BOSTON
(Boston, MA)

Edgar Degas (French, 1834–1917)

Jean-François Millet (French, 1814–1875)

Claude Monet (French, 1840–1926)

Maurice Prendergast (American, 1858–1924)

Dante Gabriel Rossetti (British, 1828–1882)

James Sharples (American, 1751–1811)

Everett Shinn (American, 1876–1953)

Joseph Stella (American, 1877–1946)

Sarah Wyman Whitman (American, 1842–1904)

MUSEUM OF MODERN ART
(New York, NY)

Edgar Degas (French, 1834–1917)

André Masson (French, 1896–1987)

Joan Miró (Spanish, 1893–1983)

Georgia O'Keeffe (American, 1887–1986)

Odilon Redon (French, 1840–1916)

NATIONAL GALLERY
(London, UK)

Rosalba Carriera (Italian, 1675–1757)

Edgar Degas (French, 1834–1917)

Maurice-Quentin de La Tour (French, 1704–1788)

Édouard Manet (French, 1832–1883)

Jean-Baptiste Perronneau (French, 1715–1783)

Odilon Redon (French, 1840–1916)

NATIONAL GALLERY OF ART

(Washington, D.C.)

Rosalba Carriera (Italian, 1675–1757)

Jean-Baptiste Greuze (French, 1725–1805)

Hugh Douglas Hamilton (Irish, circa 1739–1808)

Jean-Étienne Liotard (Swiss, 1702–1789)

Jean-Baptiste Perronneau (French, 1715–1783)

Jean-Baptiste Nicolas Pillement (French, 1728–1808)

John Russell (British, 1745–1806)

Ellen Sharples (British, 1769–1849)

NATIONAL GALLERY OF IRELAND

(Dublin, Ireland)

Rosalba Carriera (Italian, 1675–1757)

Samuel Cotes (British, 1734–1818)

John Downman (British, 1750–1824)

Daniel Gardner (British, 1750–1805)

Hugh Douglas Hamilton (Irish, circa 1739–1808)

Wallerant Vaillant (Dutch, 1623–1677)

NATIONAL PORTRAIT GALLERY

(London, UK)

Francis Cotes (British, 1726–1770)

Hugh Douglas Hamilton (Irish, circa 1739–1808)

Sir Thomas Lawrence (British, 1769–1830)

Edward Luttrell (British, died 1737)

John Russell (British, 1745–1806)

NORTON SIMON MUSEUM

(Pasadena, CA)

Louis Anquentin (French, 1861–1932)

Pierre Bernard (French, 1704–1777)

Giovanni Boldini (Italian, 1842–1931)

Edgar Degas (French, 1834–1917)

Valerius DeMari (American, 1886–1970)

Jean-Louis Forain (French, 1852–1931)

Hans Hartung (German, 1904–1989)

Paul Holz (German, 1883–1938)

Alexei Jawlenski (Russian, 1864–1941)

Maurice-Quentin de La Tour (French, 1704–1788)

Piet Mondrian (Dutch, 1872–1944)

Pablo Picasso (Spanish, 1881–1973)

Dimitri Petrov (Russian/American, 1919–1986)

Werner Scholz (German, 1898–1982)

Henri de Toulouse-Lautrec (French, 1864–1901)

PHILADELPHIA MUSEUM OF ART

(Philadelphia, PA)

Cecilia Beaux (American, 1855–1942)

Louis-Marin Bonnet (French, 1736–1793)

Mary Cassatt (American, 1845–1926)

Edgar Degas (French, 1834–1917)

Sidney Goodman (American, born 1936)

Sir Thomas Lawrence (British, 1769–1830)

Jacques Lipchitz (American, 1891–1973)

Claude Lovat Fraser (British, 1890–1921)

Antonio Mancini (Italian, 1852–1930)

Jean-François Millet (French, 1814–1875)

Joan Miró (Spanish, 1893–1983)

Maurice Prendergast (American, 1858–1924)

Odilon Redon (French, 1840–1916)

Diego Rivera (Mexican, 1886–1957)

William Russell (British, 1784–1870)

RIJKSMUSEUM

(Amsterdam, Netherlands)

Jean-Étienne Liotard (Swiss, 1702–1789)

Anton Raphael Mengs (German, 1728–1779)

Jean-Baptiste Perronneau (French, 1715–1783)

Cornelis Troost (Dutch, 1696–1750)

Bernard Vaillant (Dutch, 1632–1698)

Élisabeth Vigée-Lebrun (French, 1755–1842)

SMITH COLLEGE MUSEUM OF ART

(Northampton, MA)

Federico Barocci (Italian, circa 1535–1612)

Jack Beal (American, born 1931)

Joseph Blackburn (British, 1752–1778)

Bryson Burroughs (American, 1869–1934)

William Baxter Palmer Closson (American, 1848–1926)

Marc Chagall (Russian, 1887–1985)

Arthur Bowen Davies (American, 1862–1928)

Preston Dickinson (American, 1891–1930)

Paul Gauguin (French, 1848–1903)

April Gornik (American, born 1953)

Robert Henri (American, 1865–1929)

Laura Coombs Hills (American, 1859–1952)

Benedetto Luti (Italian, 1666–1724)

Henry Moore (British, 1898–1986)

Elizabeth Murray (American, 1940–2007)

Georgia O'Keeffe (American, 1887–1986)

Maurice Prendergast (American, 1858–1924)

Pierre-Auguste Renoir (French, 1841–1919)

Alexander Schilling (American, 1859–1937)

George Segal (American, 1924–2000)

Dwight William Tryon (American, 1849–1925)

John Henry Twachtman (American, 1853–1902)

Édouard Vuillard (French, 1868–1940)

Mary Rogers Williams (American, 1857–1907)

STATE HERMITAGE MUSEUM
(St. Petersburg, Russia)

Paul-Albert Besnard (French, 1849–1934)

Rosalba Carriera (Italian, 1675–1757)

Edgar Degas (French, 1834–1917)

Franz von Lenbach (German, 1836–1904)

Max Liebermann (German, 1847–1935)

Édouard Manet (French, 1832–1883)

Anton Raphael Mengs (German, 1728–1779)

Théobold Michau (Flemish, 1676–1765)

Pablo Picasso (Spanish, 1881–1973)

Pierre-Auguste Renoir (French, 1841–1919)

Georges Rouault (French, 1871–1958)

John Russell (British, 1745–1806)

Johann Heinrich Schmidt (German, 1749–1829)

Franz von Stuck (Bavarian, 1863–1928)

Fritz Thaulow (Norwegian, 1847–1906)

Pierre-Jacques Volaire (French, 1729–1802)

STERLING AND FRANCINE CLARK ART INSTITUTE AT WILLIAMS COLLEGE
(Williamstown, MA)

Jacque-Émile Blanche (French, 1861–1942)

Robert Frederick Blum (American, 1857–1903)

Mary Cassatt (American, 1845–1926)

Jules Chéret (French, 1836–1932)

Liliana Cosovel (Italian, born 1924)

Edgar Degas (French, 1834–1917)

John Downman (British, 1750–1824)

Childe Hassam (American, 1859–1935)

Benedetto Luti (Italian, 1666–1724)

Édouard Manet (French, 1832–1883)

Jean-François Millet (French, 1814–1875)

Mary Evelyn De Morgan (British, circa 1855–1919)

Camille Pissarro (French, 1830–1903)

Paul Serusier (French, 1864–1927)

James Sharples (American, 1751–1811)

Édouard Vuillard (French, 1868–1940)

TATE COLLECTION
(London, England)

David Cox (British, 1783–1859)

Edgar Degas (French, 1834–1917)

Thomas Gainsborough (British, 1727–1788)

Joan González (Spanish, 1868–1908)

Julio González (Spanish, 1876–1942)

William Henry Hunt (British, 1790–1864)

Eric Kennington (British, 1888–1960)

Oscar Kokoschka (Czech/Austrian, 1886–1980)

Odilon Redon (French, 1840–1916)

John Russell (British, 1745–1806)

Walter Richard Sickert (British, 1860–1942)

Édouard Vuillard (French, 1868–1940)

VICTORIA AND ALBERT MUSEUM
(London, UK)

Francis Cotes (British, 1726–1770)

Hugh Douglas Hamilton (Irish, circa 1739–1808)

Benedetto Luti (Italian, 1666–1724)

John Russell (British, 1745–1806)

index

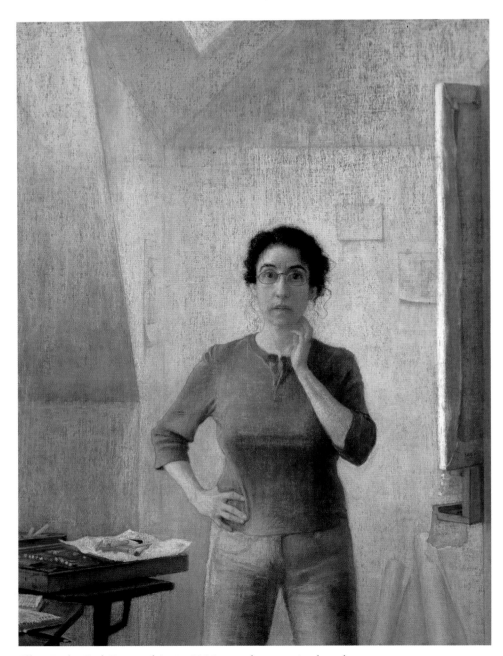

Ellen Eagle, *Each Time, and Again*, 2005, pastel on pumice board,
23 x 18 inches (58.4 x 45.7 cm)

Adding the drawings to the far wall between me and the canvas in this
piece, pictured in an earlier stage on page 125, was crucial to the depic-
tion of my questioning attitude inherent in my work.

Looking into our worlds, we open ourselves to the lessons that are
everywhere. Entering our pastel painting studios, we ask ourselves, "What
is my premise, my point of view?" The question is our constant compan-
ion. It shepherds our explorations throughout our lives, each time, and
again.